Buddha & Christ

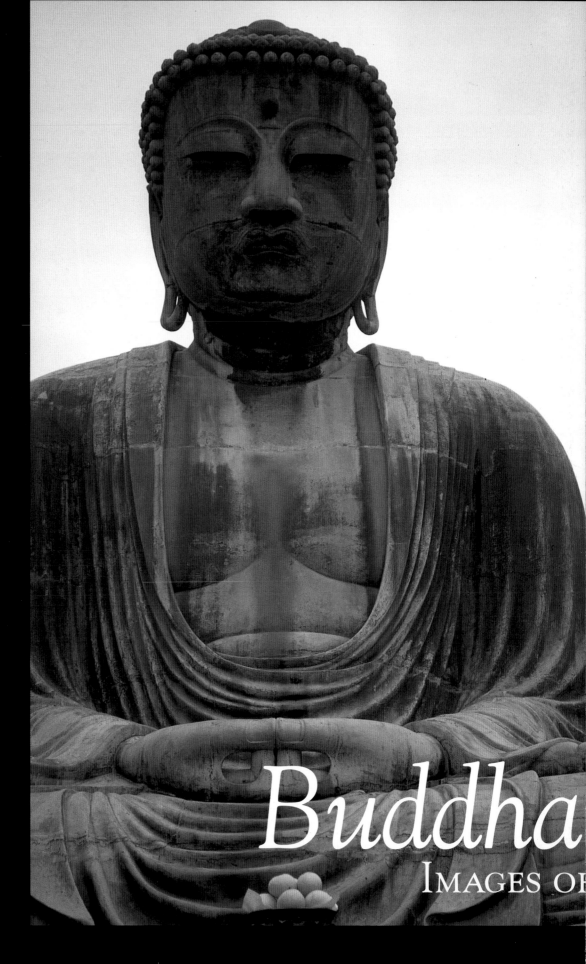

Weatherhill
New York & Tokyo

Buddha

IMAGES OF

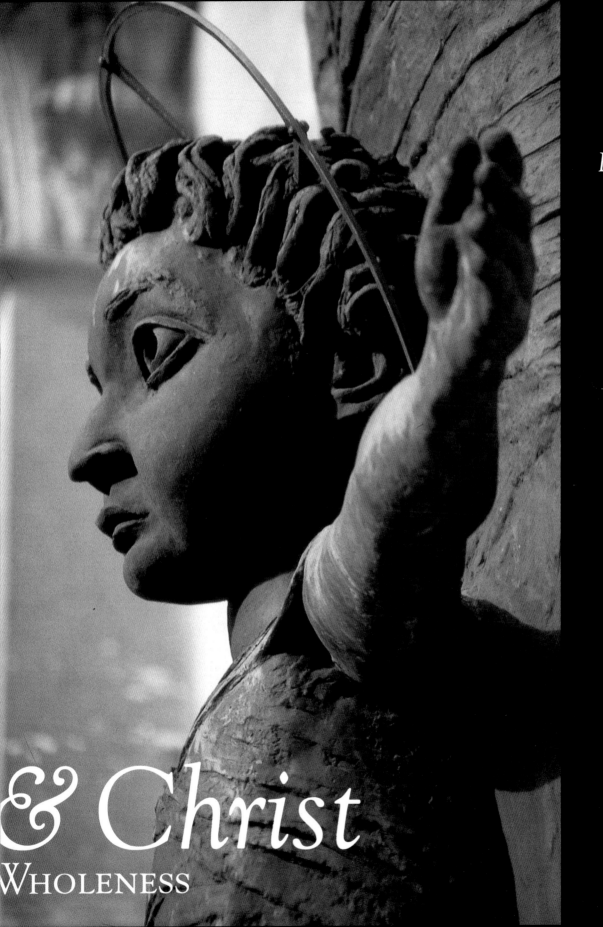

by
Robert Elin

& Christ
Wholeness

First edition, 2000

Published by Weatherhill, Inc., 41 Monroe Turnpike, Trumbull, CT 06611.
Protected by copyright under the terms of the International Copyright Union;
all rights reserved. Except for fair use in book reviews, no part of this book may be
reproduced for any reason by any means, including any method of photographic
reproduction, without permission of Weatherhill, Inc. Printed in China.

05 04 03 02 01 00 6 5 4 3 2 1

ISBN 0-8348-0446-8

Library of Congress Cataloging-in-Publication Data

Elinor, Robert.
 Buddha & Christ : images of wholeness / by Robert Elinor.—1st edition
 p. cm.
 Includes Index.
 ISBN 0-8348-0446-8
 1. Jesus Christ—Person and offices. 2. Gautama Buddha. 3. Christian art
and symbolism. 4. Buddhist art and symbolism. I. Title: Buddha & Christ.
II. Title

BT 202.E34 2000
704.9'48–dc21 00-033012

FIG. 1 (LEFT FRONT JACKET,
P. 20)
Amida Buddha. Jocho, 1053.
Byodo-in, Uji, Japan

FIG. 2 (RIGHT FRONT JACKET,
P. 132)
Christ. Rembrandt van Rijn,
c. 1650, Netherlands.
Staatliche Museum, Berlin

FIG. 3 (P. 2 AND P. 4, MIDDLE,
RIGHT)
Amida Buddha. 1253, Kotokuin,
Kamakura, Japan

FIG. 4 (P. 3, P. 4, LEFT, P. 5)
Madonna and Child. 1952,
Jacob Epstein. Cavendish
Square, London

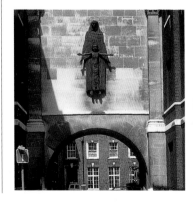
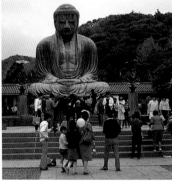
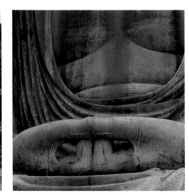

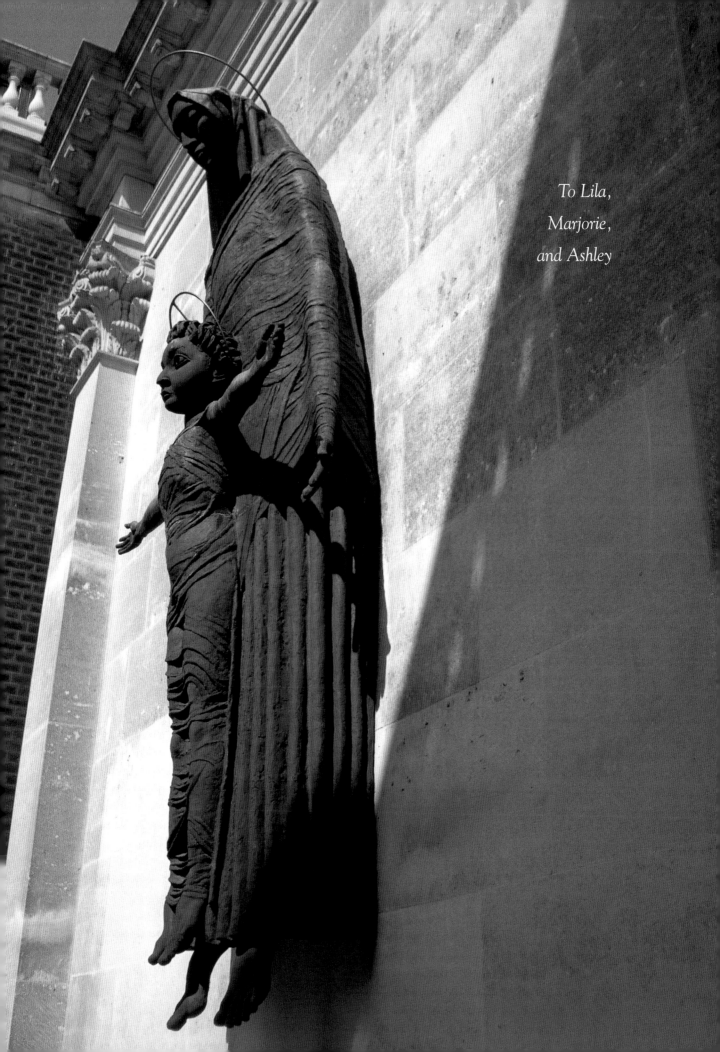

To Lila,
Marjorie,
and Ashley

Contents

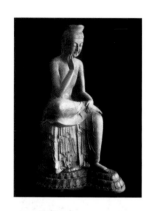

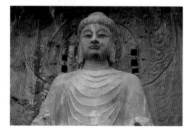

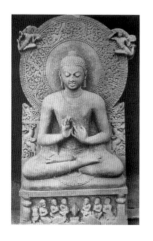

Part I: The Cage of Form

Part II: Transformations

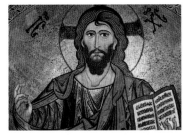

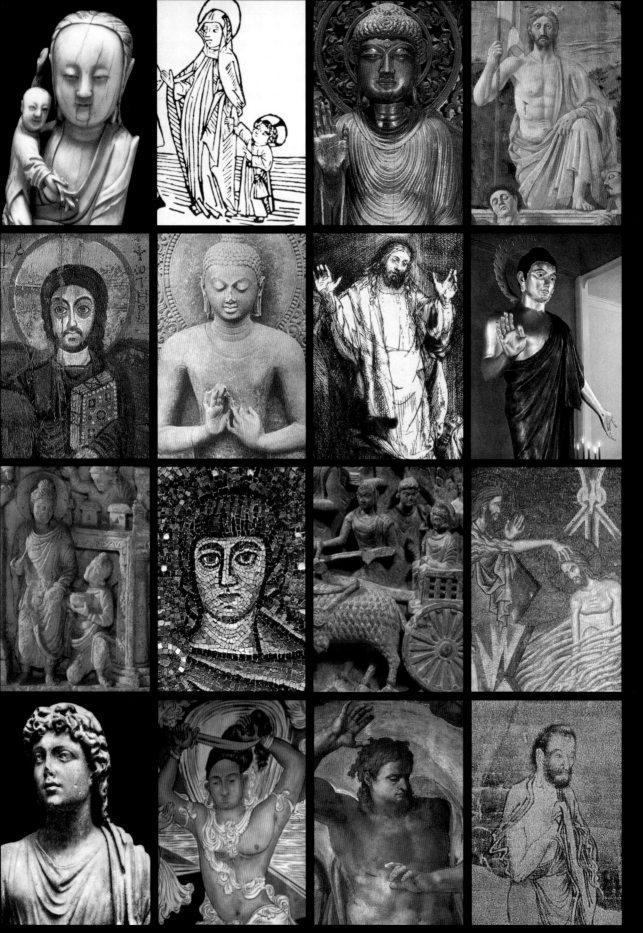

List of Illustrations

FOLLOWING PAGE 158

Maps of Image Sources

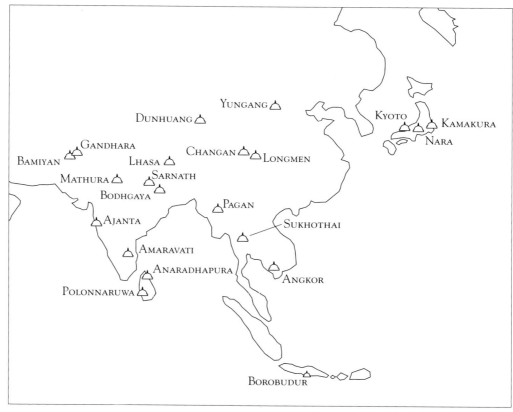

Preface & Acknowledgments

We are the only animals who make images. And in an age supersaturated with them through mass media, images of Buddha and Christ remain the two most potent images ever made. Buddha and Christ continue to impact the metaphysical mysteries, social concerns, and personal psyches of about one person in every five on the planet.

Theirs are the only major religions in which the faithful consider the founder not only the author of scripture and the model for salvation but the incarnation of ultimate reality itself.

Of all religions, theirs have had the greatest influence on human history, and global technology is making them both part of our heritage in a world that increasingly has no East or West, only the place where we are and other places. Whether we are Buddhists or Christians, or both, or neither, we recognize the growing need for at least a rudimentary understanding of other religions. Beyond the dialogue necessary for harmonious survival, the perspectives of another tradition provide opportunities for deeper insights into our own.

This book brings images of Buddha and Christ together in one volume. Several visits throughout Asia and Europe during more than forty years of teaching religious studies have convinced me that visual images not only express religious experience immediately, they often convey religious meaning more clearly and completely than words. Images of Buddha and Christ invite us into the very heart of the two religions that find the locus of universal truth embodied in a particular person. In juxtaposing the images, we see remarkable similarities as well as profound differences.

When these images are works of art they have their own intrinsic value. A work of art is a unique fact. It transforms the world of its focus, rendering that world conformable to itself. While many images of Buddha and Christ are innocent of aesthetic value, others have been made with sufficient skill and insight to grace any catalogue of the world's most significant art.

We may respond intuitively to these images without knowing what they mean. We may not even know the stories of the lives of Buddha or Christ. To begin to realize the depth of their religious and aesthetic potential, however, requires seeing them within their cultural contexts. This book introduces some of the history, myth, and doctrine, as well as some of the patterns of symbols and styles, that enable the images to say more clearly what finally cannot be said in words.

Brevity requires enormous simplification and generalization. Similarly, every picture suggests a host of alternatives. Neither argument nor inventory, this book is primarily evocation. It invites the viewer and reader to see Buddha and Christ as local inflections of a universal

archetype: the cosmic Person imaging wholeness. It nonetheless celebrates the distinctive character of the face of Buddha and the face of Christ, the incredible variety of their forms, and, frequently, their extraordinary beauty. It encourages informed, contemplative looking. The intensity of such moments must finally, as in all genuine religious and aesthetic experience, so reverberate in us as to decisively effect the decisions and actions of our daily lives.

I have omitted diacritical marks for the transliteration of Oriental terms. Such marks are unnecessary both for those familiar with these languages who can identify the words without them and for those unfamiliar with these languages for whom the unmarked words are strange enough.

For further convenience, dates indicate the number of years before or after the birth of Christ. Buddha smiles patiently at this Western conceit. He knows no one knows when Christ was born. Time is not that important to Buddha.

My thanks to the following people for their advice and encouragement after reading all or parts of the various drafts of this book during its eighteen year gestation. Prof. Hugo Buckthal of the Warburg Institute, David Buckton of the British Museum, Sally Dormer and John Guy of the Victoria and Albert Museum, Dr. William Fore of Yale University, Barbara French, Burton Hersh and Dr. Evelyn Pitcher in New Hampshire, Patricia Gracey in Twickenham, England, Stephen Hodge, Ronald Maddox, Ray Percheron, Clive Sherlock, and Garry Thomson of The Buddhist Society, London, Denise Leidy of the Museum of Fine Arts, Boston, Prof. Donald Lopez, Jr., of the University of Michigan, Dr. Eleanor Mattes in Lexington, MA, Dr. Vrej Nersessian and Penelope Wallis of the British Library, Dr. Tadeusz Skorupski of the School of Oriental and African Studies, and William Steele in New York City.

Among the many who patiently answered my questions, I especially remember in England: the Rev. Jack Austin, Prof. Anthony Bryer, Dh. Chintamani, Joseph Cribb, Dr. Jeremy Davidson, Prof. Philip Denwood, Oliver Everett, John Lowry, Dr. T.S. Maxwell, Prof. Richard Pankhurst, the Ven. K. Pitatissa, Tissa Ramasinghe, Prof. Edward Robinson, Ian Wilson, and Dr. Wladimir Zwalf; in Sri Lanka: Albert Dharmasiri, T.B. Karunaratne, the Ven. Nyanaponika Mahathera, Mendawala Pannawansa, Dr. Anuradha Seneviratna, H.D. Sugathapala, the Ven. Mapalagama Vipulasara, and H.B. Weerakoon; in Japan: the Rev. K.M. Kumata, Robert Singer, the Rev. Kobori Sohaku, the Rev. H. Fredrik Spier, and the Rev. M. Tokunaga; Purna Harsha Bajacharya and Kesar Lall in Nepal; Sukome Miraboon and the Ven. H. Pragnasara in Thailand; Nyaioang Jinpa Rimpoche in India; and in the United States: Hugh Downs, Dr. Robert Ellwood, Dr. Sylvia Feinburg, Dr. Richard Gard, Prof. Balkrishna Gokhale, Prof. John Huntington, the Rev. John Makeras, Robert Mowry, the Rev. Makarios Niakaros, Dr. Pratapaditya Pal, Piyadassi Thera, Charles Sawyer, Dr. Richard Schuster and Dr. Robert Zeuchner.

I am, of course, also grateful to the many college students, professional conferees, and Elderhostelers whose questions made me reconsider.

Finally, my thanks to the staffs of the British Library and the Victoria and Albert National Art Library for years of courteous and diligent assistance, and to those at the Danforth Library of New England College who produced all those inter-library loans.

Lords of East and West

He indeed is the Lord . . . the Happy One, Knower of the World,
Supreme Charioteer of Men to be Tamed, Teacher of Gods and Men,
Buddha, the Lord.—Majjhima-nikaya

Joy to the world! the Lord is come: let earth receive her King: let every heart
prepare Him room, and heaven and nature sing.—Isaac Watts

Buddha and Christ know each other very well.—Kobori Sohaku[1]

Startled, we first see the top of his head peering over the wall. We turn the corner and see *Daibutsu* (Great Buddha) in the distance. As we come closer he becomes huge. The authority of his closed and compacted forms rolls up above us in perfect equilibrium. He looks inward, not at us. He has been meditating and greening here in Kamakura, Japan, for more than seven hundred years, his great bare chest exposed to all kinds of weather since a tidal wave bore away his enclosure almost five hundred years ago.

Families, friends, and tour groups pose for pictures beneath his imperturbable calm. Laughing children run all around him. Many people sit in the sun eating. The souvenir stand is busy. We are in a playground. The gigantic self-confident image that brings us here seems to understand. These joys are brief. No sentimental sadness marks his face, only despair of delusion.

We stand in line with a few adults among many children and soon walk through a small door into his cavernous innards. Shrieking rings around the metal. We climb the winding stairs, finally reaching a platform where people are throwing coins at a small Buddha on a ledge several feet away. This Buddha inside Buddha faces in the opposite direction from his host, as if to disassociate himself. He smiles, thoroughly enjoying the few coins that land on him. Most clank down onto the stairs and the people below. Through the press and clamor we see a small sign:

Strangers who ever they are and what so ever their creed when those [sic] enter the
sacred statue should remember this is Tathagata. The ceremonial body should be entered
with reverence not contamination.

The sign is in English. Am I the only one who can read it?

I had asked several Buddhists in this most westernized country of Asia if there could be anything like a rock opera "Sakyamuni Buddha Superstar." Absolutely not. The Buddha is much too traditional. It could never happen. Emerging from *Daibutsu* into the bright sun, I was not sure. Big Buddha, superstar, are you who they say you are?

4

Half the world away people walk quickly on the north side of London's Cavendish Square. With only a few offices and no shops, it is not a place to linger. Turning and looking up, we see hanging on a recessed bridge connecting two buildings a Madonna and Child.

The child stares ahead into a great distance. His mother looks down over him at us. His arms fully extended, he makes of his body the emblem of his death. Her arms thrust down, presenting her son in a remarkable way. Their enormously elongated bodies dominate the otherwise realistic sculpture: tightly tangled clothing exposes him; heavy drapery covers and enlarges her. Only their thin gold halos punctuate the whole black lead cruciform against the white wall of the bridge. When the sun strikes them directly, the sign of their crossed forearms repeats in shadows on the wall. Their hands open toward us, offering and welcoming. But their bare feet hang, vulnerable. High and lifted up, floating with no apparent support, absolutely alone, we cannot get near them. People walk under them toward the entrance of a health care charity.

"No work of mine has brought so many tributes from so many diverse quarters," Jacob Epstein said.[2] Just a few blocks away, nineteen years after the statue was bolted to the bridge, *Jesus Christ Superstar* opened to generally unfavorable reviews. It ran for eight years, breaking all box office records for a musical. As the festivities surrounding *Daibutsu* and the revivals of *Superstar* suggest the susceptibility of Buddha and Christ to modish celebrity, the Great Buddha and the Christ of Cavendish Square both evidence the authority to survive domestication and revive commitment.

At the height of their influence centuries ago, Buddha and Christ each claimed a following of more than a fourth of the human race. Although we may now speak, with some accuracy, of Christian Ireland and Buddhist Burma, a more nominal influence is more typical in today's urban wired world where "Jesus Christ" as an expletive following Sunday morning's golf slice frequently accompanies the same expression in the morning's worship, and where a Japanese student replied when I asked if he was a Buddhist: "Yes," he said, "but I've never had much to do with it."

For millions of Buddhists and Christians, however, Buddha and Christ still exist only as Lords. They elicit ultimate concern. Lord Buddha and Christ the Lord have always sought the allegiance of everyone:

> Go now and wander for the welfare and happiness of many, out of compassion for
> the world, for the benefit, welfare and happiness of gods and men.

> Go therefore and make disciples of all nations, baptizing them in the name of the
> Father, and of the Son, and of the Holy Spirit, teaching them to observe all that I
> have commanded you.[3]

Each man was born into an ethnic religion and fathered a universal one. Jesus was born, lived, and died a Jew, and Gautama was born into what would later be called

Hinduism. The very words "Jew" and "Hindu" originally indicated people from geographical areas: people of Judah, the Southern Kingdom in Palestine, and people from the Indus, the river approximating the western extent of India. Jesus came "not to abolish the law and the prophets . . . but to fulfill them." His followers were the new Israel, and from a Christian point of view the Hebrew Bible points to Christ. Although the Buddha's acknowledgment "I have seen the ancient way and that is the path I follow"[4] affirms continuity with Buddhas of former aeons rather than fulfillment of a particular historical tradition, it was Indian gods, serpent-kings, and tree-spirits who guarded and worshipped him. Jews see Jesus as another prophet; Hindus consider Buddha the ninth incarnation of Vishnu. But Christianity and Buddhism were virtually extinguished in their native lands: the former almost immediately, the latter only after some seventeen centuries.

Buddha and Christ have always been both essentially supranational and easily adaptable to ruler cults. Born into areas awash with political and religious ferment, after two or three centuries they both became stabilizing forces when the ruler of a very large empire was converted to a religion claiming the allegiance of a very small part of the population. The Indian emperor Asoka and the Roman emperor Constantine each called a council of religious leaders from all over their Empires to establish a unity that never materialized, and each erected monuments that still exist.

By the sixth century Buddhism and Christianity had penetrated most of the Eurasian continent: Buddhism spreading east from India throughout Southeast Asia and through central Asia to the Japanese Pacific; Christianity spreading west from Palestine to the Spanish and Irish Atlantic. The Christian movement into Armenia, Persia, and southwest India and the Buddhist thrust into the much closer Afghanistan only illustrates by exception the movements of Christianity west and Buddhism east.

No evidence suggests that these two religions had sufficient contact for significant influence. They matured in almost complete isolation from each other on opposite ends of the Eurasian landmass—geographical and political barriers combining to make communication difficult and dangerous—each committed to its own universe with its own presuppositions in its own languages. In spite of missionary campaigns from the sixth century Nestorian Christians to the extensive Catholic and Protestant missions of the nineteenth century, with the exception of the Philippine Islands, Christ has never really been at home in Asia. And although a few nineteenth century intellectuals opened Europe and America to Buddha, and many Western cities now have Buddhist societies, Buddhism remains exotic in the West. With technology bringing the world's religions into inescapable contact under the common threat of irrelevance, we become among the first who can see Buddha and Christ as two masks of one transcendent mystery.

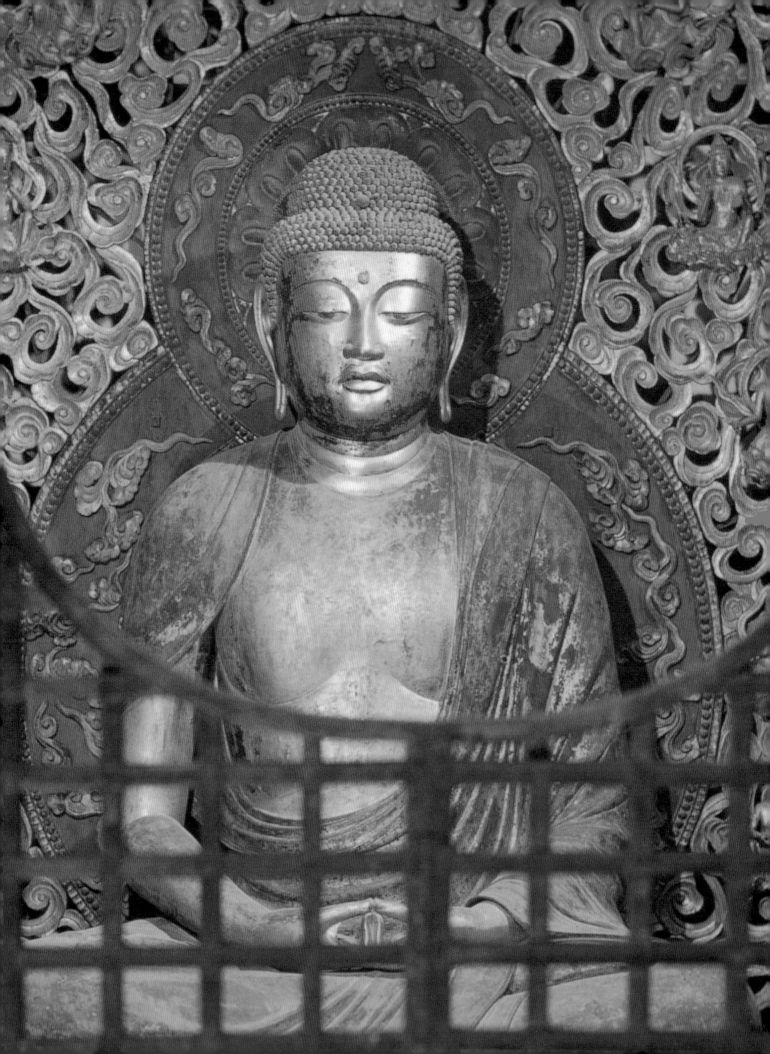

Part 1

The Cage of Form

He was trapping heaven and earth within a visible form,
forcing all creation into the tip of his brush.
—Lu Chi

Man can embody truth but he cannot know it.
—William Butler Yeats

As with politicians,
nothing is more important to gods than image.
—Thomas Mathews [1]

The Lives of Gautama the Buddha and of Jesus the Christ

Buddhists and Christians have always told the stories of the lives of their Lords because the stories reveal the way to salvation. Every image of Buddha and Christ visually summarizes the life of the Lord it represents.

The stories themselves have always been stories of what happened in the re-membered past and of what is of ultimate significance in the present: at once history and myth. As history is someone's interpretation of the past, and the story historical to the extent that it corresponds to what actually happened, a myth never happened; it is always happening. A myth is true to the extent that it corresponds to what we have experienced and recognize as part of universal human experience. Although many modern Christians and Buddhists take their myths not only seriously but historically, many Christians understand the story of the resurrection and ascension of Jesus Christ not as his reanimation and journey up through space but as his presence experi-enced in the life of faith; and many Buddhists consider Sakyamuni Buddha sitting on a throne in the sky with a Buddha of past eons not as levitation in a time warp but as symbolic of time and space transcended in the mind of enlightenment.

In spite of the thousands of scholarly studies of the life of Jesus and the relatively few of Gautama's life, we still know very little about Jesus and even less about Gautama. Wrenching history from myth has left few residual facts.[2]

Historical Facts

Each man was born in a relatively remote area: Gautama probably in Kapilavatthu in the Himalayan foothills of southern Nepal; Jesus, contrary to tradition, probably in Nazareth of Galilee, a small province on the eastern frontier of the Roman Empire. Their birth dates also lack certainty. Gautama's has usually been placed at around 566 B.C., but most modern scholarship suggests about 480 as more plausible. Almost five centuries later Jesus was born, contrary to another general assumption, sometime shortly before the death of Herod the Great in 4 B.C.

Siddhartha, the Buddha's given name, was the son of the chief of the Gautama clan (hence the name, Gautama, especially in the South) of the Sakya tribe (he is called Sakyamuni, Sage of the Sakyas, especially in the North). Jesus' father was a carpenter or a stonemason and Jesus and his brothers probably would have learned the trade. We know nothing else of the early life of Jesus. Gautama probably married and fathered a son.

Both men enter history with profound transforming experiences, Jesus at about thirty years of age, Gautama at about thirty-five. Jesus was probably a member of John the Baptist's prophetic movement when he was baptized by John in the Jordan. Gautama renounced prosperity for several years of austerity, only to renounce extreme asceticism and finally achieve enlightenment through yogic meditation near the Ganges.

Both men became itinerant teachers. Jesus probably first attracted attention and followers as an exorcist and healer. He moved primarily among the lower classes in Galilee and the neighboring districts of northern Palestine, possibly for only a year, at the most three years, before a few final days in Jerusalem. Gautama probably demonstrated the extraordinary powers associated with yogic concentration. He preached to people of all classes of society for about fifty years, primarily in the large towns and cities of the Gangetic plain.

Both men established a community unified through loyalty to themselves. Both men spoke to the occasion, responding to particular incidents and people. Both frequently used parables, similes, irony, and hyperbole. They avoided metaphysical speculation. Both emphasized ethical rather than ritual purity. Both renounced worldly wealth and secular power. Although bearing radical social implications, neither was primarily concerned with social reform: theirs was an imperative of individual salvation. Both taught a way of thoroughly transforming lives through commitment to an absolute, infinite, eternal reality. Gautama's was a middle way between the two extremes he had experienced, self-indulgence and self-mortification, whereby moral living and mental awareness assure release from unsatisfactory existence. Jesus proclaimed the necessity of entering the kingdom of God, a spiritual kingdom of love and righteousness. He was himself manifesting God's saving power, thus fulfilling Hebrew scripture and human experience. Both men clashed with the religious establishment, Gautama with the Brahmins, Jesus with the Pharisees.

Both men died about seventy miles from the place of their birth. Gautama, at about the age of eighty, probably died from food poisoning surrounded by his disciples outside the small jungle village of Kushinara. Jesus, at about the age of thirty-three, was condemned by Roman authority as a dangerous troublemaker and crucified with criminals outside the walls of Jerusalem.

Their followers' commitment attests to the power of the personalities of both men.

> *Never before was seen by me*
> *Nor heard by anyone*
> *A Master so sweetly speaking.*
>
> *No man ever spoke like this man.3*

There have been many such charismatic people. But Buddhists do not take refuge in Gautama the sage, nor do Christians worship Jesus the rabbi. Neither Buddha nor Christ has lived primarily as a historical figure. Pictures of transcendent Buddhas far outnumber

Fig. 5
Dream of Queen Maya. 1st-2nd century b.c., Bharhut, Madhya Pradesh, India. Indian Museum, Calcutta. Photo: Borromeo/Art Resource, N.Y.

Fig. 6
The Annunciation. Unknown artist, Northern Italian school, 15th century. Musée Jeanne d'Aboville, La Fere, France. Photo: Giraudon/Art Resource, N.Y.

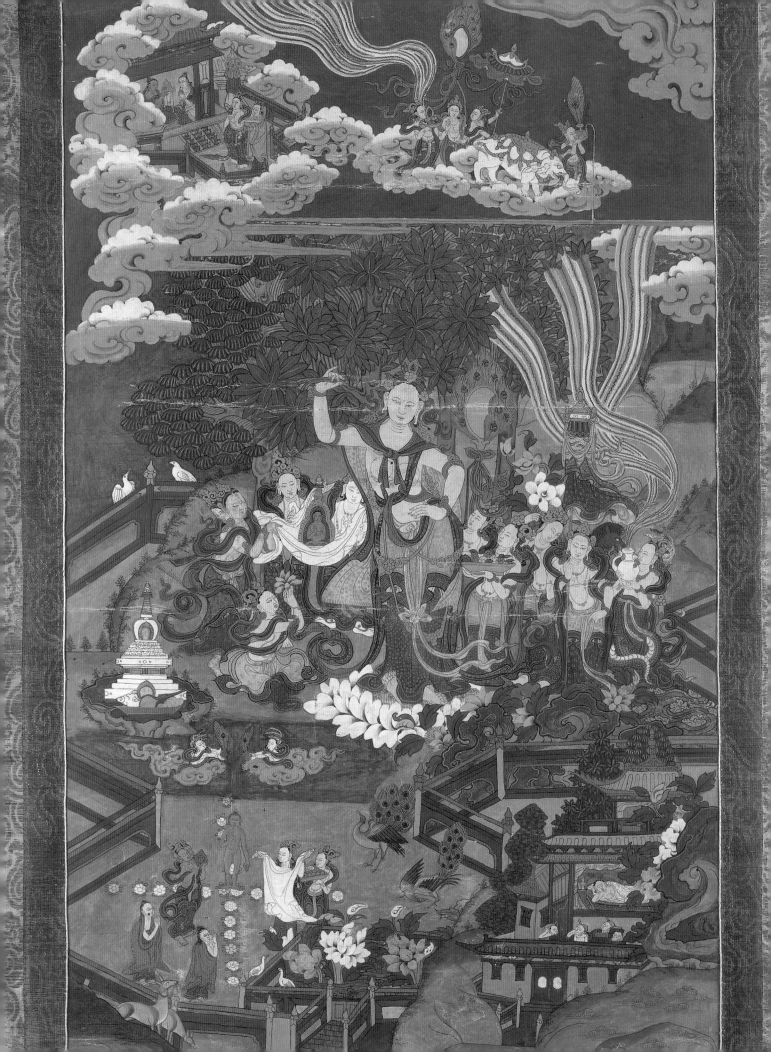

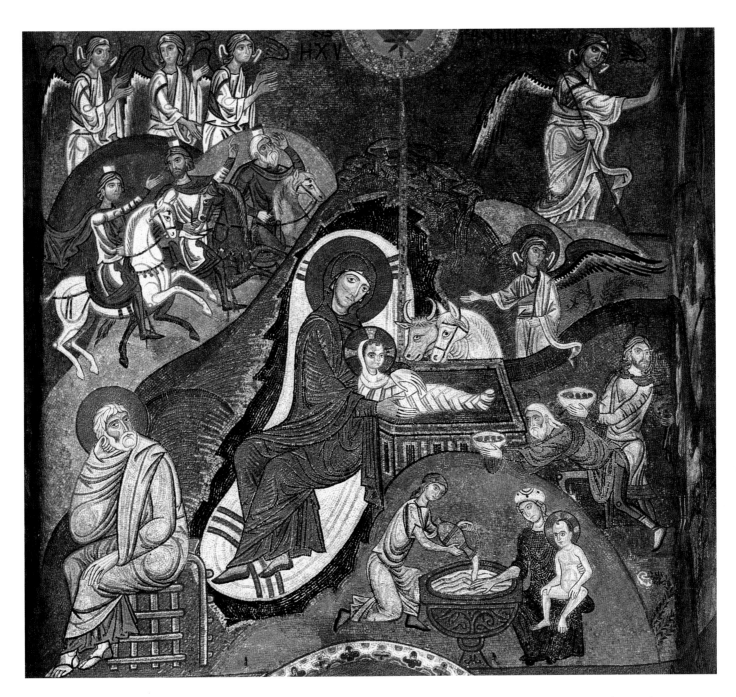

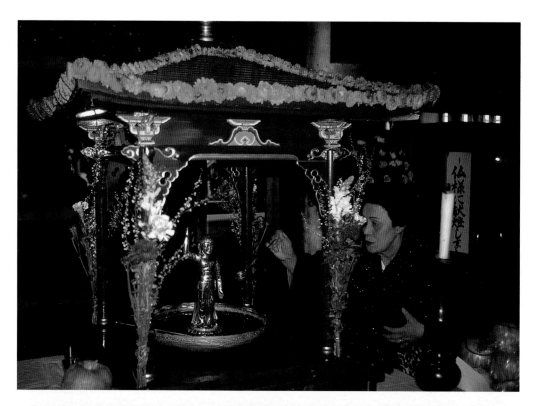

Fig. 9
Birthday Buddha. 1984,
Kiyomizu, Kyoto, Japan.
Author's photo

Fig. 10
Christmas Creche. 1986,
Jefferson Church of Christ,
Rural Hall, North Carolina.
Author's photo

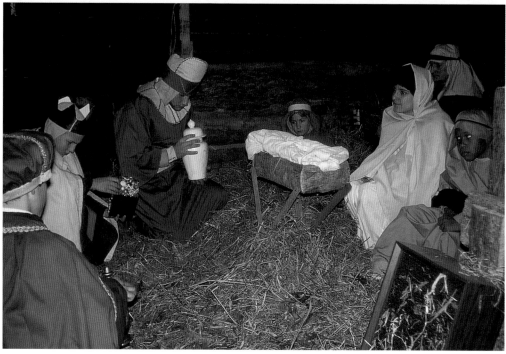

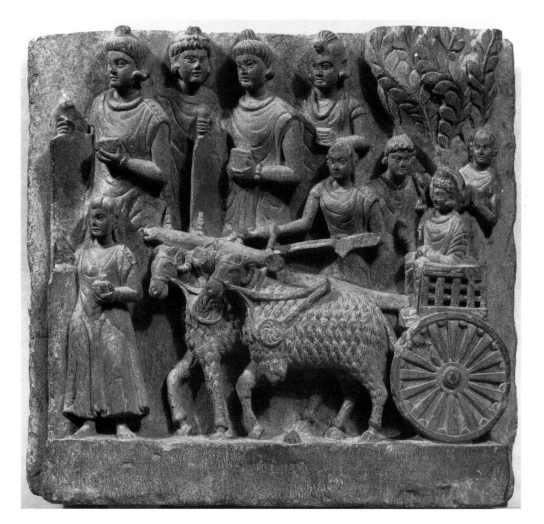

Fig. 11
Siddhartha Goes to School.
2nd-4th century, Pakistan.
Victoria and Albert Museum,
London. Photo: V&A Picture
Library

Fig. 12
Jesus Goes to School. Anton
Sorg, 1476, Germany.
Deutsches Buch und Schrift-
museum, Leipzig. Photo:
University of London, The
Warburg Institute

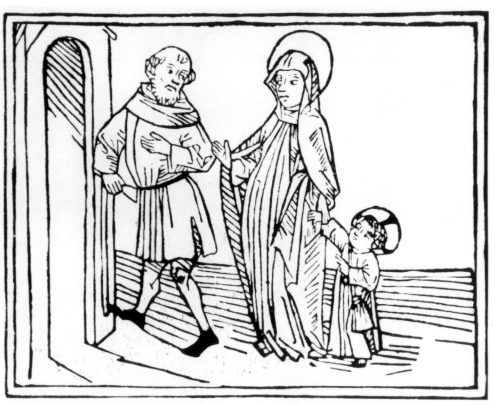

FIG. 13
Tonsure of Buddha. George
Keyt, 1940. Gotami Vihara,
Colombo, Sri Lanka. Author's
photo

FIG. 14 (OPPOSITE)
Baptism of Christ. 15th
century, Basilica of St. Mark,
Venice. Photo: Scala/Art
Resource

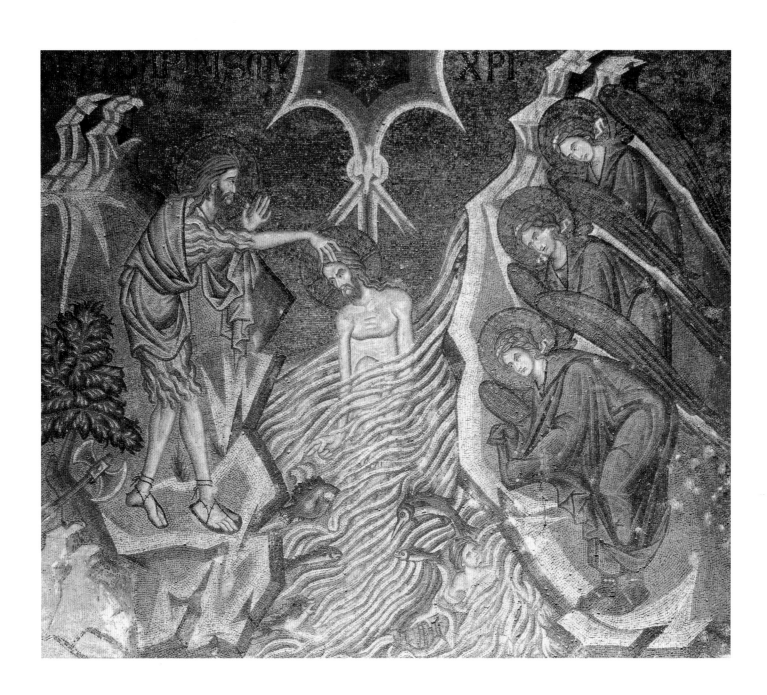

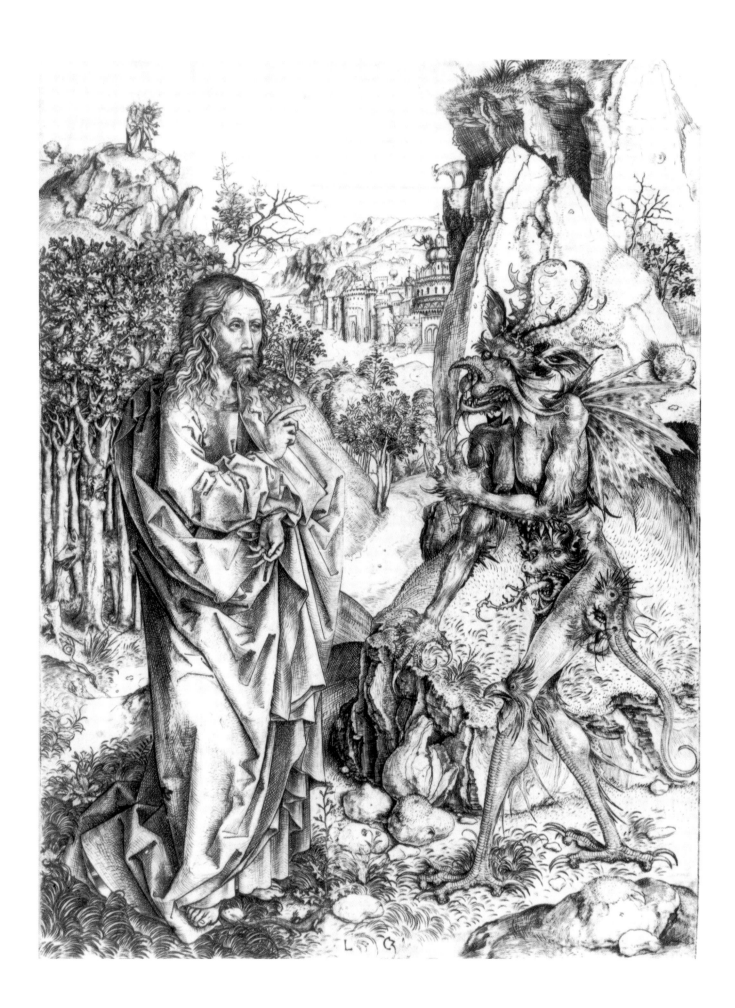

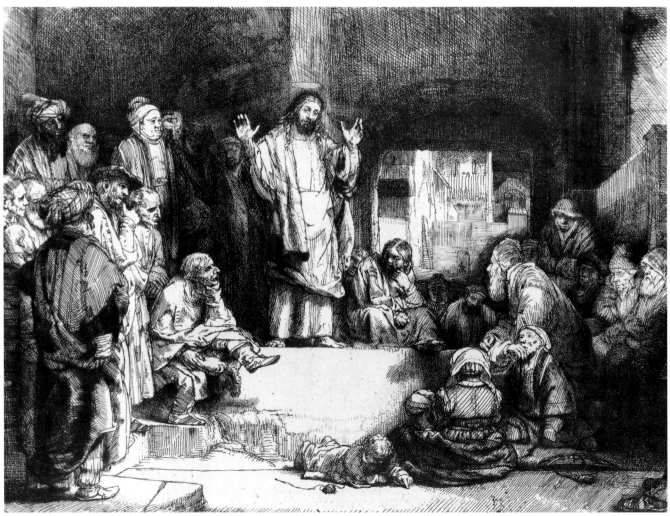

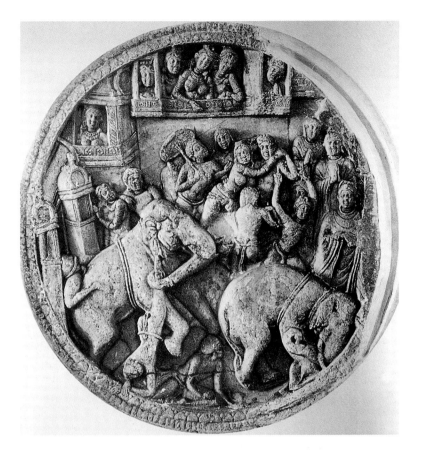

FIG. 17 (OPPOSITE, TOP)
Buddha Converting Nanda.
3rd-5th century, Afghanistan.
British Museum, London.
Photo copyright The British
Museum

FIG. 18 (OPPOSITE, BOTTOM)
Christ Preaching. Rembrandt
van Rijn, c. 1650, Netherlands.
Photo: Foto Marburg/Art
Resource, N.Y.

FIG. 19
*Buddha Subduing the Mad
Elephant.* 2nd-3rd century,
Amaravati, India. Govern-
ment Museum, Madras

FIG. 20
*Christ Healing the Woman of
her Hemorrhage.* 3rd century,
Catacomb of Saints Peter
and Marcellinus, Rome.
Author's photo

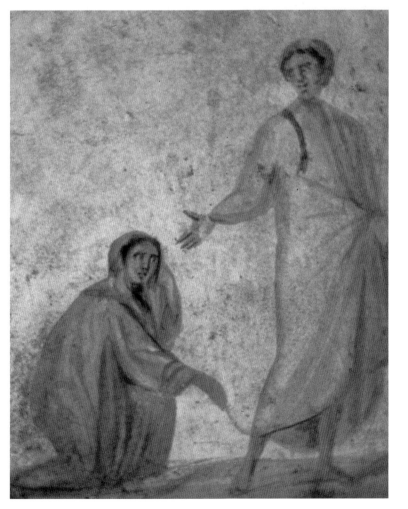

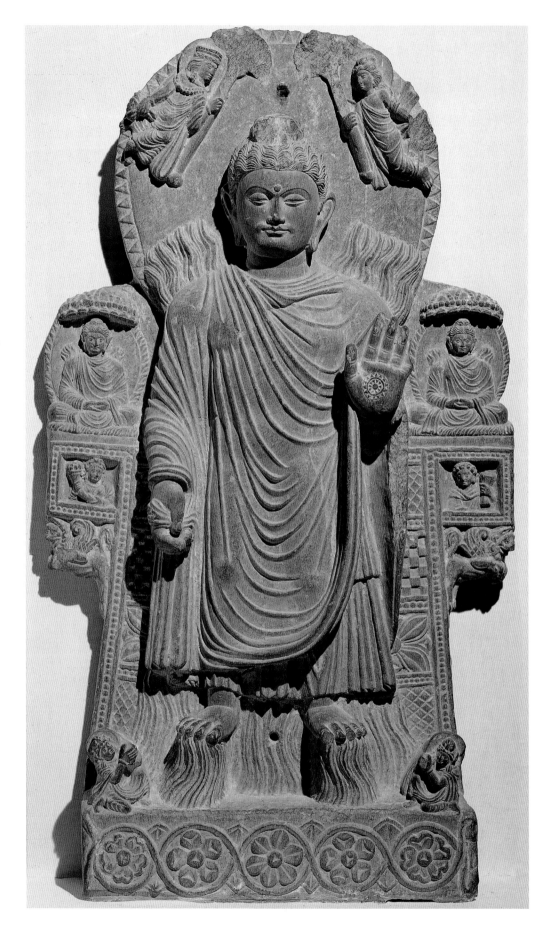

Fig. 21
Miracle of the Fire and the Water at Sravasti. 3rd-4th century, Afghanistan. Musée Guimet, Paris. Photo: Giraudon/Art Resource, N.Y.

Fig. 22 (opposite)
Last Supper. Leonardo da Vinci, c. 1495-98. Santa Maria delle Grazie, Milan. Photo: Scala/Art Resource, N.Y.

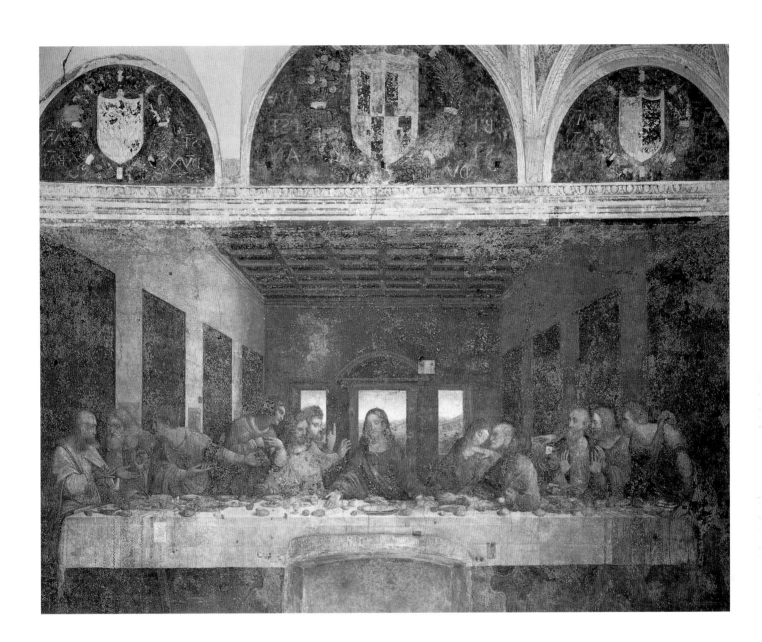

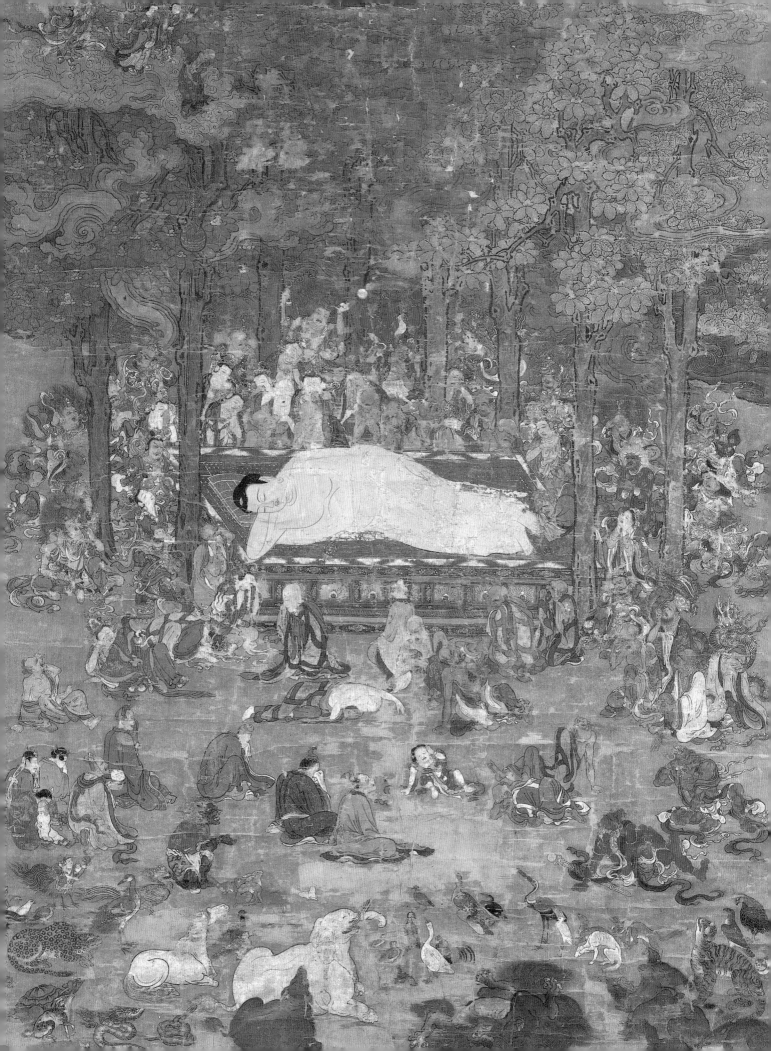

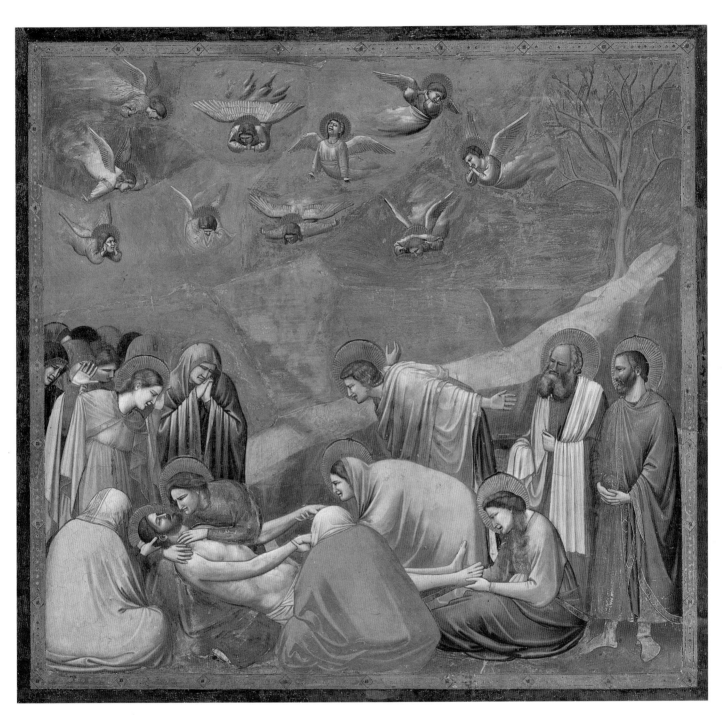

those of Gautama, just as Christ the holy child, vicarious sacrifice, triumphant judge, and glorious redeemer is pictured far more frequently than the Galilean teacher. Narratives of their ministries portray them as transfigured Lords. Each has always been a living presence alive in the memory and practice of Buddhists and Christians. "I take refuge in the Buddha." Emmanuel, "God with us."

Stories of Incarnation

The lives of Buddha and Christ resonate with appropriate mythic detail. With variations on universal hero and savior stories finally inextricably meshed with particular cultural and historical memories, we expect both similarities and uniqueness in the two lives, and more significance than consistency in the several narratives of each life.

The morality tales of Buddha's more than five hundred previous incarnations have been among the most popular subjects of the visual and verbal tradition. Through successive rebirths in animal, human, and divine forms he lived in accordance with the Dharma (the true nature of reality) for countless eons before coming to teach the Dharma at a time when knowledge of it had disappeared from the world. Christ has an equally infinite past. Begotten of God the Father "before all worlds," he declares "Before Abraham was, I am."[4] In the fullness of time, God sent his son to reconcile the world to himself. More than chronological references, the previous existence of Buddha and Christ affirms their paradigmatic presence in all human becoming.

Both men have royal lineages: Buddha's father is King of the Sakyas, Christ is of King David's line. Buddha and Christ will rule the world.

Their conceptions are miraculous. Buddha descends from one of the heavens into Maya's womb as she dreams of a white elephant entering her side. Christ is conceived when the Holy Spirit in the form a white dove enters Mary's ear. Incarnation requires the absence of the fathers, Suddhodana and Joseph, as Buddha and God make themselves manifest through Maya and Mary.

Both babies are delivered while their mothers are on a journey. The world is with child, not just these families. Buddha is born in a beautiful garden near the palace, Christ in a stable far from home. Maya, accompanied by a retinue of servants, stands, grasping the branch of a tree, as the Buddha springs painlessly from her right side. Gods catch him in a golden net. Streams of water fall from the sky to bathe him, the earth quakes, flowers bloom out of season, he takes seven steps in each of the cardinal directions and declares that this is his last birth. Over the Christ child a star shines, ox and ass attend, angels proclaim his birth to shepherds in the fields, wise men come from the East bearing gifts.

In each tradition, a holy man holds the infant in his arms and recognizes a savior. Each child is threatened by kingly power, Buddha in spirit by his benevolent father and Christ literally by the malevolent Herod. Their home lives, however, could hardly be more different. "If you scratch Buddha, you will see a prince, whereas if you scratch Christ there is the carpenter's son."[5]

Among many indications that Siddhartha is no ordinary prince, he demonstrates knowledge of sixty-four languages, and he throws a dead elephant two miles across the city's

seven walls. When he enters a temple the gods step down from their shrines to praise him. He sits under a tree whose shadow remains constant all afternoon as he attains his first trance. Told that his son would become either a Buddha (Enlightened One) or a Cakravartin (World Monarch), Suddhodana seeks to assure the latter by taking care that the prince would not wish to leave home. He provides him with a vast retinue of servants and dancing girls, three palaces for the three seasons, and, at the age of sixteen, an ideal marriage to his beautiful cousin. But three trips outside the palaces shatter Siddhartha's pleasures as he sees for the first time an old man, a sick man, and a dead man. They awaken him to life's misery and brevity. During a fourth trip he meets an ascetic and sees the way of release from suffering. That night he summons his favorite horse and trusted groom, pauses to look at his wife asleep with their newborn son, and, assisted by the gods, who have assured that the palace doors are open, he escapes.

At dawn in the forest Siddhartha cuts off his long hair. He exchanges his royal clothes for the crumpled yellow robe of a passing hunter, sends his servant back to the palace with his sword, ornaments, and horse, and begins a homeless life. Later he will return to initiate his wife and son into the Sangha (community) he had formed. He will preach to his father on his deathbed, and he will ascend to one of the heavens to instruct his mother, who had died seven days after his birth.

Joseph, Mary, and the Christ Child flee Judaea for Egypt to escape the wrath of King Herod, who feared the newborn "king of the Jews" as a royal claimant. Christ's childhood is no less wondrous than Siddhartha's. Throughout the Middle Ages the Church and her artists welcomed the many apocryphal stories that filled the canonical gospels' silence. The holy child molds birds of clay and makes them fly away. He enters a temple and the idols fall from their pedestals. He even leads playmates to their death by encouraging them to emulate his walk on a sunbeam. Upon the death of Herod the family returns to Nazareth. The Third Gospel records the young man's growth in "wisdom and in stature, and in favor with God and man." The apocrypha notes his superior carpentry. He remains celibate.

Both men undergo severe fasts in solitude, overcome the strongest possible temptations by the personification of evil, and return to the world to begin their ministries. Both reject family ties for other kindred: Buddha refers to his lineage of previous Buddhas, Christ to those who do the will of his heavenly Father. Both possess perfect virtue and wisdom attested by miraculous power. Among many wonders, both walk on water, heal the sick, and feed a multitude. Both are transfigured. One of Buddha's disciples conspires to murder him, one of Christ's betrays him, and the disciple closest to each momentarily fails his Master at the end.

Buddha calls the neighboring monks together, tells them of his intention to die after three months, and reminds them to spread his teaching out of compassion for the world. Christ, on the way to Jerusalem, tells his disciples what will happen to him, and at a last supper he institutes the sacrament of his remembrance and renewal in bread and wine. Buddha dies peacefully, absorbed in four degrees of meditation; Christ violently, as the suffering servant foretold in scripture. Both deaths engender earthquakes, and for Buddha celestial music with a rain of flowers, for Christ darkness over the land. In his final nirvana Buddha realizes the cessation of individuality; in his resurrection Christ manifests its consummation. Buddha's body is cremated, Christ's is raised.

Margin notes: 25; 13; 15, 16; 19, 20; 22; 23; 28; 33

We know very few historical facts about these men, but no stories are more well known than theirs. Every spring Japanese Buddhists may awaken their Buddha-nature when pouring tea over a small bronze image of the newborn Buddha standing on a lotus. Every winter Christians may see through the figures of the creche to the "mystery on the bestial floor."[6] All social distinctions collapse as Buddha and Christ ask for a drink of water from an outcast woman and eat with a prostitute. We know the value of giving when both men praise a poor widow's offering of two copper coins above anything given from abundance. Buddha tames the mad elephants we all meet, and Christ heals the lepers we all avoid.

The Definitive Image: Enlightenment and Crucifixion

Above all, Buddha's enlightenment and Christ's crucifixion are seminal moments in human history and in the individual experience of Buddhists and Christians. Profusely illustrated cycles attend each event, beginning with Buddha's "Great Renunciation" riding out of the palace and Christ's "Triumphal Entry" riding into Jerusalem. Not merely the climactic moments in their lives, enlightenment and crucifixion define the men and authenticate their teaching.

The crucifixion gradually developed throughout the Church into a mythical event symbolizing the whole redemptive work of Christ. Endlessly and variously interpreted in scripture, theology, doctrine, and in all the arts, it is suffering, sacrifice, and triumph. Jesus obeys his understanding of God's will. God empties himself. We kill God's love, and God loves us at our worst.

Although essential in the earliest Eucharistic worship and apostolic preaching, Christ's crucifixion was very seldom represented visually during the period when persecution was rife and misinterpretation probable if taken out of a verbal theological context. Around the end of the second century someone scratched on a Roman wall a graffito of a man worshiping a donkey-headed figure on a cross. Whether this is evidence that Christians venerated the ass or, more probably, a derisive reference to a reviled sect, it is the first known representation of the crucifixion. Magical amulets of crucifixion probably date from the third century. But the image does not appear as part of the gospel story until about a century after the Emperor Constantine proscribed this form of execution in 314. It remained a rarity until the sixth century. With the once familiar horror no longer a part of common experience, the image probably first emerged as another affirmation of Christ's humanity in the continuing struggle with those who saw only his divinity.

For almost a thousand years Christ hovers on the cross. Often wearing a long robe, eyes open and head erect, unbloodied by nails or spear, his feet rest on a platform. Perhaps symbolizing resurrection, this triumphant Christ probably indicates the difficulty of expressing the death of the Son of God. Between the eighth and tenth centuries the doctrine of the substantial unity of Christ's fully human and fully divine natures became sufficiently assimilated for images of his death to coexist with his victory. Gradually the robe becomes a loincloth, his eyes close, his head drops to one side, his weight hangs from his arms, his diaphragm contracts, and his legs twist as his feet are crossed and nailed with a single nail.

His blood flows into several doctrines and images. The blood of the New Adam washes the skull of our first parent at his feet. As the first woman came from the side of Adam, the

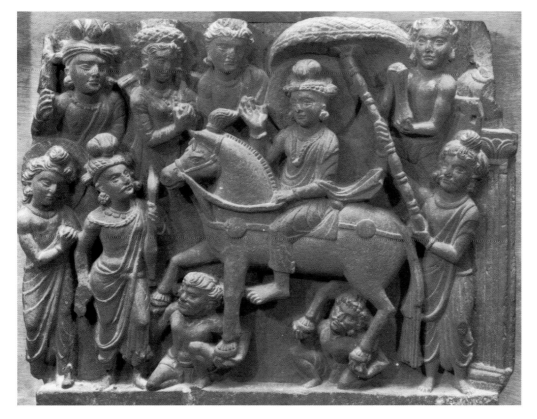

Fig. 25
Great Departure. 2nd-3rd
century, Loriyan Tangai,
Pakistan. Indian Museum,
Calcutta. Photo: Giraudon/
Art Resource, N.Y.

Fig. 26
Triumphal Entry, detail of sar-
cophagus. 4th century, Rome.
Museo Laterano, Vatican
Museums. Photo: Alinari/Art
Resource, N.Y.

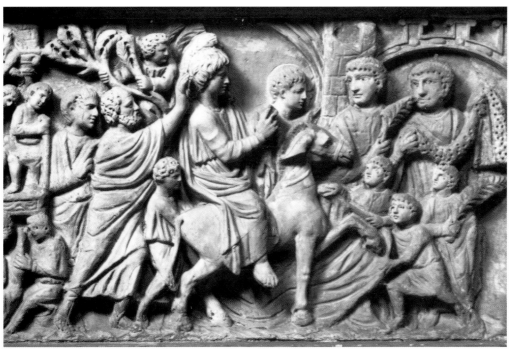

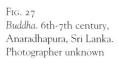

FIG. 27
Buddha. 6th-7th century,
Anaradhapura, Sri Lanka.
Photographer unknown

FIG. 28 (OPPOSITE)
The Crucifixion, detail of the
Isenheim Altarpiece (BELOW).
Matthias Grünewald, c. 1509-
15. Musée d'Unterlinden,
Colmar, France. Photo:
Giraudon/Art Resource, N.Y.

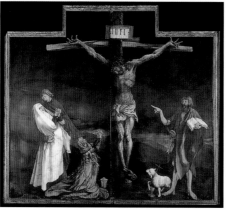

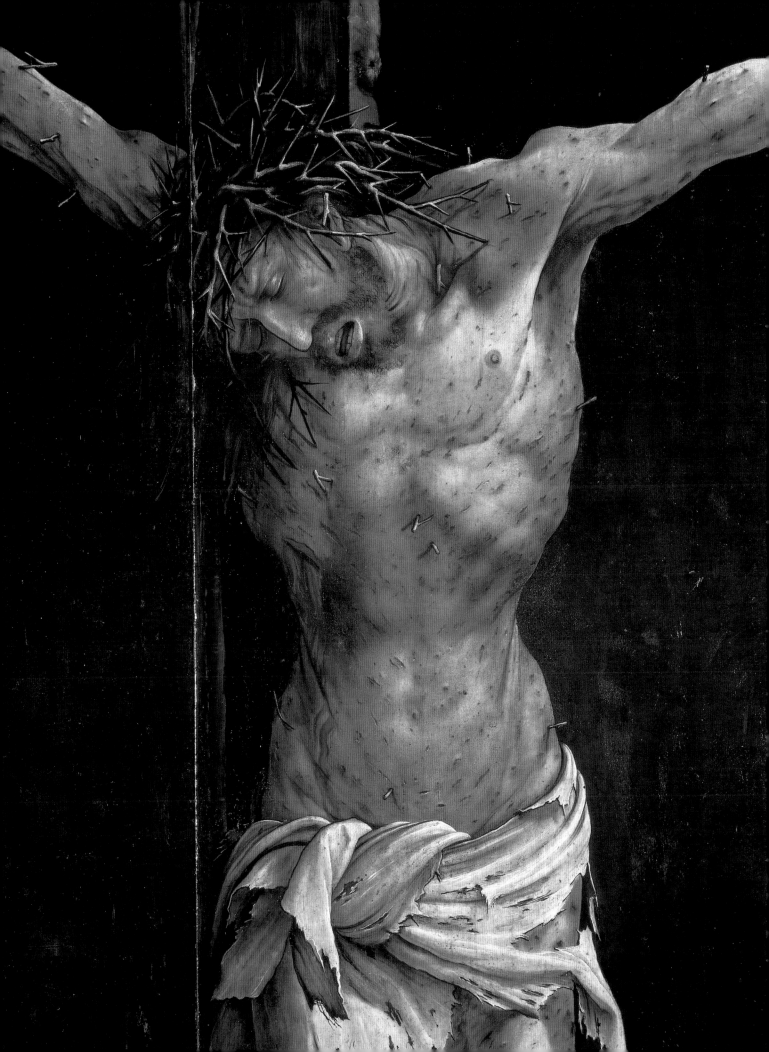

FIG. 29
Buddha Sheltered by the Naga.
12th century, Kompong Svay,
Cambodia. Musée Guimet,
Paris. Photo: Werner
Forman/Art Resource, N.Y.

FIG. 30 (OPPOSITE)
Crucifix. 12th century,
Gerona, Spain. Museu
Nacional d'Art de Cataluna,
Barcelona. Photo: Scala/Art
Resource, N.Y.

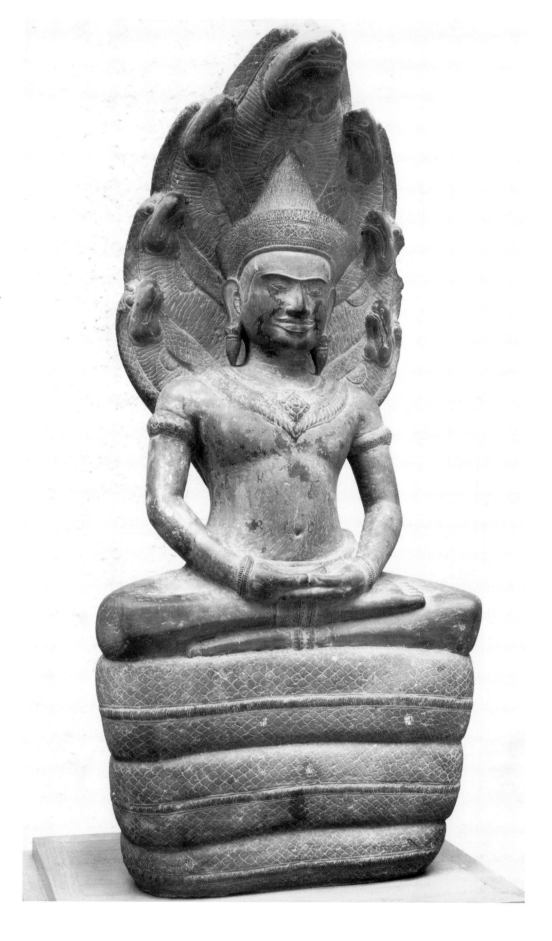

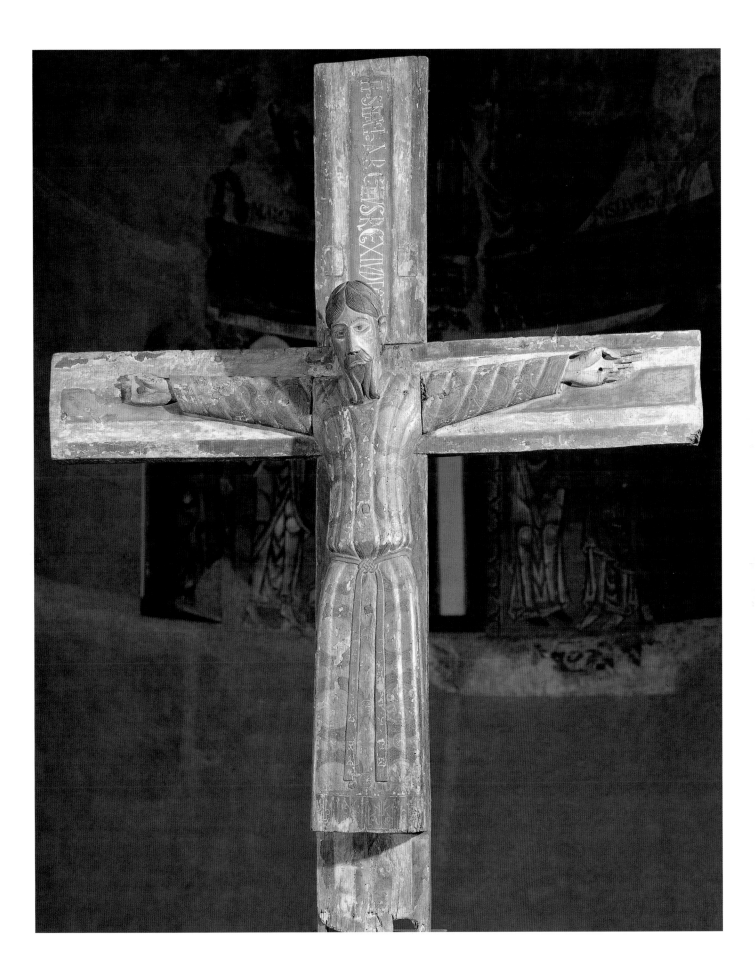

Church in the form of a woman comes from the wounded side of Christ. The Church as the woman on his right receives his blood in a chalice, while the Synagogue as the blindfolded woman on his left turns away. The water and blood from his side signify new life in every baptism and Eucharist. On the top of the cross a pelican recapitulates the redemption by tearing her breast for blood to revive her young from three days' death. Overhead the sun and the moon, polar opposites united in a timeless sorrow, ask all heaven and earth: "are you washed in the blood of the Lamb?"

In 1224 Francis of Assisi showed the five wounds of Christ in his own body. Fifteen years later King Louis IX enshrined the reputed crown of thorns in Paris. In the Black Death of the fourteenth century at least a fourth of Europe's population died in extreme agony, and the crucifixion became convulsive, saturated in suffering.

Late medieval churches brought both forms of the crucifix together when Christ hung in perpetual agony above the rood screen and a cross held him crowned as king on the altar: the tree of death the cause and condition of the glory of life. Eastern Orthodox churches have characteristically emphasized only one form, the anguish subsumed in the victory.

With the Italian Renaissance passion was subjected to reason and Christ's death is serene again. His sensuous body is fully and ideally human, more the divine man than the incarnate God of the Middle Ages. Attention often shifts to the emotions of the increasing number of people under the cross.

Subsequently, except for the Counter Reformation art of Spain and the Protestant paintings and etchings of Rembrandt, the crucifixion attracted few major artists until the twentieth century. The modern world understands crucifixion, but usually as humanity on the rack rather than as love's perpetual endeavor to transform the world.

27 Buddha meditating in the yogic position of mental and physical discipline was as indigenous to the Indian tradition as the image of a crucified god was absurd to the Jews and Romans. It is among the earliest images of the Buddha. Through all its various reflections of ethnic prototypes and aesthetic values, its symbolic significance has remained constant.

As scorn and agony clog Christ's road to Calvary, Buddha strides toward his enlightenment, in at least one account, accompanied by gnomes, birds, snakes, heavenly musicians and other beings who bring flowers, perfume and other offerings as ten thousand worlds are filled with delightful scents, sounds, and garlands. After bathing in a river, he sits, facing east, on cut grass spread on a rock beneath a tree.

15 First he struggles with Mara, the spirit of desire and death. He resists the attacks of Mara's monstrous armies, his personal arguments and commands, even the seduction of his daughters, the three most beautiful women in the world. It is six o'clock in the evening. The moon is full.

Having withstood intimidation, persuasion, and temptation, the Supreme Conqueror sits for a final twelve hours, passing through four states of mind to equanimity, undisturbed by any thoughts or emotions, fully aware. He sees all of his previous existences. He then sees the death of all living beings followed by their rebirth, favorable or miserable depending upon the quality of their previous lives. Finally, he awakens to the true nature of all reality: everything arises dependent upon conditions and is therefore empty of self-nature.

In this realization he experiences freedom from ignorance, desire, and rebirth. It is daybreak. He has become the Enlightened One.

Bring the scenes of Buddha's enlightenment and Christ's crucifixion together. Buddha sits meditating under a blossoming tree on a carpet of grass by a river; Christ hangs bleeding from a denuded tree on a hill outside the city walls. Buddha looks inward through the flux of existence to the unconditioned; Christ looks out at individuals persisting in the world. Buddha, in a timeless present, smiles; Christ, calling from the fulcrum of history, speaks his last words. The triangular position of meditation settles down, suggesting completeness; the cross rises up and out, requiring action. Buddha remains meditating for seven weeks before starting his teaching; Christ immediately descends from his tomb to liberate the righteous in limbo. "Stand up, stand up for Jesus." Sit down for Buddha.

Although crucifixion rehearses the world's anguish and enlightenment its bliss, in visualizing these polarities of experience each image embraces the other. Christ crucified anticipates resurrection. Gautama enlightened remembers suffering. In emptying themselves, both become transparent to ultimate reality. Christ, the Wisdom of God in whom all fullness dwells, extends his arms in redemptive love. Buddha, the Supreme Charioteer who brings others to the further shore, centers himself in liberating knowledge.

Most Buddhists recommend meditation, while recognizing that few Buddhist laymen have the temperament and hence the time for it. Most Christians recognize that Christian love leads to a cross, and even fewer laymen or clergy have this temperament. But in images of the meditating Buddha and the crucified Christ all Buddhists and Christians see the way to salvation prompting and judging their immediate lives.

"My teaching has but one savor: salvation."[7] Buddha offers salvation from unsatisfactory existence (*dukkha*). We are immersed in greed, hatred, and delusion because we fail to see the interdependence and evanescence of everything, including ourselves. In our ignorance we eagerly consume and inevitably abuse.

"Today salvation has come to this house."[8] Christ offers salvation from sin. Not doing the will of God, we are not in the right relationship to him. Self-centered, rather than God-centered, we seek security at the expense of others, becoming anxious and guilty.

Both Buddha and Christ require nothing less than everything: ourselves. For Buddha a permanent, independent self is delusory. A Tibetan teacher summarizes: "our instinctive, emotional attachment . . . to a vague notion of self is the source of all our suffering." Christ calls for complete transformation. "If any man would come after me, let him deny himself and take up his cross and follow me." The apostle Paul did: "It is no longer I who live, but Christ who lives in me."[9]

Not only do both men teach the way to new life, they are themselves the new life. Buddha is our true nature, awakened in us as it was in Sakyamuni. Christ is our true self; when we are born again, he is our new being. From anthropologies that take *dukkha* and sin most seriously, comes this assurance of a joy and peace that pass all understanding:

We live happily indeed, though we call nothing our own.
We shall be like the bright gods, feeding on happiness.

These things I have spoken to you, that my joy may be in you,
and that your joy may be full.[10]

In both traditions salvation is a present possession and a future fulfillment: nirvana, never reentering the cycle of rebirth; heaven, never being separated from God.

Buddhists and Christians come to these stories like those who first told them, knowing the end before they begin. Gautama and Jesus are born bearers of salvation. The festival of Wesak simultaneously celebrates Buddha's birth, enlightenment, and death. Easter makes Good Friday good. Every event in the life of Buddha and Christ offers the invitation made imperative: realize your Buddha-nature; lose yourself in Christ.

As stories of the life of the cosmic Person, they image wholeness. In these stories Buddhists and Christians move through the contingencies that surround, form, and fragment them into integrated lives within an ordered universe. Because these stories are stories of the incarnation of universal truth in a particular person, they evoke analysis that ends in paradox and images that render transcendent mystery in human form.

The Paradox of Incarnation

As light appears only on whatever it illuminates, energy appears only as matter in some form. Contemporary physics and ancient Buddhist philosophy both distinguish between the common-sense solid appearance of things and their incessant energy, the interrelated swarm of events we know but never see. Buddha and Christ are for Buddhists and Christians the clearest perception of this energy perfectly directed in human beings. Capture the Lord of this dance in print, stone, or some other medium, and the experience will be, at the very least, intense.

"He who sees the Dharma sees me; he who sees me sees the Dharma."

"He who has seen me has seen the Father."

Nothing is of greater importance.

"Those who have enough faith in me, enough affection, are bound for heaven."

"He who believes in the Son has eternal life."[11]

Difficulties in conceptualizing this experience of salvation mediated through a particular person who manifests the transcendent absolute drove many Buddhists and Christians to a triadic formula. In the Trikaya and the Trinity three forms are distinct but not separate dimensions of one ultimate reality.

Buddha's Bodies and Christ's Natures

For expediency Buddhism divides into two main expressions. The Theravada (Way of the Elders) came to prominence in Sri Lanka in the third century B.C. and spread throughout Southeast Asia; the Mahayana (Great Vehicle), by its very nature a vehicle of new and different forms, developed in India around the first century A.D. and spread primarily throughout Central and East Asia.

Early Theravada texts speak of the body of the Buddha's teaching *(dharmakaya)*, the Buddha's human body *(rupakaya)*, and they identify the Buddha with his teaching: he *is* the Dharma. They also hint of a mind-body enabling the Buddha to appear in various places simultaneously.

Mahayana Buddhism, emphasizing the unity of reality, gradually expanded these ideas into the doctrine of the *Trikaya*. The Buddha's one ineffable essence manifests itself in three bodies: *dharmakaya* (truth-body), the power of Buddhahood without form, infinite and eternal; *sambhogakaya* (body of bliss), Buddha's glorified body, the radiant form in which he appears to celestial beings in transcendent realms and to enlightened humans through inner vision; and *nirmanakaya* (manifest-body), the physical form in which Gautama and other past and future Buddhas appear.

35

Gautama Buddha has always been one of many Buddhas. Several Buddhas preceded Gautama, the Buddha for our time, and Maitreya Buddha will be his successor. Theravada Buddhists attend especially to Gautama. While insisting that the Truth-winner was only a man who by virtue of his enlightenment became a superman, Theravadins find in him most of the qualities Mahayanists find in *sambhogakaya*. Theravadins take refuge in the Blessed One. Their texts call him "teacher of gods and men" and "god above gods," their monuments show the faithful kneeling before him in adoration, and, as in all Buddhist traditions, thirty-two auspicious marks distinguish him from other human beings.

41

84

86

Gautama Buddha becomes relatively less significant for Mahayana Buddhists, who recognize an infinite number of Buddhas presiding simultaneously over their respective Buddha-fields in all directions of space. An integrated pantheon of five Buddhas has exerted great influence. Ultimate, inexpressible reality *(dharmakaya)* generates these five cosmic Buddhas (who may be regarded as *sambhogakaya*), each of whom correlates with one of the four cardinal directions and the center. Amitabha, the Buddha of the Western Paradise, and Vairocana, the Buddha of the center, have attracted independent, wide-spread devotion. Each of the five embodies a particular wisdom. Each is associated with one of the five senses and with one of the five elements of which everything is composed. Each has a special gesture, color, emblem, and supporting animal. Most important, each begets a spiritual family, any one of whose many members may be visualized according to individual psychological needs.

Like many families, these have their wrathful relatives: ferocious figures who express compassion in an angry form. They purge, limit, and contain malignant power by defining its appearance. They often wear human bones, bear lethal weapons, and trample corpses. Tibet's Vajrabhairava, among the most awful, wears a crown of skulls and a belt of severed heads. His bull's head of the god of death he has conquered and his eight other heads assure that nothing escapes his fury; his thirty-four arms wield instruments of fearsome power; his sixteen legs trample various creatures of the world. Japan's immovable fiery Fudo stands on a rock in his aureole of flames. Eyes bulging, fangs protruding, biting his upper lip, he burns with invincible rage. His rope in one hand ensnares evil, his sword in the other destroys it.

The uninitiated should not expect to understand or even recognize the many cosmic Buddhas and their exuberant emanations. Attributes, functions, and names vary in different traditions. They finally defy explanation, requiring visual images for their most complete expression.

Many in the early Church either resolved the paradox of Christ as the God-man or leaned heavily in one direction. In the earliest records Paul refers to the Church as "the body of Christ," and in seeing Christ Jesus as "the image of the invisible God" he offers few bio-

graphical details. The *Gospel of Mark* reveals a man who gets angry, asks questions, and proclaims the Kingdom of God. The *Gospel of John* portrays the man who *is* God. A Jewish sect of Christians, the Ebionites, regarded Christ as the greatest prophet, the Messiah of the Jews, and entirely human. Gnostics usually repudiated the Hebrew Bible and emphasized Christ's spirituality; many denied that he was ever human.

Two bishops led factions in the first confrontation that officially divided the Church. Arius saw Christ as more than a man yet subordinate to God. Athanasius held that Christ, though fully human, was of the same substance as God. In the early summer of 325 the emperor Constantine called more than three hundred bishops to the pleasant lakeside town of Nicaea to settle the issue. They decided in favor of Athanasius. Their formula, later developed into the Nicene Creed, still informs most Christian liturgies.

A second struggle soon emerged. The Nestorians taught that Christ had two wholly separate but conjoined natures, one divine and one human; the Monophysites that he had one nature, his humanity absorbed in the divine. The Council of Chalcedon rejected both views, proclaiming Christ's two distinct natures inseparably united in one person. Again an attempt to unify the Church hardened its divisions. As late as the twelfth century Nestorians and Monophysites were as numerous as Catholic and Orthodox Christians.

The Trinitarian formula grew out of this concern to define the person of Christ. Since at least the fourth century normative Christianity has recognized the divine life of love through the Father, Son, and Spirit as individuating forms of the Godhead while emphasizing the second form, Christ, who embraces both the historical physical world and the transcendent mystery. Similarly, most Buddhists have seen Buddha as, in the words of a contemporary English Buddhist, "the mystic marriage of the human and the divine, the individual and the universal, the terrestrial and the cosmic."[12]

Many have noted that the *Trikaya* and the Trinity invite comparison: the *dharmakaya* with God the Father—the transcendent absolute; the *sambhogakaya* with the Holy Spirit (or Christ in glory)—the absolute empowering the faithful; and the *nirmanakaya* with Jesus—the absolute in human form. But the Trinity plays a far greater role in Christianity than the *Trikaya* does in Buddhism, and contextual comparisons preclude any facile identification of the three bodies of Buddha with the three persons of God.

However tenuous the parallels, and however far removed from the thought world of Gautama or Jesus, the doctrines of the *Trikaya* and the Trinity expressed the experience of people who knew the saving power of a living Lord. They still do.

"Mother of all Buddhas" and "Mother of God"

It has not gone unnoticed that Buddha and Christ are men. Any image of a particular incarnation implicitly puts those of another gender or race outside the norm, effectively distancing them from centers of power. It has been easier for Buddha and Christ to reflect the racial characteristics of their faithful than for the two men to shed their gender.

Theravada Buddhists, like Protestant Christians, have no significant complement to the male image. But Mahayana Buddhism reveals a pantheon of feminine deities who function

essentially as Buddhas, and Catholic and Eastern Orthodox Christians have found the supreme feminine expression of God in the instrument of Christ's incarnation, Mary.

The Buddhist Tara, primordial energy, is called "savior," and "mother of the world." As the energy of the essence of Avalokitesvara, the personification of the compassion of all the Buddhas, Tara has graced household altars throughout northern India, Tibet, Nepal, and Mongolia, and her statues have been found as far south as Java and Sri Lanka. Her protean character takes many forms. White Tara and Green Tara protect, reassure, fulfill our hopes, and are by far the most popular. Their slender bodies and round breasts are often adorned with gold. Their right hands reach out in the gesture of charity. White Tara's seven eyes, three in her face and one on each hand and foot, show the vigilance of her compassion. When the Green Tara sits on her lotus she extends her right leg slightly, ever ready to step into the world to help those in need.

36 Avalokitesvara himself underwent a sexual transformation as he moved East. During the tenth to the twelfth centuries this often multi-limbed male Indian deity, probably assimilating Tara along the way, began emerging in China and neighboring countries as a beautiful woman. Called Guanyin (Kannon in Japan), alternately appearing as male and female, this immensely popular figure became in her female form the "Goddess of Mercy." Usually demure, without Tara's impishness or jewelry, "she who hears the cries of the world"

37 often wears a graceful white robe and hood. Sometimes she holds a male child as a gift to childless women. Sixteenth-century Christian missionaries identified her with the Blessed Virgin, and persecuted Catholics in feudal Japan secretly venerated images of Mary under the pretense that they represented Kannon. They called these images "Maria-Kannon." Several new colossal statues indicate Kannon's popularity in modern Japan. In Taiwan her picture enjoys wide circulation with tracts that combine traditional legends of her appearances, devotional chants, and advice for modern women.

Among many multi-armed and bejeweled benefactors, Vasudhara, a goddess of abundance, usually holds her auspicious water pot, sheafs of gems and grain, and a hand showering her treasures in the gesture of giving. Prajnaparamita, with two or four arms, and Ushnishavijaya, with three faces and eight arms, are goddesses of wisdom—both far less popular than Tara, but, like her, "mother of all Buddhas."

7 No mothers are more different than Queen Maya and the Virgin Mary. As a fertility goddess Maya grasps a branch of a tree and gives birth to the Buddha. Standing in the triple flexation of a dancer, often with legs crossed, she is the ideal of Indian beauty: slim waist between globular breasts and exuberant thighs. Chinese and Japanese decorum requires a flowing gown in which the stately Maya resembles her semitic counterpart more than the voluptuous semi-nude Indian. The Buddha emerges not out of her undulating hip but from her long sleeve. In either form she plays her brief but important role in the story. Her identity defined only in relation to her son, she is called "womb of the Buddha" (*tathagata-garbha*). Her very name, Maya, means illusion. She never approaches the Virgin Mary's prominence as a cult figure.

Mary's title "Mother of God" (*Theotokos*), officially conferred at the fifth-century Council of Ephesus, grew out of Christological controversies. Like Maya, Mary is defined in terms of her son: the mother of the Christ of God affirms the indissoluble humanity and divinity of her son. But the frequent need to condemn those who regarded her as a goddess

indicates her inherent power. As Mary became Queen of Heaven she would sit on Isis' throne, wear Cybele's crown, and fulfill the needs of men and women as the Great Goddess has always done.

Mary and her Child became the dominant image of medieval Christianity. Rising over the altar in the apse, they unite the roof of the church with the floor, heaven with earth. Arms upraised in prayer and with a medallion of the child against her breast, Mary is the "Virgin of the Sign." Or her son sits in her lap and blesses us. Wooden statues make this transcendent "Throne of Wisdom" tangible: Christ's divinity and humanity are immediately apparent in relation to the Mother of God, who supports her divine man-child, offering him to the world. Toward the end of the thirteenth century the child sheds his robe and maturity as the equilibrium of his two natures begins shifting toward his humanity. His hand, formerly raised in blessing, now frequently grasps or reaches for a bird, flower, or fruit, or holds his mother's hand or veil. Occasionally the child chucks his mother's chin in a conventional erotic gesture anticipating the heavenly bridegroom's choice of his eternal bride.

Classifications such as "Madonna of Expectation," "Nursing Mother," "Madonna of Humility," and "Sorrowing Mother" suggest the many facets of their relationship even as they obscure the variety of positions, gestures, and expressions that express the intimacy of this relationship. In the *pieta* a young maiden grieves over the mature dead son she holds in her lap. A different tension intrudes with Orthodox icons of the risen Christ at the deathbed of his mother: in a reversal of the mother holding her child, he holds her soul as if it were a swaddled infant.

The most popular of all Orthodox icons portrays the Virgin holding the divine child on her arm. In the majestic "Indicator of the Way," mother and child face us: he blesses us, and she points to him. "Our Lady of Tenderness" is more private. Each absorbed in the other, he grasps his mother's veil as she looks past her child and us into his future. The two forms often merge in variations of maternal compassion and prescience.

At least by the third century Christians were reading the biblical love songs attributed to King Solomon as allegory:

> *In the spiritual interpretation . . . Bride and Bridegroom*
> *denote either the Church in her relation to Christ,*
> *or the soul in her union with the Word of God.*

Mary soon became this Bride:

> *Everything that is said of the Church can also be understood as being said of the Virgin*
> *herself, the bride and mother of the Bridegroom.* [13]

Illuminated Bibles frequently elaborate the first letter of the first word of the Song into a frame in which Christ embraces his Beloved.

By the third century the Church had also assimilated a much older story mingling erotic and spiritual ambiguities. The unicorn first appears on Assyrian reliefs and was represented in the arts of numerous ancient Asian and European cultures. This noble, beautiful animal that could be captured only by a virgin became a symbol of Christ, who dwelt in the womb

of the Virgin and lifted up the horn of salvation. Fierce and solitary, the unicorn frequently rests in gentle submission to the Virgin, his head on her lap.

Finally, throughout the Catholic world Mary stands without her son. With her great cloak the "Mother of Mercy" shelters her diminutive suppliants. Although proscribed by the Council of Trent, these images were not confiscated and remain one of several expressions of the periodic renaissance of the Great Goddess within the Church.

The crowning event in Mary's life was not defined dogmatically until 1950, but by the fifteenth century the "Assumption of the Virgin" was portrayed frequently. She rises to heaven on a cloud born by angels. And long before it was declared dogma in the nineteenth century, Mary's "Immaculate Conception" was the subject of innumerable paintings. Perceived as existing in the mind of God since the beginning of time, the perfect sinlessness of Mary's conception found visual expression in her serene descent to earth. As the Second Eve she tramples the serpent who had tempted the first. By the seventeenth century she was assimilated to the Apocalyptic Woman: "clothed with the sun, with the moon under her feet, and on her head a crown of twelve stars."[14]

Whether visualized in the innumerable small statues of private gardens or in such public shrines as the basilica in Mexico City where "Our Lady of Guadalupe" welcomes more than ten million pilgrims every year, the Madonna continues to grace all who turn to her. During vespers of the August 26 feast of Our Lady of Vladimir, Orthodox Christians hear what they have heard at other feasts of the Virgin's icons:

> *When for the first time your icon was painted by the announcer of evangelical mysteries [Luke] and was brought to you so that you could identify it and confer on it the power of saving those who venerate you, you rejoiced . . . looking at the icon, you say with force: My grace and my power are with this image. And we truly believe . . . that you are with us through this image.*[15]

———

Even as institutional Buddhism and Christianity have used Buddha and Christ to reinforce male dominance in their respective patriarchal societies, both traditions have also always seen their Lord as the genetic expression of human being and potential. The Dharma leads Buddhists beyond all distinctions. "Whoever has such a vehicle, whether a woman or a man, shall indeed, by means of that vehicle, come to nirvana." The apostle Paul concluded: "there is neither male nor female; for you are all one in Christ Jesus."[16]

91

Why do images of Buddha bear this undifferentiated sexuality more frequently than those of Christ? Not because Buddhists have more frequently actualized the inclusive ideal in either their societies or their doctrines, but primarily because the Indian ideal of beauty has characteristically lived in a soft, rounded, lightly muscled physique, and Buddha carried this ideal throughout most of Asia. From the walls of Thailand's temples to the centers of Tibetan mandalas, the Enlightened One frequently defies any gender designation.

69

But the world has not been without a sexually ambiguous Christ. In his early Greco-Roman form he often has a soft, full, beardless face, narrow shoulders, wide hips, and girlish breasts. More akin to the youthfully beautiful, frequently androgy-

nous Apollo than to the mature muscular male reminiscent of Jupiter, this gentle, non-judgmental, occasionally even nurturing Christ has been revived most conspicuously in the twelfth to fourteenth century devotional tradition of Jesus as Mother, in the painting and sculpture of the Italian Renaissance, and in modern feminist awareness.

The Sacred as Love

Buddha and Christ would draw us at once out of the world and further into it. Each calls us from ordinary times and attachments into the depths and out to the edges of reality, while insisting on the most compassionate involvement with the world's suffering. In the first instance we lose ourselves in the universal; in the second we lose ourselves in others. Finally we hear that the two are one. "God is love." "It is great compassion that is called Buddha's mind."[17]

Awe is the seminal religious experience. Moses on a mountain heard God in a burning bush, took off his shoes, and was afraid. Arjuna in a chariot saw the universe in Krishna, trembled in fear, and prostrated himself. Eugene O'Neill's Edmund remembered lying on the bowsprit of a ship:

> *I dissolved in the sea, became white sails and flying spray, became beauty and rhythm, became moonlight and the ship and the high dim-starred sky! I belonged without past or future, within peace and unity and a wild joy, within something greater than my own life, or the life of Man, to Life itself! To God, if you want to put it that way.*[18]

Such ecstatic experience underlies the whole panoply of security and meaning called religion. Even if it never erupts, its tremors quicken all religious experience and remain part of the human psyche, however deeply buried in the subconscious.

Because experience of the sacred dissolves the distortions of intelligibility, and because every negation affirms something, spaciousness is an expression of sacredness, silence a response. "When the Lamb opened the seventh seal, there was silence in heaven." When asked the way of initiation into the absolute, the sage Vimalakirti "kept silent, not saying a word."[19]

Buddhists never tire of saying that the ultimate can only be realized, not described. It is usually known as "nirvana." The Buddha said little about the nature of nirvana. He had experienced it in his enlightenment, and he knew others could experience it. His whole teaching and life illuminate the path to this consciousness of the end of becoming: perfect bliss.

Mahayana Buddhists reject any final distinction between our phenomenal world and nirvana. Enlightenment consists in realizing the interrelated dynamic process of all reality and hence the emptiness of all substantial perceptions. This "diamond knowledge of Emptiness" (*sunyata*) is a "roaring silence," sometimes called, more positively, "Suchness" or "Thusness." Devoid of predicates, neither something nor nothing, it is the creative ground of "unconditioned potentiality." All is Emptiness. Even the Buddha. He is simply the way Buddhists recognize their own buddhahood when they are one with all Buddhas and the several bodies of Buddha in the effulgence of Emptiness.

Fig. 31
The Bodhisattva's Sacrifice,
detail of the *Tamamushi
Shrine.* 7th century, Horyuji,
Nara, Japan. Photo: Askaen
Co., Ltd.

Fig. 32 (opposite)
*God Sending the Son and the
Visitation* (detail). Workshop
of Konrad Witz, 1445-50,
Germany. Staatliche
Museum, Berlin. Photo: Foto
Marburg/Art Resource, N.Y.

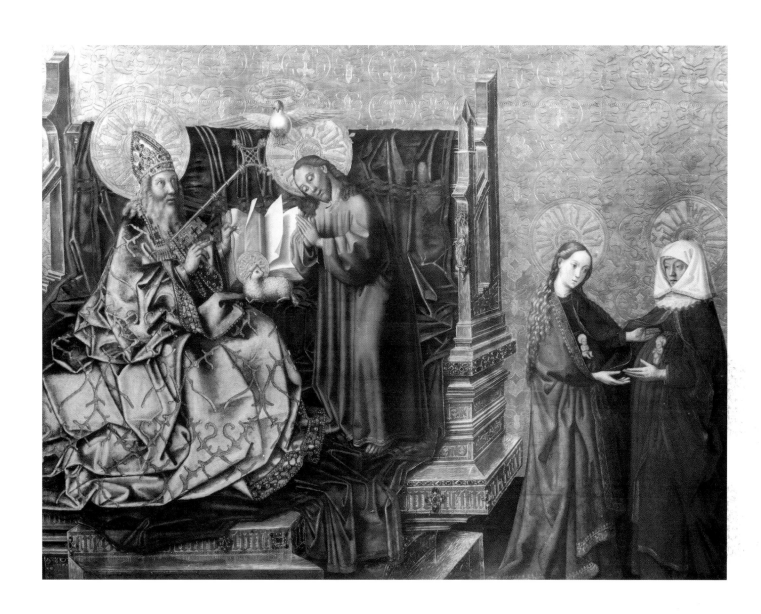

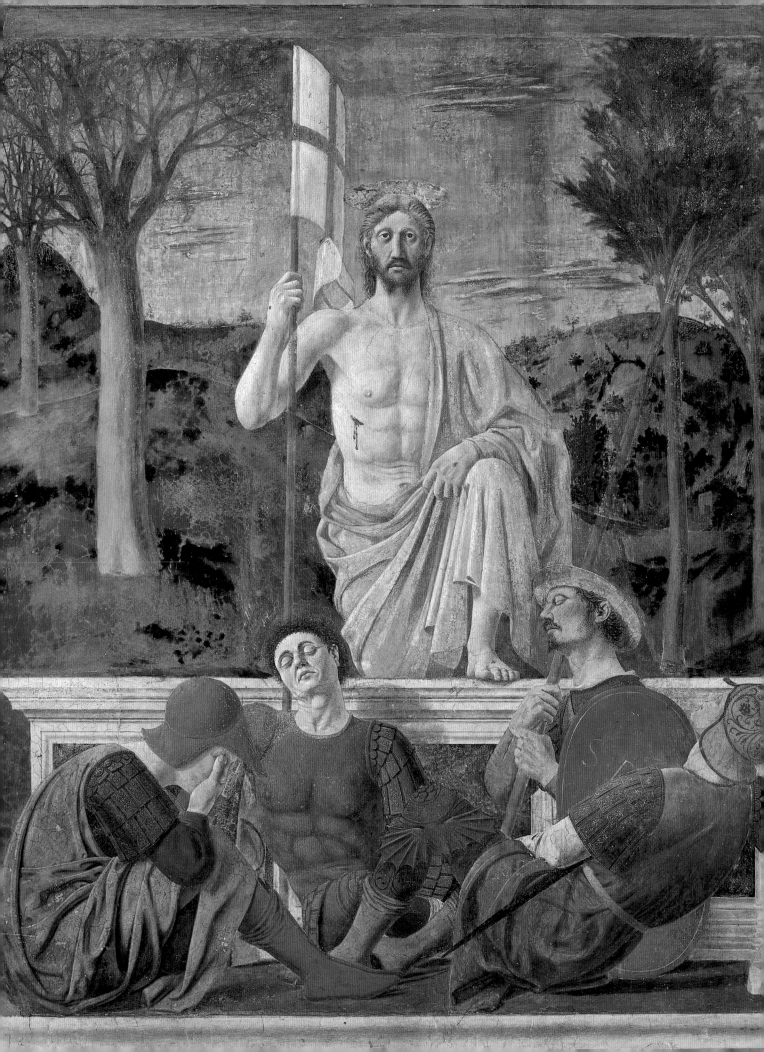

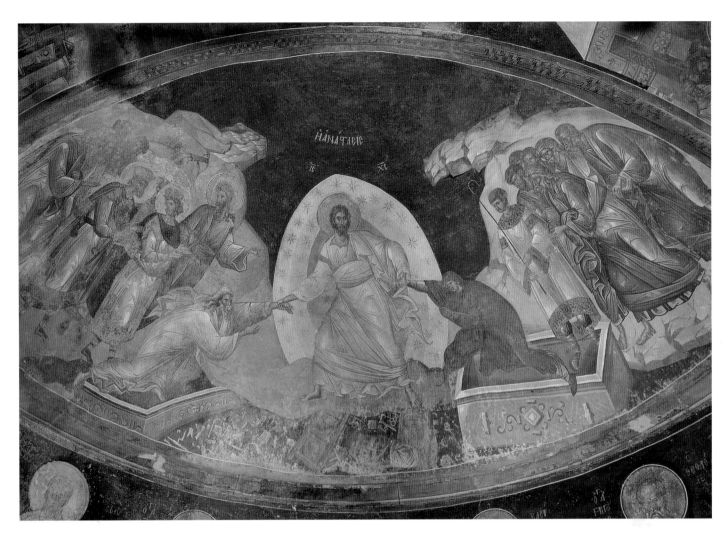

FIG. 33 (OPPOSITE)
The Resurrection. Piero della
Francesca, c. 1462-64. Museo
Civico, Sansepolcro, Italy.
Photo: Scala/Art Resource,
N.Y.

FIG. 34
Descent into Hell. c. 1310,
Kariye Camii (Church of the
Savior in Chora), Istanbul.
Photo: Erich Lessing/Art
Resource, N.Y.

FIG. 35
Maitreya Buddha. 7th century,
Korea. National Museum of
Korea, Seoul

FIG. 36 (OPPOSITE)
Avalokitesvara. 17th century,
Tibet. Collection of Philip
Goldman, London. Photo:
Werner Forman/Art
Resource, N.Y.

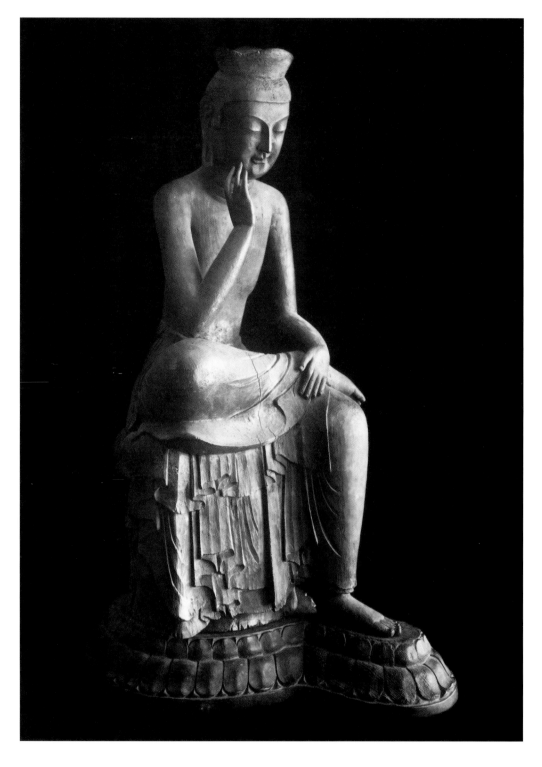

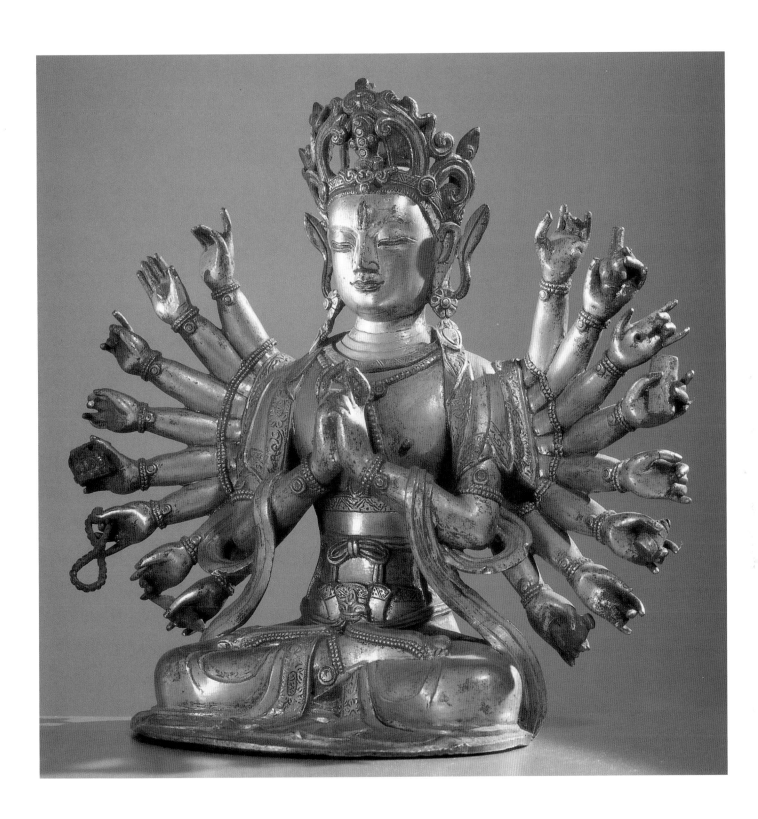

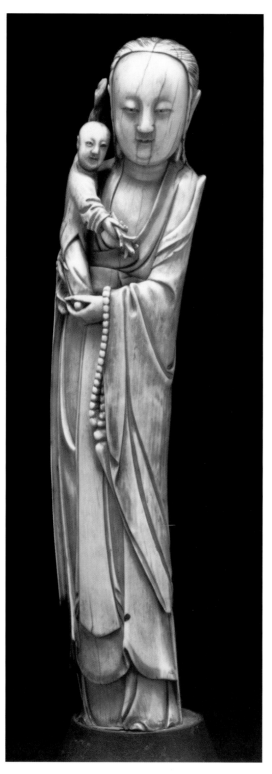

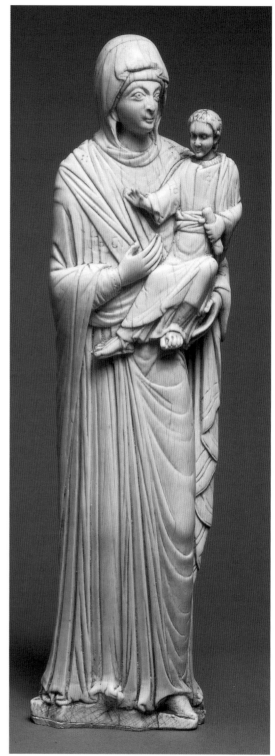

Fig. 37
Guanyin with Child. 19th
century, China. Victoria and
Albert Museum, London.
Photo: V&A Museum/Art
Resource, N.Y.

Fig. 38
*Virgin and Child (Theotokos
Hodegetria).* 11-12th century,
Constantinople(?). Victoria
and Albert Museum, London.
Photo: V&A Museum/Art
Resource, N.Y.

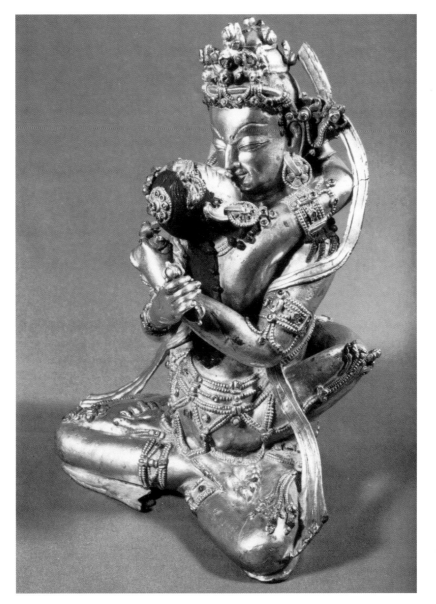

Fig. 39
Vajradhara and Consort.
15th century, Nepal. Private
Collection. Photo: Ulrich
von Schroeder, *Indo-Tibetan
Bronzes*, 1981

Fig. 40
Bridegroom-Bride, from
Alardus Bible of St. Amand.
12th century. Valenciennes
Bibliothèque, Valenciennes,
France

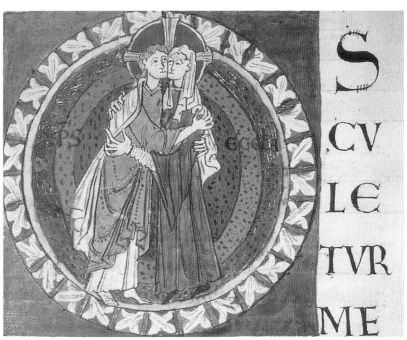

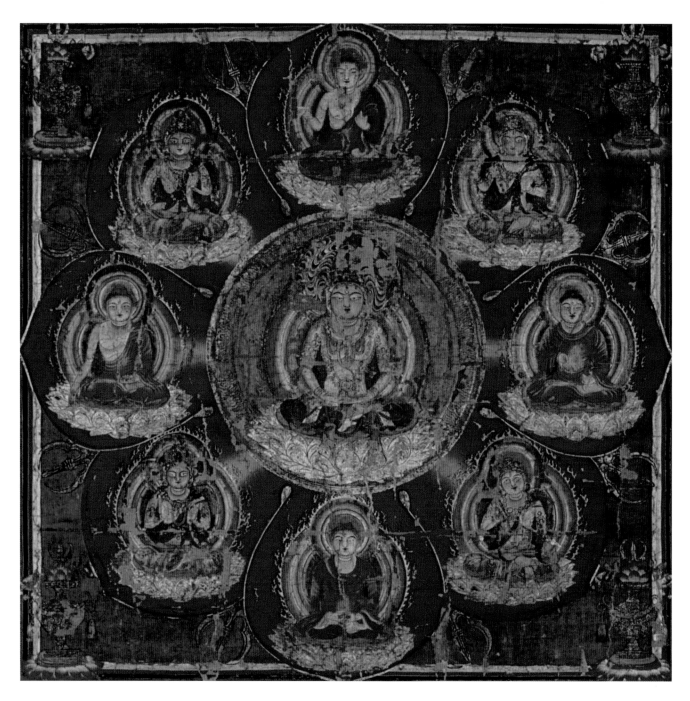

FIG. 41
*Five Cosmic Buddhas and Four
Bodhisattvas,* detail of *Womb
World Mandala.* 9th-10th cen-
tury, Toji, Kyoto, Japan. Photo
from David Snellgrove, ed.,
The Image of the Buddha,
copyright UNESCO, 1978,
reproduced by permision of
UNESCO

FIG. 42 (OPPOSITE)
The Holy Trinity. Andrei
Rublev, c. 1410, Russia.
Tretyakov Gallery, Moscow.
Photo: Scala/Art Resource,
N.Y.

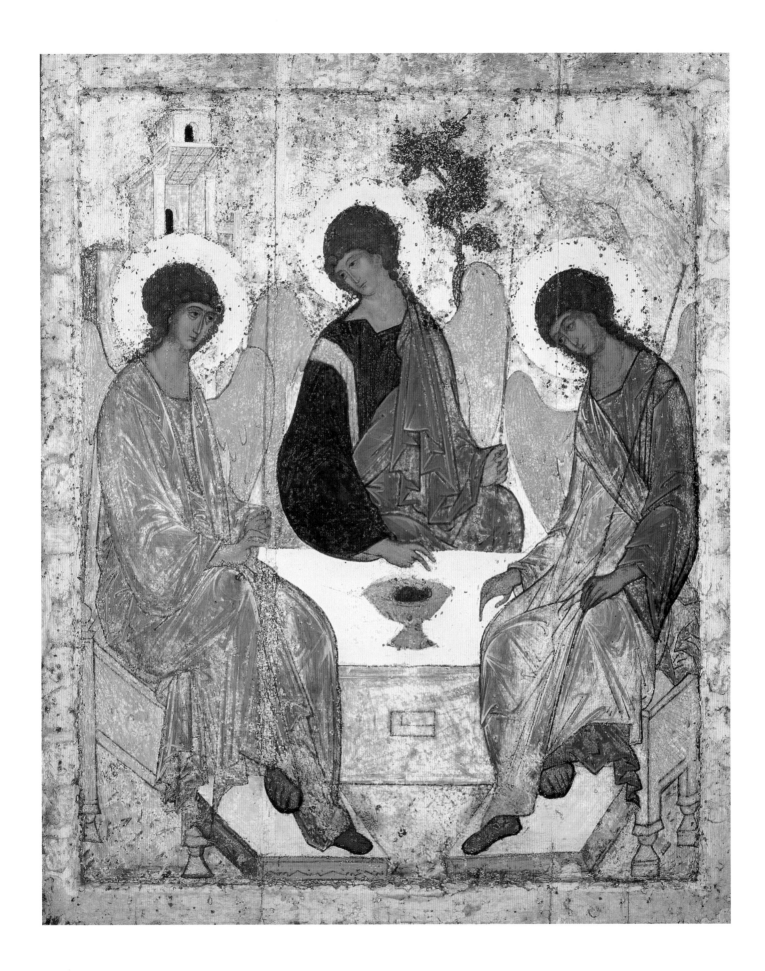

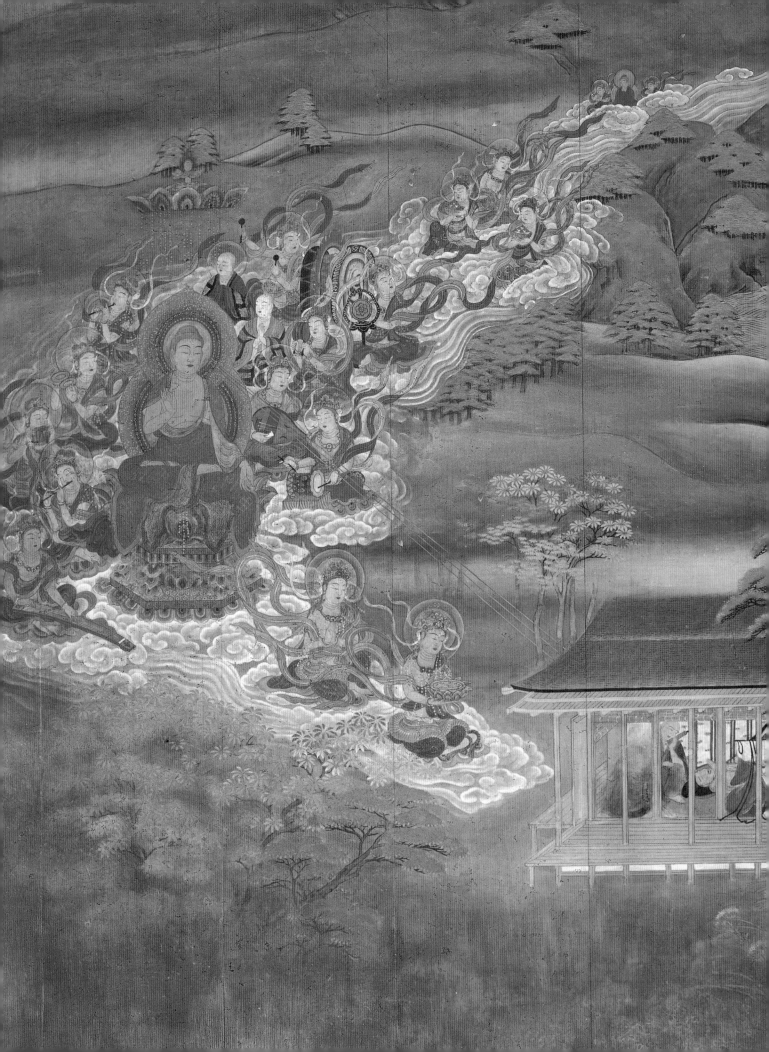

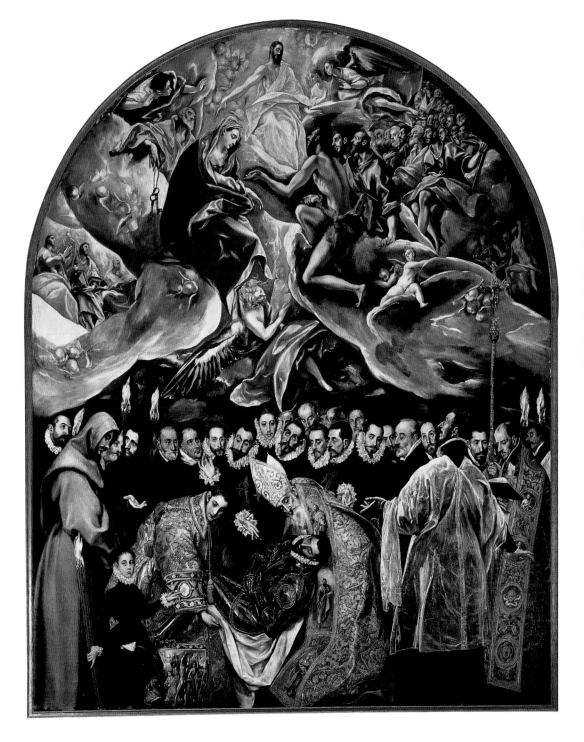

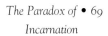

Fig. 43 (opposite)
*The Descent of Amida and the
Twenty-five Bodhisattvas to
Attend the Deceased.* c. 1053,
Byodo-in, Uji, Japan. Photo:
Scala/Art Resource, N.Y.

Fig. 44
The Burial of Count Orgaz.
El Greco, Domenikos Theoto-
kopoulos, 1586-88. San Tomé,
Toledo, Spain. Photo:
Scala/Art Resource, N.Y.

Christians know the silence out of which the word "God" comes and to which it returns, and they know as well that God speaks to them and acts in history. Whether understood as a Supreme Being wholly other than the world he creates, or as the self-emptying ground or power of being itself, Christians pray to their "Father who art in heaven." He lives where all designations and descriptions of ultimate reality live—in the interface of ultimate reality and human projections.

Clearly there are differences between this personal God who creates, commands, and covenants with his people and the impersonal Buddhist nirvana, *dharmakaya, sunyata.* While Buddhist and Christian ultimates comport cautiously together in such dynamic, relational doctrines as the *Trikaya* and the Trinity, they are truly one only in their ineffable, irreducible, universal, absolute value. They are what Buddhists and Christians say when they want to say the most they can say. They are at the limit of language and in the heart of life. In the ecstatic language called enlightenment or revelation Buddhists see nirvana in Buddha and Christians see God in Christ.

The whole paradoxical affirmation of Buddha and Christ as particular incarnations of ultimate reality revealing the way of liberation implies love at the heart of the sacred. No religions have so absolutized love as have Buddhism and Christianity.

But this love is not what the world means by love. We naturally love the lovely: our beloved, our country, blueberry pie, even people in general—in the abstract, in newspapers. Christ, however, calls for the love of whoever we meet, even our enemies. Buddha's love extends even further—to all sentient beings. In a previous incarnation, while standing on a cliff he saw below him a family of starving tigers. He immediately leapt down into their lair to become food for the mother, who could then feed her young. Is it not surprising that paintings show the whole animal kingdom, from crabs to elephants, mourning the Buddha's death.

This indiscriminate, unconditional Buddhist and Christian love does not come from an emotional attraction to others. "From affection comes grief, from affection comes fear; he who is free from affection knows neither grief nor fear."[20] Thus the Buddha wanders "lonely as a rhinoceros," but with unlimited, detached benevolence to all. Buddhist love is the result of realizing the interdependence in all diversity and identifying with the suffering this reveals.

Christian love, if not as inclusive, is just as absolute. It comes from God.

God sent his only Son into the world, so that we might live through him.
In this is love, not that we loved God but that he loved us...
If we love one another, God abides in us and his love is perfected in us.[21]

In his two most famous parables, those of the "good Samaritan" and the "prodigal son," and, above all, on the cross, Christ instances the radical result of accepting this initiative.

Each tradition frequently understands virtue as conformity to a series of vows or commandments, a few for laymen and many more for monastics. But the number of obligations only increases for the more committed out of their greater concern to realize a single aim. Both ethical traditions are rooted in metaphysical reality. Augustine summarized Christian ethics: "love God and do as you please." A Zen teaching: "Drink and eat as it best pleases you, once within the nature of complete Nirvana."[22]

The holy wars that stain both traditions (the Christian incomparably more than the Buddhist), the vituperative texts, and the violence coursing the daily thoughts of Buddhists and Christians remain exceptions from the origin and essence of both religions, proving the rule: holiness embraces rather than outrages love. "Whoever, monks, would tend me, he should tend the sick." "As you did it to one of the least of these my brethren, you did it to me."[23] The only way to love everyone is to see the only way everyone is of equal value: seeing them as an expression or creation of ultimate reality. Liberated from preoccupation with self into wholeness, Buddhists identify with all living beings in Buddha, Christians with their neighbor in Christ.

About the same time Christians began venerating the saints, Mahayanists developed the ideal of the *bodhisattva* (a being destined for enlightenment). Theravadins consider Sakyamuni a bodhisattva throughout his previous lives and during his last life on earth before his enlightenment. Mahayana opened the bodhisattva career to everyone and established cults of bodhisattvas as divine beings.

Instead of turning from the world to achieve their own salvation, bodhisattvas turn toward the world to help bring everyone to enlightenment. They do not feel compassion, they are compassion. Throughout East Asia images of the bodhisattva Avalokitesvara, the manifestation of compassion, far outnumber those of any Buddha.

This total, consuming Buddhist and Christian love is for fools: only idiots, clowns, children, saints, and bodhisattvas have the innocence required. Without status to protect or gain, free from virtue and authority, they dissolve events and topple distinctions. They surface in unexpected places, and they light the world.

36

Mining the religious and aesthetic density of the great images of Buddha and Christ takes us through identifying marks and gestures as well as variants of era and area to a common experience: incarnation. The primordial cosmic Person who is at once Buddha and Christ reveals the sacred as love. The images neither reduce the authority of the ultimate to human scale nor absorb the human into a spiritual abstraction. They portray, in some inexplicable way, the indissoluble unity of Buddha's *dharmakaya* (truth-body) and *nirmanakaya* (manifest-body); the divine and human nature of Christ. They are abstract enough to evoke the transcendence of everything and human enough to evoke the transformation of everyone.

Images of Incarnation

Every child recapitulates the history of the race in seeing and drawing before talking
and writing. Since image-making is such an inveterate and irreducible human activity,
images suffer in translation into concepts just as religious doctrines and philosophical
thoughts resist illustration.

 Images are more explicit than words because images bear some resemblance to
what they signify, whereas words are purely conventional. Images compress: they pre-
sent their meaning immediately, whereas words present their meaning sequentially.
Images are more effective than words in arousing emotion, exciting empathy, and
reinforcing memory. Governments can ignore reports of famine until pictures of starv-
ing children shatter television's nightly news.

"All Buddhism was in This Face."

We see the complex interdependence of verbal and visual traditions in Buddhism and Christianity most clearly when words and pictures are superimposed in movies or juxtaposed in illuminated manuscripts and inscribed pictures. Although the image of God in the form of the risen Christ frequently holds the word of God, only the seldom portrayed Buddhist personification of Wisdom, Prajnaparamita, holds a book. This reminds us that while most images of Christ correspond to generally well-known texts in a relatively consistent canon called the Bible, the stories of Buddha survive in several regional, linguistic, or sectarian collections, and few texts are common to all of them. The sheer amount of Buddhist scripture (no one has read all of it) prevents any book from being normative for all Buddhists in the way the Bible speaks to all Christians.

 Images of Buddha and Christ seldom simply illustrate scripture. Images have their own integrity and their own traditions. Not only does every work of art bear the artist's distinctive skill and vision, all images absorb the values of the cultures into which they move. This is clearly confirmed in narrative pictures without any textual reference. Buddhist scripture, for instance, records nothing of a haggard Gautama descending a mountain after severe austerities. The Chan and Zen painters who frequently depicted this event found their inspiration in the common Chinese and Japanese belief that mountains are especially

118, 34
79

94

8

sacred. Gautama should, therefore, descend from one. The Gospels say nothing of bathing the Christ Child. The popular scene probably owes its origin to imagery of the lives of Roman citizens, which typically includes the bath of the newborn. Amid signs of his divinity, how better illustrate the human nature of Christ who, like all babies, needed washing after his birth? The first known reference to Christ's bath appears on a fifth-century Syrian marble. The earliest literary description in a tenth-century collection of legends was obviously inspired by pictorial tradition.

5

Images may also develop characteristics for purely formal reasons. Perhaps to parallel the position of Buddha at death or perhaps guided by requirements of composition, Maya occasionally appears conceiving the Buddha while lying on her right side, thereby exposing her left side to the elephant. Texts that specify a particular side, mindful that the right is auspicious, always record the elephant entering her right side. Finally, images affirm their distinctive power when they violate doctrine. Several medieval statues of the Virgin open to reveal her secret truth—all three persons of the Trinity within her.

The founder of one of the great schools of Japanese Buddhism, upon his return from study in China at the beginning of the ninth century, told his disciple:

Since the Esoteric Buddhist teachings are so profound as to defy expression in writing,
they are revealed through the medium of painting to those who are yet to be enlightened.
The various postures and [gestures] are products of the great compassion of the Buddha;
the sight of them may well enable one to attain Buddhahood.

One of the more esoteric writers of the twentieth century, when travelling through Sri Lanka, was overwhelmed by a Buddha image in a small temple near Colombo: "But when I attempted to ask myself what the face of the Buddha expressed, I realized there could be no answer . . . All Buddhism was in this face."[24]

Images, like scriptures and creeds, are perceived and understood in many ways. Since the significance of images, as well as of words, comes primarily from our own personal worlds that the images and words themselves have helped to create, images admit orthodox interpretations but no universal or final ones. As indefinable nuances vibrate in every intense conversation, Buddhists or Christians before a great image of Buddha or Christ are face to face with one of the most immediate and inexplicable expressions of their faith.

What Did Gautama and Jesus Look Like?

Almost everyone pictures Buddha and Christ in some form. But whatever the form, it is not based on representations or descriptions from contemporaries of Gautama or Jesus.

Lacking an authentic portrait tradition, early Buddhist texts extol the traditional glorious form expected of the Universal King. A Brahmin sees the Buddha:

You have a perfect body, you are resplendent, well born, handsome, of golden colour; you
have white teeth . . . bright eyes . . . you are great, straight, majestic; you shine like the sun.

Or the Master simply is "attractive." He refers to himself, when he was "quite young, with a wealth of coal-black hair untouched by grey and in all the beauty of my early prime." Later descriptions confirm and elaborate the metaphors of beauty born of wisdom. The Buddha's groom addresses his master:

> You, who have long eyebrows, and eyes like the petals of an unfolded lotus flower, and a face like a beautiful white lotus which has been caused to unfold by the moon of good deeds, and a luminous body like a glittering golden mountain that is touched by the beams of sun, and the walk of the luminous and handsome elephant!

A Brahmin greets him:

> Your form shines like the moon in the night sky, and you appear to be refreshed by the sweet savor of a wisdom newly tested. Your features shine with intellectual power, you have become master over your senses, and you have the eyes of a mighty bull.[25]

The New Testament says nothing about Jesus' physical features. The earliest known references depreciate his appearance in contexts praising humility and condemning vanity. A first-century letter of Clement, Bishop of Rome, is but the earliest record of many who saw Christ in Isaiah's text: "he had no form or comeliness that we should look at him, and no beauty that we should desire him." Origen, preeminent among the early Church Fathers, wrote of Jesus as "little and ugly and undistinguished." The North African theologian Tertullian refers to his "ignoble presence" and of "men who even despised his outward appearance, so far was his body from being of human comeliness."[26]

But at least by the fourth century the opposite view had emerged. The beginning of *Psalm 45* was commonly considered a reference to Christ: "You are the fairest of the sons of men." One description, probably not written before the thirteenth century, had substantial influence on representations because it was attributed to Publius Lentulus, a Roman official who had reportedly seen Jesus:

> A man in stature middling tall, and comely... having hair the hue of an unripe hazel nut and smooth almost down to his ears, but from the ears in curling locks somewhat darker and more shining, waving over from his shoulders; having a parting at the middle of the head ... a brow smooth and very calm, with a face without wrinkle or any blemish ... a full beard of the colour of his hair, not long, but a little forked at the chin ... the eyes grey, glancing and clear; in rebuke terrible, in admonition kind and lovable.

The description attributed to the eighth-century John of Damascus became widely quoted in Byzantine painting manuals:

> Sweetness is the characteristic expression of the face. Fine eyebrows, meeting; beautiful eyes and finely formed nose. Complexion the color of wheat. Hair curled and inclining to golden; a dark beard. The fingers of His pure hands, are very long and finely proportioned.

And medieval devotional literature varied its visions of "the handsomest man that ever might be seen or imagined."[27]

As early as the second century, however, Irenaeus, Bishop of Lyons, implied that Jesus' physical features were unknown. Irenaeus also scoffed at the assertion of a Gnostic sect "that a likeness of Christ was made by Pilate at the time when Jesus was among them." By the beginning of the fifth century Augustine, Bishop of Hippo and the most influential of Church Fathers, concluded: "The image of Christ according to the flesh has been created and modified by countless conceptions, all varying. His true likeness is unknown to us."[28]

Clearly, the earliest image makers, like the writers of scripture, were intent on goals other than historical record. But with the proliferation of images of both Buddha and Christ, both traditions developed legends of miraculous portraits to fill the historical vacuum. Many icons have derived their power from being copies of originals believed to have been made from the living men. Like relics, these images relate a living spiritual presence to a historical physical person.

Miraculous Portraits

In the most famous story of the first Buddha image, King Udayana missed the Buddha when the Blessed One was in one of the heavens for three months preaching to his mother. The King sent a craftsman (according to some sources, 32 craftsmen) to make and bring back his image. When the Buddha returned to earth and this sandalwood likeness saluted him, the Buddha said, "The work expected from you is to toil in the conversion of heretics, and to lead in the way of religion future ages."[29]

It did, becoming the most famous icon of East Asian Buddhism. Conflicting stories recite the wanderings and disappearance of the original and its first copies. Most people who now see one of the early descendants of this image see it in Japan. On special occasions in Kyoto's Seiryoji Temple, the drum beats and the curtain rises to reveal the copy commissioned in China in 987. When opened, its precious relics were found to include not only pictures, texts, and coins, but cloth intestines and organs.

There are many variations of the King Udayana story, and many other stories of the first Buddha image. According to Japanese tradition, the first image was a five-foot-high statue made of gold brought from Mount Meru, at the center of the universe. In other stories a cloth bears the blessing. One relates how King Bimbisara received a priceless gift from King Rudrayana and asked the Buddha how he could ever make an appropriate gift in return. The Buddha suggested a portrait of himself. Bimbisara immediately called his painters, but they were so overwhelmed by the Buddha's presence they could not paint. Bimbisara prepared a banquet for the Buddha so his painters could observe him at leisure. Unsuccessful. The Buddha, knowing of their difficulties, told the king to spread a cloth on which he would allow his shadow to fall; the painters would then draw the outlines and later add color. That was done and, after appropriate ceremonial, the first portrait of the Buddha was presented by Bimbisara to Rudrayana.

Stories from Tibet tell of the Buddha receiving a request for a picture of himself from a virtuous princess. He let the rays from his body shine on a cloth so artists could outline his

form. In another story, when artists came to paint him and became so filled with blissful contentment they were unable to paint, the Magnanimous One sat by a pool while they painted his picture from his reflection.

The Buddhist tradition of *tathagata-pratima-pattaka* (cloth bearing an image of the Buddha) has clear counterparts in the Christian *acheiropoietos* (image not made by hands). Indeed, Christian concern with the substantive events of a history coming in the fullness of time to the one Christ has given Christians an even greater impetus to preserve a picture of their Lord.

As the cross-laden Christ walked to Calvary, Veronica gave him her veil on which to wipe the sweat and blood from his face. The cloth then miraculously bore his imprint. This relatively late and now definitive version of the Veronica story was first introduced in a thirteenth-century French compilation of legend and doctrines. It gained popularity in the fourteenth century when actors added it to their Passion pageants, and it became an integral part of Catholic devotion in the fifteenth century as the sixth of the Stations of the Cross.

A much earlier story, current by at least the seventh century, involves the ailing emperor Tiberius. In one among several variations, the Emperor sent an officer, Volusianus, to Jerusalem to bring the miracle-working Christ to Rome. By the time Volusianus arrived Christ had been crucified. The envoy did, however, meet Veronica, who had asked her Lord for his picture to keep near her when he was away teaching. Jesus had taken a cloth from her, pressed it to his face, and the cloth had retained his features. Veronica agreed to accompany Volusianus to Rome with the image. Upon seeing it Tiberius was instantly cured. As might be expected, the two stories are reflected in two types of images: the suffering face crowned with thorns and the tranquil face of the teacher.

47

A further complication involves the unnamed woman in the Gospels who was healed of her hemorrhage as she touched Jesus' robe. As early as the fourth century she was called Veronica. Bishop Eusebius is among those who refered to a bronze statue of Jesus and this woman that she had erected in gratitude for her cure. This Veronica eventually became identified with the Veronica who had the cloth imprinted with Jesus' face before his arrest. Little wonder that by the thirteenth century, when stories of the Veronica who met Jesus on the road to Calvary appeared, the legends were sufficiently tangled for some to conclude that the name Veronica was simply derived from *vera eikon* (true image) and appropriated to the women and their cloths.

20

Whatever its origin, by the twelfth century a Veronica cloth was drawing countless pilgrims to Rome. In 1216 the Pope composed a prayer to the image and promised an indulgence of ten days to whoever read the prayer. By the fifteenth century subsequent Popes had inflated the indulgence to 30,000 years, assuring the dispersion of the Veronica motif throughout the Western Church. The Vatican still secludes a cloth which some say is the relic on which the image is now indiscernible.

Eastern Orthodoxy does not preserve any Veronica tradition but remembers one "image not made by hands" and celebrates another. Both of these legends have taken several forms. In the most popular story of the "Camulian Image," Hypitia, a woman who could not believe what she did not see, found a cloth in her garden fountain. When she took the cloth from the water it was completely dry and bore the face of Christ. When she wrapped the cloth in her dress the image miraculously copied itself on her dress, making the first of

what would become several "true images" engendered by a sacred cloth touching something. In 574 the original cloth was brought from Camulia, a small town in central Turkey, to Constantinople, where it became the main palladium of the Byzantine Empire until it disappeared during the eighth-century iconoclastic struggles.

The doyen of *acheiropoietoi* is the "Edessa Portrait." One of many variations of its story—strikingly similar to the early Veronica legend—relates how King Abgar V had incurable leprosy, heard of Christ's healing power, and sent him a letter by his servant and painter, Ananias, who was told to bring a portrait back to Edessa if he could not bring the healer himself. When they met, Christ declined to come to the Syrian city, explaining that his mission was among the Jews. Since the glory of his face was beyond Ananias' ability to sketch, Christ called for water, washed his face, and wiped it on a cloth on which his portrait remained. He gave this to Ananias, who took it to his master. King Abgar was cured instantly. When Christianity subsequently declined in Edessa, the local bishop is said to have hid the cloth for safety in a niche above the city gate.

The cloth first enters history in the sixth century when at least six cities had an "image not made by hands." Known as the *mandylion* (napkin or mantle), the "Edessa Portrait" was proclaimed the greatest relic in Christendom. The Byzantine emperor Lecapennus ransomed it for 20,000 pounds of silver from the Muslims who had captured Edessa, and in the summer of 944 he had it brought to Constantinople where it remained until it disappeared during the Fourth Crusade's sack of the city in 1204. Some historians trace it to Paris and conclude that it was destroyed during the French Revolution. The images in Moscow's Tretykov Gallery and in St. Martin's Cathedral in Laon are famous examples of twelfth to thirteenth-century copies. Among several that have been claimed as the original, the one in Genoa's Church of St. Bartholomew is probably the oldest surviving copy. Its earliest phase, visible in X-ray, was probably made while the "Edessa Portrait" was still in Edessa. A similar face in a similar silver casing, now in the Pope's private Matilda Chapel, is probably at least as old as the eleventh century. Every August 16, on the anniversary of the *mandylion's* arrival in Constantinople, the Orthodox Church honors this sacred cloth with the Feast of the Holy Face.

Since the end of the seventeenth century, Turin Cathedral has preserved still another cloth. Considered the burial shroud of Jesus, this fourteen-foot piece of linen has been among the most venerated objects in Christendom. In 1898 it was photographed for the first time. On the photographic negative the obscure figure on the cloth suddenly became clear. The anatomically correct body bears marks consistent with the wounds described in the Passion story. The face resembles early copies of the Edessa Portrait as well as many of the subsequent Veronicas. Could the burial shroud of Jesus be the prototype of both the *mandylion* and the Veronica?

Its authenticity questioned since its first recorded appearance in the fourteenth century, the shroud has become the world's most studied artifact. In 1978 a team of scientists reported somewhat conflicting results from several physical, chemical, and biological tests to determine the date of the cloth and the nature of its image. Ten years later, radiocarbon dating established parameters for its origin: 1260–1390. But was the procedure flawed? The sample chosen, especially subject to microbiological contamination from centuries of handling, was not subjected to chemical analysis. Botanists have since concluded pollen grains

on the cloth date from before the eighth century. Failure to find any trace of paint or brush strokes leaves the nature of the image inexplicable. International conferences continue.

Sacred cloths, in suggesting clothing and skin, have been uniquely appropriate to images of incarnation. But other images claiming miraculous origin have been only slightly less potent. The Sancta Sanctorum Chapel in Rome has attracted pilgrims since at least the eighth century with its vestiges of a painted panel of Christ enthroned attributed to the evangelist Luke and to God himself, who completed it through the hand of an angel. And an eleventh-century wooden crucifix in the Cathedral of San Martino, Lucca, Italy, has enjoyed great fame through its attribution to the disciple Nicodemus, who fell asleep while carving it and awoke to find that angels had completed the face. Many paintings of the Virgin and Child attributed to Luke have been valued as if they were of miraculous origin: they have guaranteed an authentic portrait by a painter with impeccable credentials.

We have almost no idea of the physical appearance of these two most portrayed people in the world. We can be reasonably certain that they had the features of their race. Gautama did not resemble Kojiro Hongo in the Japanese film *Shaka*, nor did Jesus look like the tall, blond, blue-eyed Jeffrey Hunter in Hollywood's *King of Kings*.

Suppose photographs of Jesus and Gautama were found in old pots. Whatever this would do to the history of technology, we would then clearly see the art and icons for what they have always been: visualizations of a living Lord, parables of a glorified body moving toward what the apostle Paul called a "spiritual body" and what Mahayanists call *sambhogakaya* (body of bliss).

Art, Icons, and Idols

What is that over there? An image is always more than the shapes, colors, lines, and textures we see. It has some meaning. We see what we remember and expect. If we see significant form, we call it art.

This form that demarcates an image from all other experience and integrates all of its parts may be called "classical" or "expressionist." Although classical form is most clearly focused in Greek art of the fifth century B.C. and expressionist form in German art at the beginning of the twentieth, the distinction roots in two universal fundaments of human experience.

Classical images emphasize volume. Symmetrical and closed, they represent ideal physical appearance and universal rhythms such as breathing and heartbeat. They satisfy our rational, volitional nature, rendering experience in coherent and harmonious equilibrium. In their repose we recognize our common humanity. They affirm established values and heal the terrors of life.

Expressionist images emphasize line and color. Asymmetrical and open, they abstract intangible qualities of experience. More intense, dynamic and personal, they stir our subconscious, emotional lives. They rupture conventional perception. In their birthing we intuit significance rather than comprehend meaning. Through them the raw complexity of the world seeps and disturbs.

Classical form predominates, for example, in several early Indian images of Buddha and Roman images of Christ, in Buddhas of the Indian Gupta and Chinese Tang Dynasties, in the Italian Renaissance Christ, and in most of the Buddhas and Christs of film, advertisements, and greeting cards. Expressionist form characterizes Chinese Buddhas of the Wei Dynasties, many Tantric deities and Zen figures, the Celtic, Romanesque, and Ethiopian Christ, and the Christ of most of modern art.

Boundaries blur. All perception and creation involves something of both forms. Although Buddha, moving away from the world's contingencies, more frequently takes a more classical form and Christ, moving into the world of confrontation, more readily takes expressionist form, both forms are capable of expressing different dimensions of the self-emptying love at the heart of the sacred that characterizes both Buddhist and Christian experience.

The best art not only clarifies and intensifies what we recognize, it requires at least momentary self-abdication to see its unique vision. Time and space dissolve as we lose ourselves in the image. The greatest art touches, however tangentially, inexplicable elemental forces. Language falters.

> *Something holy, that's what it is. That's the kind of word you ought to be able to use, only people would get it wrong, give it a meaning it doesn't possess. You ought to be able to say that such and such a picture is what it is, with all its latent potentialities, because it has been touched by God. But people would take your words in another sense. Yet that's what comes nearest to the truth.—Pablo Picasso*

> *The wonder and mystery of art, as indeed of religion in the last resort, is the revelation of something 'wholly other' by which the inexpressible loneliness of thinking is broken and enriched . . . a reality that forces itself upon our consciousness and refuses to be managed and mastered. It is here that the affinity of art and religion is most evident today.*
> *—Wallace Stevens*

> *Chosen are those artists who penetrate to the region of that secret place where primeval power nurtures all evolution. There, where the power-house of all time and space—call it brain or heart of creation—activates every function; who is the artist who would not dwell there?—Paul Klee30*

What makes a work of art sacred art is not its subject, its style, or its inspiration, but its ability to evoke "primeval power." Paul Tillich enjoyed finding more religion in an apple by Paul Cézanne than in a Jesus by Heinrich Hofmann.31

When Georg Friedrich Hegel wrote, "truth is beauty intellectually understood," and Albert Einstein praised a theory as "a beautiful element of truth," they spoke for all philosophers, scientists, artists, and saints who see the beauty of "primeval power" in the dynamic, unifying patterns of all nature and human experience.

> *All that is beautiful*
> *hangs on a thread that is tied to a nail*
> *in Christ's palm . . .*

Out from the hollow
Of the great Buddha's nose
A swallow comes.[32]

Just as we speak languages and, with such exceptions as a laugh or cry, cannot speak language, we usually see Buddhist, Christian, Islamic, Melanesian, or some other specific sacred art. We remember a particular past with traditional answers to ultimate questions. We retain this cumulative experience of particular people, even as their art, like meditation and prayer, finally frees us from ourselves and the traditional images that make the experience possible.

As we externalize conscience in traditionally approved rules of behavior, we visualize invisible ultimate reality through these traditionally approved images. They change only slightly and slowly. With such an image in the fabric of our memory, we see through any of its particular faces to the same spiritual presence in all of its kind. Just as classical and expressionist form appears in all traditions, traditional images have a life of their own, whatever their form.

Long before computer users began clicking icons, Othodox Christians kissed them. Although usually associated with Eastern Orthodoxy and then usually restricted to portable pictures, the term "icon"originally referred to any traditional sacred image. Often without aesthetic distinction, icons evoke the sacred. Respond to them by bowing, kneeling, prostration, or circumambulation. Put candles, incense, flowers, and food before them. Guild some, veil some, encrust some with metal and precious stones, clothe some according to the seasons, let some be covered with layers of soot. Kiss, touch, bathe, cense, or anoint them. Carry some in procession. Keep some in the holy of holies; hide them from harm or profanation. Keep one very close: on the bedroom wall, at the entrance of the mine, on the dashboard of the car.

Or use them for public instruction. They teach the most important lessons. They point the way to salvation. Like modern advertising posters, they do not define, qualify, or analyze. They tell us to buy now. Consider their form and they may become art. Most icons are to art what most sentences are to poetry. Although advances in photography have made reproductions of icons that are art readily available, the greater prevalence of kitsch indicates its iconic power. The world's most widely reproduced painting is Werner Sallman's *Head of Christ* (1940; Anderson University, Indiana). More than five hundred million copies have inspired and comforted. But such sentimental pictures move in the shallows of religious as well as aesthetic life. It behooves Buddhists and Christians to continually affirm the power of art to vitalize deeper levels of religious experience.

One more distinction. The difference between an icon and an idol, like the difference between art and kitsch, is as important as it is ambiguous. Both icons and idols are traditional and sacred. But whereas an icon symbolizes power beyond itself, an idol is not symbolic, it is power. Thus icons facilitate worship, and idols are worshiped—a distinction more easily made in theory than in practice.

Verbal images of the ultimate—poems, scriptures, doctrines, buddhologies, theologies—share this aesthetic, symbolic, and idolatrous potential with visual images. So does music and ritual. Indeed, anything may take significant form and reveal "that secret place where

primeval power nurtures." But visual images share with Buddha and Christ the power and danger of incarnation: a physical locus of truth aspiring to universality.

Making the Image

Since paying for the making of an image creates merit for the donor as well as for the person who makes it and the person who sees it, Buddhist temples are frequently filled with statues that were made only because making them was a good thing to do.

> *One [image] made of wood gives greater merit than what is made of clay; one made of bricks yields greater merit than a wooden one; one made of stone yields greater than what is made of bricks. Images made of gold and other metals yield the greatest religious merit. Sins accumulated in seven births are dissipated even at the very conception.*

The votive offerings that cluster around Christian cult images prompted the prince of humanists, Desiderius Erasmus, to remember visiting Walsingham Priory: "You could pronounce it the very dwelling place of the gods."[33]

While Buddhist donations often record their intention to benefit all sentient beings as well as some in particular, Christian votives usually express individual gratitude, veneration, or the discharge of a vow. The Buddhist or Christian donor's occasional appearance in his painting or sculpture makes it a perpetual happening. Both in it and looking at it, he is himself and everyone.

An unknown builder of the great Kailas temple of Ellora, India, left the inscription: "Oh how did I make it?" The ridge-poles of several cathedrals declare: "Not unto us Lord, but unto thy name be the glory." The traditional image-makers of Asia and Europe did not create primarily from their own imaginations to express themselves, nor did they work from living models. They studied and absorbed prototypes. They interpreted detail within prescribed parameters—as most of us do when making music, playing games, or cooking—occasionally with sufficient genius to make old forms new.

Although the Sangha and the Church authorized the images, these craftsmen were the immediate conduits. And although the spiritual power of an icon has never depended on the piety of its maker any more than an effective mass has required a virtuous priest, exemplary character has been expected of craftsman and priest. Indian craftsmen were said to know themselves as no less than descendants of—and when working the embodiment of—Visvakarma, architect of the universe.

> *The painter must be a good man. No sluggard, not given to anger, holy, learned . . . a master of his senses, pious, and benevolent, free from avarice, such should be his character.*

A Western view from Cennino Cennini's *The Craftsman's Handbook*:

> *Your life should always be arranged just as if you were studying theology, or philosophy, or other theories, that is to say, eating and drinking moderately . . . electing digestible and*

wholesome dishes, and light wines; saving and sparing your hand, preserving it from such
strains as heaving stones . . . There is another cause which, if you indulge it, can make
your hand so unsteady that it will waver more and flutter far more than leaves do
in the wind, and this is indulging too much in the company of women.

An Orthodox painter: "the true iconographer fasts and prays, and his work is the fruit of the Spirit."[34] The Council of 869 forbade excommunicates from both teaching and making icons. Almost seven hundred years later a Moscow synod codified extensive rules for the moral life of icon painters.

Pressures of production have always been a problem. As explorers have found in the sands of Turkistan ancient stucco molds for mass producing parts of large statues of the Buddha, archaeologists have found fifteenth-century casts for the manufacture of small terra-cotta statues of the Virgin and Child. Workplaces have often throbbed with more commerce than piety. A sixteenth-century Tibetan yogi's diatribe:

And for those 'divinely emanated' painters of religious images—Phooey!
Not thinking of the payment offered by the patron as being a basis for
 gathering a stock of merit,
They fix a price of one bre for each deity—Phooey!
Without restoring the murals of old temples
They sell for a profit the thankas that they lazily paint—Phooey!
I have still more gossip of various kinds about such painters.
Even if I do not utter it, I would like to!

Maxim Gorky described his visit to a Russian workshop.

A blue cloud of tobacco smoke hangs over the heads of the apprentices. It mixes with
the acid smell of lacquer and rotten eggs . . . Icon painting seems to be no joyful occupa-
tion for any of these painters. One of the mean know-it-alls has split up the work into
a whole series of boring details . . . the cross-eyed carpenter Panfil . . . approaches with
prepared and cemented plates of varying size . . . His friend Sorokin adds the white
mastic from chalk and cement. Miljaschin executes the draft from the original. The old
Gogolew provides the gold and impresses the seal on the gold. Vestment painters execute
both the landscape as well as the vestments . . . When the face painter has painted the
flesh, the icon is turned over to the master who enamels the work. The inscription is
done by a special man for the job, and lacquering is done by the superintendent of the
workshop.[35]

Whatever the deviations in practice, in the texts and in popular expectation traditional procedures for making Buddhist or Christian icons have been similar and sacred. An image-maker contemplates an icon; then, following a ritual of purification and an invocation, he identifies with a mental image of the icon through meditation or prayer. The work that finally materializes through his skill objectifies this vision. "He who would paint a figure, if he cannot be it, cannot draw it." Dante's dictum had its Eastern counterpart:

In order that the form of an image may be brought fully and clearly before the mind, the imager should meditate; and his success will be proportionate to his mediation. No other way—not indeed seeing the object itself—will achieve his purpose.[36]

A ceremony finally consecrates the new image. The craftsman or a priest transforms what has been an ordinary painting or sculpture into an object suitable for veneration. At an auspicious time in a closed temple he paints the Buddha's eyes, carves the pupils, or sets stones into sockets in the "eye-opening ceremony." The power of the Buddha is invoked to reside in the image. Relics or precious stones or materials are often ritually sealed inside. The Orthodox blessing of an icon asks God through the grace of the Holy Spirit to imbue the image with miraculous power. The Catholic blessing implores that all who pay homage to Christ in the image's presence may through Christ's merits obtain God's grace. Buddhist and Christian image-makers, like gurus and priests, have been the guardians of sacred mysteries. Traditional images would loose their potency if prototypes were not followed, just as a mantra or mass would be ineffective if said incorrectly.

Few images, of course, conform precisely to any model. Prescriptions frequently differed in the various manuals. In any event, the craftsmen's directions came mostly through oral tradition, and their work reflected the images they saw all about them rather than treatises they could seldom read. Every flaw in rock or wood also demanded its own modification. Far greater than the minor differences in images and models, however, is their obvious similarity. These images have always been intended and received as images of a prototype rather than as products of individual imagination or reflections of people observed.

Images of Buddha: Marks, Positions, Gestures, Dimensions

Most cultures have developed theories relating the human figure to their concept of the universe and its laws. Through signs and proportions the human figure reveals its superhuman nature. Pre-Buddhist Indian tradition included thirty-two auspicious marks and eighty minor ones by which the Great Man (*mahapurusha*) and the Universal King (*cakravartin*) could be recognized. Buddha has these cosmic emblems.

The protuberance on the crown of his head (*ushnisha*) and a circle of hair above the bridge of his nose (*urna*), two conspicuous marks of uncertain origin and many forms, probably suggest his inordinate wisdom. Sometimes the *ushnisha* is his only visible auspicious mark. In Japan it may take the form of a slight bald spot.

Buddha's other distinctions vary from text to text but usually include ankles like rounded shells, legs like an antelope, eyelashes like a cow, and a jaw like a lion. His back is flat, his chest broad, his torso, limbs and shoulders well rounded, and his arms, fingers, and toes are long. His skin is the color of gold and so smooth that neither dust nor sweat adheres to it. He has dark blue eyes, recessed genitals, interdigital webbing, projecting heels, flat feet, and a thousand-spoked wheel imprinted on each hand and foot.

Every Buddha image is understood to have all the marks, even if we cannot see them, and including those not within a craftsman's scope. He has forty very white teeth of equal size, acute taste, and a long, slender tongue. The down of his body turns to the right. Standing erect, he can touch his knees with his hands, even though the length of his body equals the compass of his arms.[37]

Most of the marks reflect Indian aesthetic ideals. Others are symbolic. Recessed genitals, for example, indicate chastity with procreative power displaced upward to a long tongue for extraordinary teaching. And the strange idea of Buddha's webbed fingers may have developed only after Buddhists had seen early statues of him with what were probably the sculptor's expedient to reinforce body parts easily broken.

A few texts imply that at least those in a high enough state of consciousness saw some of these marks on the Buddha. In one instance, a disciple tracks his Master by his distinctive footprints. Not parts of the Buddha's mere appearance, however, the auspicious marks distinguish his transformed body.

> *When you have perceived Buddha, it is indeed that mind of yours that possesses those thirty-two signs of perfection and eighty minor marks of excellence…it is your mind that becomes Buddha, nay, it is your mind that is indeed Buddha.*[38]

The lists of auspicious marks do not include some of the Buddha's most consistently identifiable features. His long ears enable him to hear everything. Since distance is measured in sound, all space has come to him through his ears, and he holds within himself all the regions of the universe in perfect balance. Long ears are a pre-Buddhist Indian sign of divinity. Vishnu has them. It is also said that the Buddha's permanently stretched earlobes attest to his having relinquished the luxury of princely earrings. Each curl of his closely cropped hair turns to the right following the course of the sun, the path of life. His hair grew back this way when he cut it off after leaving the palace, perhaps a symbolic compromise between the luxurious locks of the Universal King and the monk's shaved head of renunciation. Many of his features are derived from nature's repertoire of perfect forms. His head is the oval of an egg, his eyes the shape of lotus petals, his nose like a parrot's beak, his chin like a mango stone, and three lines circumscribe his neck like the folds of conch shells.

Whatever the style and however bejeweled, Buddha usually wears the unstitched robes of a monk: an undergarment tied at the waist falling to just above the ankles and a long outer one draped over one or both shoulders. His age seldom shows. The "birthday Buddha" is a man-child, fully formed, just reduced in size. Thereafter, he is invariably in the prime of life, even in death in his eightieth year.

He appears in three positions throughout Asia. In the tradition of a yogic ascetic, he sits erect with legs crossed, feet resting on opposite thighs with soles upward (*padmasana*) or in the variant "half lotus" with only one foot athigh (*virasana*). At the opposite pole of Indian religious experience he stands in a stance probably derived from images of monarchs and tree-spirits of superhuman size and power, both seen as heavy and prosperous. And in a position without any clear antecedent, he lies on his right side while leaving the world for final nirvana, or occasionally in Southeast Asia, when it becomes too abhorrent to think of the Buddha dying, he simply rests in this position.

Sometimes he walks—very seldom in sculpture, and not in three dimensions until the thirteenth century in Thailand. He may sit in the "European position" with both legs pendant. Maitreya Buddha especially favors this position. Reflecting on his forthcoming earthly appearance, Maitreya also sits in the graceful "pensive position": elbow resting on his raised knee with foot on the opposite knee, one hand raised toward his cheek, the other resting on his crossed leg, his head slightly inclined.

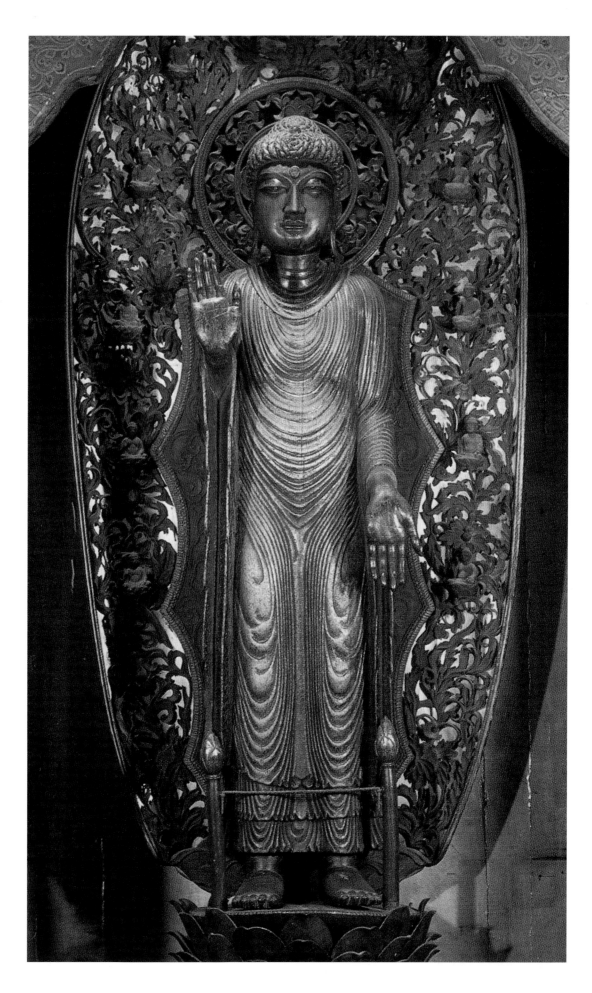

FIG. 45
Buddha. 987, China. Seiryoji,
Kyoto, Japan

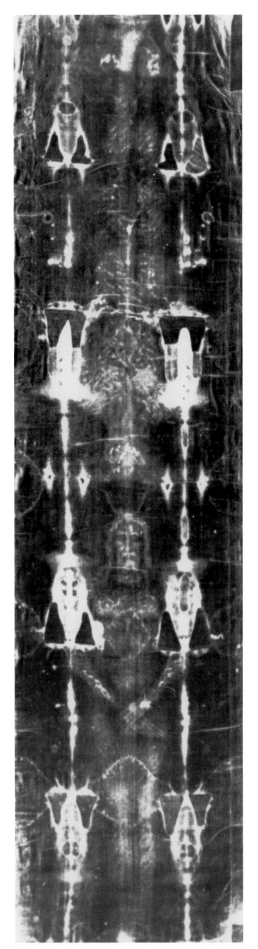

Fig. 46
Shroud of Turin (and detail).
13th-14th century(?), Turin
Cathedral, Turin, Italy. Photo
copyright British Society for
the Turin Shroud

Fig. 47
Veronica, from a *Book of
Hours*. Master of Guillbert
de Mets, 1450-60, Flanders.
Collection of the J. Paul
Getty Museum, Los Angeles,
California

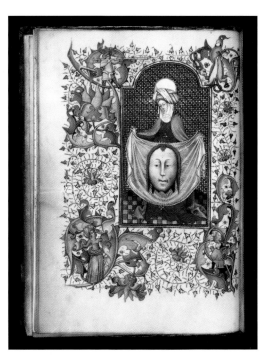

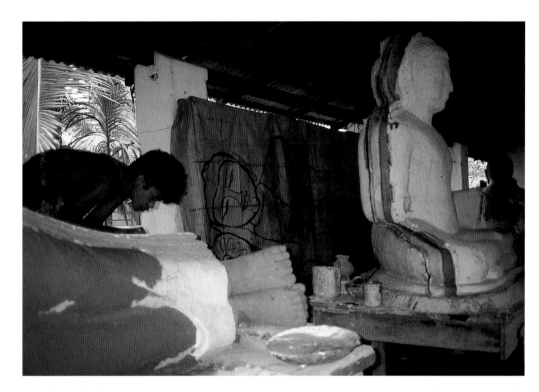

FIG. 48
Sculptor. 1984, Vipulasara's
studio, Colombo, Sri Lanka.
Author's photo

FIG. 49
Painter. 1989, Church of St.
Martin in the Fields, London.
Author's photo

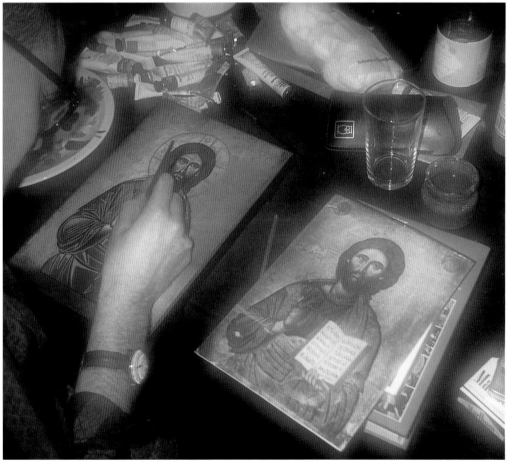

23

1.

27

15

2.

77

3.

71

4.

84

5.

6.

50

When lying on his side, the Buddha's left arm usually extends naturally along the side of his body, and his head rests on his right hand. But in other postures a variety of gestures (*mudras*) indicate his activities or, in a Mahayana context, designate a specific cosmic Buddha. Six gestures of Indian origin are pan-Asian, although the frequency with which each is represented varies considerably according to time and place, and their symbolism does not become consistent until about the end of the sixth century.

In meditation (*dhyana mudra*) the Buddha's hands rest together in his lap, fingers extended, palms upward (1). Earth-touching (*bhumisparsa mudra*) signifies his enlightenment: calling the earth to witness his triumph over the temptations of Mara, the fingertips of his right hand extend over his right knee (2), his left hand resting palm upward in his lap. His teaching "turns the wheel of Dharma" (*dharmacakra mudra*), the motion of a wheel suggested by both hands held before his chest, forefingers touching thumbs to form two circles (3). Reasoned argument (*vitarka mudra*) is similar to turning the wheel of Dharma, but usually only one hand gestures, forefinger and thumb curled to touch (4). In dispelling fear (*abhaya mudra*) he raises his right hand, palm outward (5)—or, being perfectly ambidextrous, his left hand or both hands—in the blessing of protection and assurance. And in giving or vow-fulfilling (*varada mudra*) his hand points down, palm outward, in the gesture of generosity (6).

Many variations and many other gestures have endured extended interpretation in moving through different schools, areas, and times.

Finally, Indian treatises on images prescribe the dimensions of every part of the Universal King and hence, for Buddhists, the Buddha. One of the oldest manuals reports, "eight atoms make one hair point" and works up to "eight lice are to be taken to make one barley grain. Eight barley grains make one finger; a finger [width] is taken as a digit...." Buddha's height is 108 digits, the width of his face fourteen digits, the width of each nostril six barley grains, the space between nostrils two barley grains; his penis (although recessed) is six digits in length, his large toe four, and both penis and toe are two digits broad. Metaphors reach for qualitative distinctions:

> [Teeth] *white as pearls, as cow's milk, as the stem of a lotus, as a heap of snow . . . The eyelashes resemble the best kind of oil, and are long . . . the whole body is luscious indeed.*[39]

Discrepancies, even within the same document, may be attributed to long oral traditions and conflations of earlier and later material.

Every image of the Buddha proceeds from a central line corresponding to the spine. From this axis of life—the "Brahma line"—symmetrical, horizontal, vertical, and diagonal lines, measured in a prescribed number of finger widths, intersect to locate the contour of his body. "If the plumb line is drawn amiss, the image-maker will be afflicted with illness."[40]

An important principle infuses all of this body language. The form (*rupa*) of anything is not seen but known. An object's form is finally its spirit, not its physics. Elephants stand on lotuses. Manuals governing painting and sculpture from fourth and fifth-century India emphasize "life movement" (*cetena*), as slightly later Chinese painting formulas insist on "spirit resonance" (*chi-yun*). The cornerstone of Asian aesthetics requires that every image capture this vitality in reflecting the reverberations of the cosmic spirit in whatever is portrayed.

The West had its own traditions. Egyptians fit the human form into a grid of equal squares, each square the height of a foot from sole to ankle top. The Greek philosopher Pythagoras saw "everything arranged by number," and from the canons of the sculptor Polyclitus: "beauty consists in the harmonious proportions of the parts." The Roman architect, Vitruvius, drew a man into the perfect forms of a circle and a square by the appropriate extension of the man's arms and legs. The philosopher Plotinus, like Indian and Chinese aestheticians, saw beautiful figures as illuminations of "universal soul."

By the eleventh century a distinctively Christian formula had evolved in Byzantium. Since man is conceived in the image of God, his measurements, like the Buddha's, are derived more from concepts of perfection than from a study of anatomy.

Three concentric circles inscribe Christ's head. Their common center, the center of his head at the bridge of his nose—comparable to the Buddha's *urna*—indicates the seat of wisdom. With a nose-length radius, the first circle includes his eyes and forehead; double the nose-length radius and the circle outlines his head; trebled, it forms his halo. The three circle model provided artists with harmonious proportions from which most deviated only slightly in painting a face that embodies the symbol of eternity and totality.

Byzantine manuals stipulate the body's proportions with all the precision and imagination of their Indian counterparts.

> *From the top of the head to the chin . . . four lengths; from the chin to the clavicle, one length; from the clavicle to the dimple of the diaphragm, three lengths; from there to the navel, three lengths . . .*
>
> *The two extended arms, from the tips of one hand to the tips of the other, represent twenty-eight lengths of a nose which correspond to the total length of the body; this means that men must nourish their bodies by the work of their arms. Besides, this width of two extended arms is equal to one side of the equilateral triangle whose point is situated a bit below the heel, which means that the Trinity of God has been restored to us on the cross.[41]*

More demonstrably, Christ's height, like the Buddha's, exceeds Polyclitus' prescription for a natural ratio of total body length equal to seven heads. From the more natural proportions of early Byzantine figures, Christ's height gradually extends to ten head lengths. Elongation reinforces symmetry, centrality, and frontality in suggesting supernatural grandeur.

Although a few medieval manuals for image-makers in the Western Church show lingering concerns for geometry, the Romanesque and Gothic Christ deviated dramatically from such formulas. It was Renaissance artists and scholars who frequently made human proportions into explicit metaphysical postulates. They were as fascinated as their Indian and Byzantine counterparts with the rational basis of beauty and the harmony between man and the universe. It was widely accepted during the Renaissance that the ratio of the height, width, and depth of the human body was related to the measurements of Noah's Ark, the length of each being ten times their thickness and six times their width. Despite Leonardo da Vinci's celebrated direct observation and precise measurement, he furthered the revival of classical canons by drawing one of the few convincing examples of "Vitruvian

51

man." Albrecht Dürer finally devised several human types rather than one ideal and represents the end of the search for geometric models of the ideal man.

The Church's memory of the historical Jesus has precluded anything comparable to the Buddha's auspicious marks. Although Christ occasionally shares with Buddha the distinction of "recessed genitals," the simple naked sexless Christ at baptism and crucifixion is rare. Opaque water or a shielding hand usually provide cover in the Jordan, and a loincloth serves both occasions, with possible historical justification on the cross. Buddha's body is gold; Christ's body is surrounded by it.

Apart from traditional facial features, relative size, and narrative context, we recognize Christ through the halo he shares with the Buddha, the deep blue of his robe (the color of divine life), and what he holds occasionally: the scroll of his teaching, his wonder-working wand, the orb of universal empire, or an apocalyptic handful of stars (the seven churches and his astral domain) and mouthful of sword (his judicial smiting power).

A raised right hand was one of the most pervasive gestures in the ancient world. Buddha raised his in reassurance (*abhaya mudra*); Israel's Yahweh protected his servants and destroyed his enemies with his mighty right hand; the Greek god Hermes repelled all hostile forces with the same gesture. Extraterrestrials may now expect this greeting from a plaque on the National Aeronautics and Space Administration's Pioneer spacecraft. As Christ's only enduring gesture it has had three quite different implications.

From the time of Constantine through the Middle Ages innumerable coins and monuments show the raised right hand as an imperial gesture. In his right hand, the emperor incarnates God's compelling power. Christ Pantocrator (Universal Ruler) raises his right hand; with raised right hand Christ gives the law to Peter; with outstretched right arm he heals the sick.

But the raised hand also indicated discourse. Widely used throughout the ancient world, it still punctuates talk in the animated markets of Mediterranean towns. Thumb, forefinger, and middle finger extended, the two remaining fingers flex against the palm. Or the thumb touches the fourth finger, or the forefinger and thumb form a circle, with the other fingers extended (Buddha in reasoned argument—*virtarka mudra*). In a frequently repeated image from the end of the third century Christ wears a philosopher's cloak, holds a scroll in his left hand, and raises his right hand in this oratorical gesture. He who said "I am the truth" expounds holy wisdom. The speech gesture visualizes the written and spoken word.

Finally, in transition from antiquity to the Middle Ages, Christ begins raising his hand in blessing. Two extended fingers may signify his dual nature. In the Latin Church three fingers extended may signify the Trinity. Among several variations in the Orthodox tradition, when the third finger, or the third and fourth fingers, touch the thumb, and the other fingers remain erect, an Orthodox eye may see the first two letters of the Greek word Χριστός (Christ) as the Chi Rho monogram ☧. All Christians see in the raised hand the assurance of God's grace.

While the benedictory Christ usually replaced the teaching Christ, the teaching *mudra* has always remained one of Buddha's foremost gestures. As Christ more frequently heals people, Buddha more frequently teaches about healing.

Usually, of course, the great traditional images of Buddha and Christ indicate an intimate awareness of the human body, not just the study of iconographic and iconometric formulas.

14
28
81, 80

34, 45, 42

70

79

72

85
80

20, 88

They simply emphasize conception over perception, as Plotinus reminds us traditional images always do—even Greek ones, especially through Platonic eyes:

> *For Phidias too did not make his Zeus from any model perceived by the senses, but understood what Zeus would look like if he wanted to make himself visible.*[42]

Narrative Scenes

Buddhists see the traditional stories of the life of Buddha as Christians see the traditional stories of the life of Christ, not primarily as an ancient community's response to an historical person but as timeless reenactments of the life of their Lord. Frequently only essential figures populate these scenes. Landscapes or architectural settings are reduced or eliminated. Perspective is as unnatural as proportion: size reflects importance rather than proximity. If many figures are required, some may simply appear in a second zone above the first and, if necessary, in a third above that. A single scene may illustrate several parts of a story simultaneously, chronological sequence vying with schematic arrangement. Gestures are usually exaggerated. Natural light does not intrude to cast shadows. This triumph of conceptual abstraction over perceptual realism may give small narrative scenes the immediate emotional impact of much larger cult images.

25, 26

7, 8

31, 32

92, 97

We See What We Bring

Just as something of the artist mirrored in a work of art makes an art object different from objects in the natural world, individual preconceptions brought to a work of art make it a different work for every viewer. Objectifying both the artist's consciousness and our own, the work of art cannot finally be separated from either the person who made it or the viewer who sees it. Whether we see the Daibutsu in Kamakura or the Christ in Cavendish Square as either icon or art is akin to whether we see Gautama as Buddha or Jesus as Christ. Just as the ways in which people have depicted Buddha and Christ over the centuries tell us more about Buddhism and Christianity than about Gautama and Jesus, the ways in which we respond to these images tell us more about ourselves than about Buddhism and Christianity.

3, 4

If we have a visceral religious or esthetic response to an image the surface realities of our world mirrored in the image become symbols of the depth of reality. People who have prepared themselves may provoke an epiphany. The disclosure of Buddha or Christ through his image usually requires fasting from the popular media's titillating images of consumption and disaster. Then, in sustained contemplative or prayerful perception, mindful of the figure without judging it, the traditional values embodied in the image may so pervade Buddhist or Christian consciousness as to "penetrate to the region of that secret place where primeval power nurtures all evolution."[43]

People who have not prepared themselves in this way but who are aesthetically sensitive may appreciate appearances that Buddhists or Christians may not see. Standing before the great images, they may also experience something of that primeval power nurturing all evolution. For what is the greatest art but the beauty of holiness?

The Threat of Images

Before images of Buddha and Christ appeared, there is the interesting fact of their absence. The first known images of Buddha were made about five centuries after Gautama and those of Christ about a century and a half after Jesus. Both Buddhism and Christianity have in common with most other religions a continuing pattern of ambiguity about images.

Fear of contaminating spiritual reality is as inevitable as the impulse to verbalize and visualize it. Because images are more explicit than words, they are more powerful and more dangerous.

The Early Church and the Eastern Crisis

The early church's distrust of images sprang from at least two sources: Hebraic and Platonic. The Jews, worshiping one invisible God, had a long struggle to separate themselves from their neighbor's idols and icons. God had given them his second commandment:

> *You shall not make yourself a graven image of any likeness of anything that is in heaven above, or that is in the earth beneath, or that is in the water under the earth.*

God manifests himself in events, not things. He reigned in majesty from the throne of the ark of the covenant, and the throne was empty. He has only living images: people. "God created man in his own image, in the image of God he created him."[44]

But the necessity for frequent proscriptions, some positive references to artists and to Israel's veneration of images, and the figures on Solomon's temple and on amulets, tombs, and synagogues throughout the Roman Empire indicate the Jews had as much trouble with the second commandment as with the others. Although nothing suggests Jesus either prohibited or endorsed images, the New Testament constantly inveighs against idolatry.

In addition to this Hebraic interdiction, the Church Fathers were also articulating the new faith from within a Platonic view of the world that repudiated pictures and statues as mere copies of material things, themselves mere copies of pure, eternal, immaterial forms. Although twice removed from the truth, images were occasionally acknowledged as useful vehicles for reaching it, a concession later Platonists seized upon when defending images.

But a Greek tradition older and stronger than Platonism embodied its gods in human form. The Church Fathers, like the Jews before them, sought to dike their new faith against an infiltrating sea of gods from Greece, Egypt, and the Near East. The third-century emperor Severus Alexander kept statues of Christ, Alexander, Orpheus, "and others of this same character" in his sanctuary, and both the tone and title of Tertullian's *Treatise on Idolatry* indicate that he was assailing well-established popular habits. The Alexandrian Fathers Clement and Origen put in opposition the Christian God who could be seen only in the mind and pagan gods with their sensual images. The second-century *Apocalypse of Peter* refers to a special section of hell reserved for image-makers. Lactantius, tutor to the Emperor Constantine's son, could conclude: "There is no doubt that there is no religion wherever there is a statue or image."[45] All that followed was either an affirmation or a repudiation of this seminal idea, with its long, tenacious Hebraic and Platonic roots.

The first institutional ban comes from the beginning of the fourth century with the Council of Elvira's proscription for that particular Spanish province: "There shall be no pictures in churches, lest what is worshiped and adored be depicted on walls."[46]

Toward the end of the century Bishop Epiphanius, the first Christian known to destroy an image, stopped to pray in a village church in Palestine. He wrote that upon entering the church he found a curtain bearing "some idol in the form of a man. They alleged that it was the image of Christ or one of the saints."[47] He tore it down and advised that it be made into a burial cloth for some poor person. This was apparently a rare response. Whatever the iconoclastic sentiment, very little destruction occurred until the eighth-century Byzantine controversy. Epiphanius had to replace the curtain.

By the end of the fourth century most of the theologians' and bishops' hostility to images had dissolved as the visual splendors of the several churches built to accomodate the influx of converts confirmed what had long been popular usage in most Christian communities. The Capadocian Father Basil remarked parenthetically: "That which the word communicates by sound, the painting shows silently by representation." The early fifth-century Bishop Paulinus justified covering the walls of his church with sacred pictures "to see whether . . . the peasants would not be surprised by this spectacle and feed with their eyes instead of their lips."[48]

Images were acknowledged to have two main purposes: to teach the faith and to incite the faithful to devotion. Pope Gregory the Great put the didactic function in terms that, though not new, were clear and authoritative enough to provide the Western Church with its official guide for avoiding the extremes of both iconoclasm and idolatry. Hearing a report that the Bishop of Marseille was removing images from the churches of his dioceses, the Pope ordered him to desist.

Pictures are used in churches for this reason: that those who are ignorant of letters may at least read what they cannot read in books by looking at the walls. Therefore, my brother, you should have preserved the images and at the same time prohibited the people from worshiping them.

He also affirmed, in a less frequently quoted letter, their significant inspirational value: "by seeing a picture of Him, your heart may be set afire with love of Him whose image you

desire to see."[49] A thorough theoretical foundation for the distinction between idols and icons lay in the future.

In the sixth and seventh centuries many images became enormously popular idols. The barrier between image and prototype—a formidable barrier only in the most sophisticated minds—was easily broken. Cults were devoted to pictures, statues and churches dedicated to them. They bled, wept, moved, spoke, and ate. They even administered the Eucharist. Images "not made by hands" appeared. Not only could these miracle-working pictures grant individual suppliants help and protection, they were put down dry wells to bring water back, paint was scraped from them and mixed with bread for communion, they relieved epidemics and turned back armies. The "Edessa Portrait" delivered Edessa from its Persian siege; the Emperor Heraclius routed the Persians after showing the Holy Face to his troops; and Constantinople survived its siege by the Avars only after the patriarch carried an icon of the Virgin and Child around the walls. Had the victories continued, there might not have followed such a severe and protracted spasm of iconoclasm.

Emperor Leo III, able general and administrator, is remembered for two important developments. Coming to power in one of Byzantium's darkest hours, he broke the year-long Arab siege of Constantinople. Then, sometime during the third decade of the eighth century— probably genuinely motivated by religious concern stemming from the Monophysite region from which he came (accepting only the divine nature of Christ, the Monophysites resisted physical representations of him), aware of the recent failure of icons as prophylactics against the Arabs, and determined to centralize authority at the expense of the powerful monasteries which gained considerable income from the sale of icons—he removed the painting of Christ from above the imperial palace gate, replaced it with a cross, and ordered all images removed from all churches. The aging patriarch Germanus claimed "seeing is more conducive to faith than hearing," and most of the clergy did not cooperate. A crowd of women rioted, reportedly killing the officer who had been charged with removing the picture. The controversy had officially begun.

Leo's successor, Constantine V, was more interested in theology than was his father. He called and addressed a Council in 754 that used the fifth-century Council of Chalcedon's formula of the two natures of Christ to argue that any picture of the true Christ is impossible because it either divides his human and divine natures, like the Nestorians, or confounds the two natures in attempting to portray his uncircumscribable divinity. The bishops posthumously anathematized Germanus "the wood worshiper," proclaimed the Eucharist the only permissible image of Christ, and declared:

> *Every image should be cast out from the church . . . as foreign and hateful, be it made of whatever material of the evil art of the painters . . . He who, from now on, dares to make an image, or to worship it, or to erect it in a church or private dwelling or conceal it—if he is a bishop, priest, or deacon, let him be deposed, if a monk or lay person, let him be anathematized and be held answerable according to the imperial laws as an opponent of the commandments of God.*[50]

Opposition to the Council gathered around Abbot Stephen, a holy recluse with many followers, and in November of 765 a mob of iconoclasts tore the Abbot to pieces in the

streets of Constantinople. As the chief defenders of images, monks suffered the most. In Ephesus they were given the choice of immediate marriage or torture and exile. Several Church officials were executed and the patriarch beheaded. Large scale emigration ensued. The whole attack appeared to many of the faithful as another crucifixion of Christ. Hostility had reached its height of passion.

The next emperor reigned over a brief pause. Images were not favored, but neither were persecutions. He was followed by the first of two women rulers, both partisans of pictures.

Irene, regent for her ten-year-old son (whom she eventually had blinded), called the second Council of Nicaea, the last of the general Councils to be recognized by the Orthodox Church as universally binding and a milestone in this struggle. If you want to paint the scene, a painters' manual found on Mt. Athos, probably written in the eighteenth century but reflecting practices in medieval workshops, tells you what to include:

> *Above is the Holy Spirit, and the emperor Constantine as a little child and his mother Irene sitting on thrones; Constantine holds an icon of Christ, and Irene one of the Virgin. On either side of them . . . Pope Peter and other bishops and fathers are seated holding icons. In the midst of them is a bishop writing: He who does not revere the holy images and the venerated Cross, let him be anathema.*[51]

This Council of 787 argued that images of Christ are an inevitable consequence of God becoming man. Christ, the visible image of the invisible God, can only be apprehended in material form and "images not made by hands" assured the validity and accuracy of the form. In rejecting images iconoclasts were denying the incarnation. Furthermore, the innumerable stories of miraculous moving, speaking, healing, and protecting images that embarrassed theologians were, from the practical experience of ordinary people, the most obvious evidence of the divine power of images.

Scripture and icons were declared equally essential, revelatory, and sacred. Indeed, one of those seated fathers at Nicaea gave a psychological fact theological interpretation: "Stronger than the word is the image, and it is so by the providence of God for the benefit of uninstructed men."[52]

The Council adopted a distinction devised by the late John of Damascus, who had in turn drawn on sixth-century texts attributed to the first-century Dionysius the Areopagite that reflected the thought of Plato. John said that Dionysius' idea that Biblical symbols and allegories lead us to the formless essences—the world of the Spirit and God—applies also to images. He reiterated the favorite formula of all defenders of images, first enunciated in the fourth century by Basil, bishop of Caeserea: "The honor paid to the image passes over to the prototype." Just as the essential difference between image and prototype quashes the charge of idolatry, the essential relationship in which the spiritual original is reflected in the material image assures the image's sacramental character. "Fear not; have no anxiety; discern between the different kinds of worship."[53] Offer veneration (*proskynesis*) to images, reserving adoration (*latria*) for God alone. Veneration of an image of Christ becomes adoration—not of the image but of God.

Contrite iconoclasts who had failed to make this distinction were welcomed back into the Church, the obdurate were excommunicated. Iconoclastic texts were destroyed, and the

patriarch described Constantine V's arguments as "the belchings of a disordered digestion." A new image of Christ was placed above the imperial palace gate.

But not to stay. In 814, and three emperors later, Leo V, seeing the military and political disasters that had befallen Irene and her immediate successors, had the image replaced by a cross. The next year he called a Council. It annulled 787, when "God's Church was undone by female frivolity," and declared icons "unfit for veneration and useless."[54]

On Christmas day, while singing an anthem in his chapel, Leo was murdered. His assassin became emperor briefly and was noncommittal regarding images. His successor, Theophilus, was an admirer of Muslim culture and a strong iconoclast. He initiated the final persecution. It was relatively mild, but hands were amputated and foreheads branded. Upon Theophilus' death his wife Theodora became regent for her three-year-old son.

Theodora closed the saga. Agreeing with the majority of her people who had loved and used images all along, her Council of 843 declared in favor of 787 and excommunicated all iconoclasts. The third image of Christ appeared above the palace gate. Ever since, on the first Sunday of Lent, Orthodox Christians have celebrated the event as the "Triumph of Orthodoxy" with a triumphant procession of images.

> *Piety has grown, error has fallen, faith blooms and Grace spreads out. For behold, once again the image of Christ shines above the imperial throne and confounds the murky heresies.*[55]

This tumultuous polemic had driven to the heart of the relationship between art and religion through Christianity's distinctive debate: Christology. How can a visible image intimate the invisible ultimate? If God has indeed become man in Christ, is not an image of Christ nothing less than an image of God? Both sides had claimed loyalty to scripture and tradition. The main result of the faithful's piety, the theological arguments, and imperial and conciliar authority was to finally justify icons as vehicles of divine power. They remain an integral sacramental part of the Orthodox liturgy, and they continue to sanctify Orthodox homes and public buildings.

The period immediately following the controversy saw accelerated acceptance of the legends of miraculous portraits of Christ, his physical description attributed to John of Damascus, and the model rendering his head within three concentric circles. Authoritative manuals eventually prescribed not only how icons were to be painted but where they were to appear in every church. All of this definition assured timeless images based on an unchanging prototype free from individual and historical encumbrances.

Sculpture in the round, however, almost disappeared in the Byzantine world. Its third dimension made it more dangerous than painting. More natural, it was more likely to be alive, an idol.

The Catholic Church's "Resplendent Walls" and Protestant Walls, "Beautifully White"

Anxiety about images continued among church leaders throughout medieval Europe. But since the Western church never exalted images to the status they attained in Eastern Orthodoxy, Western Christians were, with several intense exceptions, not so obsessed with their idolatrous potential. When Emperor Leo III banned all images in the eighth century, Pope Gregory II wrote to him:

> Go anywhere where school is held and say: I am a destroyer and persecutor of images. They will at once beat you over the head with their slates, and what you have not learned from the wise, little children, unable yet to reason, will teach you.[56]

The Pope declared the Emperor's decree heresy, and his successor excommunicated all iconoclasts.

Charlemagne's Council of 794 declared, however, that 787 had gone too far. Images are important but not essential, it stated, and they cannot be compared with scripture, sacraments, relics, or the cross. Adoration and veneration belong to God alone, not to images, whose function is to teach, decorate, and commemorate. Since images in the West were not a part of the liturgy and were not required to preserve their original form, image-makers had more freedom for individual interpretation.

By the thirteenth century the most systematic of medieval theologians, Thomas Aquinas, reaffirmed that devotion accorded images of Christ conformed to Basil's fourth-century formula:

> No reverence is shown to the image of Christ insofar as it is an independent reality—a piece of wood, carved or painted . . . Whatever reverence is shown it has in view its function as image. From this it follows that the same reverence is shown to the image of Christ as to Christ himself.

He divided this worship into *latria absoluta*, for God alone, and *latria relative*, for his image in Christ. Such distinctions were as lost on most Catholics as on most Orthodox. A fifteenth-century diary entry is timeless:

> There was much talk of the worship of an image . . . about a bowshot from Bibbona. It is, namely, a Virgin seated and holding the dead Christ in her arms, after he has been taken down from the Cross; which is called by some a Pietà. This worship began on April 5, when it was transfigured: that is, it changed from blue to red, and from red to black and diverse colours. And this is said to have happened many times . . . and a number of sick persons have been cured, and a number of miracles have been performed and quarrels reconciled; so that all the world is running there . . . I have spoken to many who tell me that they themselves have seen it transfigured, so that one must perforce believe it.[57]

Although the most powerful of all medieval orders, Cluny, was in the great mainstream of Catholic Europe in sanctioning images, the austere reforms of Bernard of Clairvaux and his Cistercians only begrudgingly acknowledged their value for "unlearned carnal folk" and severely restricted their use, wincing at their expense:

The Church is resplendent in her walls, beggarly in her poor; she clothes her stones in gold and leaves her sons naked; the rich man's eye is fed at the expense of the indigent.[58]

Sporadic protests against images continued with the Lollards in England, the Hussites in Bohemia, and Savonarola in Italy. But the virulence of iconoclasm did not strike Europe until eight centuries after it had ravaged the Orthodox Church. Then, within Protestant affirmations of the Bible as the only mediator of God's grace, most of the Byzantine arguments were rehearsed: interpretations of the second commandment, an image's ability to reflect Christ's divinity, and distinctions between symbols and idols. Ample argument was available to justify some systematic destructions by city councils, and vandalism and plunder undoubtedly fueled the rampaging crowds. But, more significant, throughout much of Europe north of the Alps images had become an accessible sign of the whole offensive liturgical and hierarchial structure of the Catholic Church. In attacking the Roman Church through its images the populace also savaged the pretensions of wealthy benefactors, whose justification by donation was spiritually useless in the new Protestant theology. The religious tide, with strong social and political undercurrents, was sufficient to drown most aesthetic and historical concerns.

"In Zurich," Ulrich Zwingli wrote, "we have churches which are positively luminous; the walls are beautifully white!"[59] Under his leadership a committee appointed by the city council took all the paintings and statues out of all the churches of Zurich, smashed or burned them, and then whitewashed the walls. Ash Wednesday, 1529, found the municipal workers of Basel igniting great piles of cult objects destroyed by rioting crowds. The fires burned for two days and nights, and the city council issued a mandate abolishing images and masses. The following year Strasburg's City Fathers, after years of argument and attempts at compromise, ordered images removed from all churches.

The most influential theologian among the reformers, John Calvin, attributed Pope Gregory's "images are the books of the unlearned" to feeble Biblical insight. He ridiculed the Council of 787's distinction between "adoration" and "veneration" as a paltry quibble "with which they would throw dust in all eyes, human and divine." Although acknowledging that art is "of some use for instruction or admonition . . . [or] amusement," he drew on the two constants of the iconoclast's arsenal, scripture and idolatry, to declare:

It [is] unlawful to give a visible shape to God, because God himself has forbidden it, and because it cannot be done without, in some degree, tarnishing his glory.[60]

Calvinists sacked the churches of northern Europe and in Scotland destroyed almost all accessories of medieval worship. English momentum began with Henry VIII's dissolution of the monasteries in 1536. A hundred years later the House of Commons ordered commissioners sent into several counties:

. . . to demolish and remove out of churches and chapels all images, altars, or tables turned altar-wise, crucifixes, superstitious pictures, and other monuments and relics of idolatry.[61]

The white unadorned churches in America's New England hills recall Puritan suspicions that all pictures are a dangerous indulgence of the senses. By 1913 the British Film Board of Censors had only two specific rules: no nudity and no pictures of Christ. And Karl Barth, a towering twentieth-century theologian who could inform God he would decline heaven if Mozart's music were not played there, stood in the mainstream of Reformed tradition with his belief that "images and symbols have *no place at all* in a building designed for Protestant worship."[62]

Martin Luther was among the least radical of the reformers on this issue. Insisting only that Christians "would do better to give a poor man a gold-piece than God a golden image," he noted the irony of his iconophobic opponents using his illustrated translation of the New Testament. Images, he contended, are "neither here nor there, neither evil nor good, we may have them or not, as we please." He castigated both their abuse and rejection of them because of their abuse. Answering his colleague known as Carlstadt, who was calling for total abolition, Luther replied: "If it is not a sin but good to have the image of Christ in my heart, why should it be a sin to have it in my eyes."[63]

Although images were essentially insignificant in Luther's emphasis on the Word, such restrained affirmations coupled with the powerful expression of his faith attracted several artists. Albrecht Dürer had hoped to paint "that Christian man who has helped me to overcome great fears."[64] Lucas Cranach not only did paint his close friend (they were godfathers to each other's children), he virtually chronicled the Reformation through his portraits and the extensive production of his workshop.

Some five-hundred woodcuts illustrated Luther's German Bible during his lifetime, and his prayerbook, catechisms, hymnal, and sermon collections were copiously illustrated. One distinctly Protestant iconographic innovation, originating with Cranach, was widely copied in many media. In "Law and Grace" the picture divides at the center: the figures on the left illustrating the law as the way to death, those on the right showing the way of life through faith in Christ. Three favorite themes, relatively infrequent in the centuries immediately preceding the sixteenth, portray Christ according to Luther's view of the redeemer displaying God's love, rather than the sovereign dispensing his justice. In "Christ and the Adulteress" mercy triumphs over the law as the adulteress is justified by faith alone. "Christ Blessing the Children" illustrates the sufficiency of faith through childlike trust. And in several Lutheran altar paintings of the Lord's Supper Christ himself distributes the bread and the wine to all the faithful.

But in northern European lands not under Luther's influence about the only sanctuary for images finally emerged as a consequence of French Revolutionary fervor. The dilemma of destroying all royal, feudal, and religious symbols while preserving the artistic heritage of France led directly to the creation of public museums. In the Louvre and in the Museum of French Monuments pictures of Christ could be safely seen as art, their iconic power drained in the artificial settings. When artists became identified with their work in the Renaissance, the cult of the artist's name subtly shifted the viewer's concern from the image to its maker.

FIG. 52
Ass-headed Crucifixion.
2nd century, Rome. Museo
Nazionale delle Terme,
Rome. Photo: Alinari/Art
Resource, N.Y.

FIG. 53
Whitewashing the Image, from
the *Chludov Psalter*. 9th century,
Bulgaria. Historical Museum,
Moscow. Photo: Anthony Bryer
and Judith Herrin, eds.,
Iconoclasm, 1977

FIG. 54
*Monk from Tan-hsia Burning a
Wooden Image of the Buddha*.
Yin-to-lo, 13th-14th century,
Japan. Ishibashi Museum of Art,
Asian Gallery. Photo courtesy
of Ishibashi Foundation,
Kurume, Japan

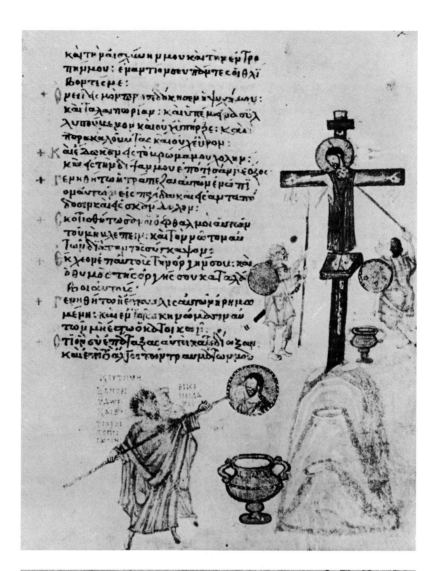

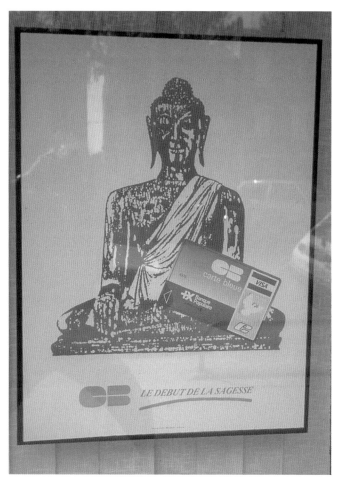

Fig. 55
*Buddha Visa Card Advertise-
ment.* 1988, Albi, France.
Author's photo.

Fig. 56
*Jesus and Mary Chain
Advertisement.* 1989, London.
Author's photo.

With either the work of art or the artist himself the object of concern, the prototype rested in all the security of an iconoclast's dream.

Catholics have characteristically seen the destruction of images as sacrilege. In its final session of 1563 the Council of Trent responded to both Protestant iconoclasm and unbridled Renaissance humanism by both affirming the use of images and acknowledging the danger of their abuse. The terms were familiar.

> *Images of Christ . . . are to be placed and retained, especially in the churches . . . not, how-ever, that . . . trust is to be placed in images, as was done of old by the Gentiles who placed their hope in idols; but because the honor which is shown them is referred to the prototypes which they represent . . . No representation . . . such as might be the occasion of grave error to the uneducated [may] be exhibited . . . No one is permitted to erect . . . any unusual image unless it has been approved by the bishop.*[65]

Before the end of the century several tracts attempted to discipline Counter-Reformation art. For the first time the decency of images became a major issue. Michelangelo's "Last Judgment" drew the most fire.

> *Who will dare to assert that it is right that, in the church of St. Peter . . . in Rome, where all the world meets together, in the chapel of the Pope . . . there should be painted so many naked figures, shamelessly uncovered both before and behind.*

Eighteen years after the figures' completion, Pope Paul IV ordered them clothed. Eight pontiffs later the painting was almost destroyed when El Greco offered to replace it with one "modest and decent, and no less well painted than the other."[66]

The Catholic Church continues its cautious sanction of images, always with a pastoral priority.

> *On condition that these modern arts steer a middle course between an excessive realism on the one hand and an exaggerated symbolism on the other, and take into account more the needs of the Christian community than the personal taste and judgement of the artist, they should be allowed full scope, if with due reverence and honor they put themselves at the service of our churches and sacred rites.*[67]

After Pope John Paul II found it necessary to denounce Jean-Luc Goddard's idiosyncratic film *Hail Mary* (1985), he led a radio broadcast of the rosary dedicated to "repairing the offense" of the film.

The pendulum has always swung back and forth in the struggle between the danger of idolatry and the need to spread the gospel, from "no one has seen God" to "the Word became flesh." Ananda Coomaraswamy knew that both Christianity and Buddhism require both iconography and iconoclasm. The mystic's vision of the absolute makes any icon superfluous, but "no one who still is anyone, can pretend to have outgrown all need of means."[68]

"If You Meet the Buddha, Kill Him."

In the centuries immediately preceding and following Gautama's life, Indians usually used only non-human religious signs and symbols. They did, however, portray minor deities such as tree-spirits as human figures, and their religions carried no explicit prohibition of images comparable to God's commandment to Israel.

Although several passages in Theravada scripture renounce sensuous beauty because it infringes on spiritual discipline, in all of early Buddhist literature only one text indicates proscription. A disciple turns to his master and says: "Lord of the World, since it is not permitted to make a likeness of the Buddha's body, I pray that the Buddha will grant that I make a likeness of his attendant bodhisattvas. Is that acceptable?"[69] The Buddha grants permission.

Two facts suggest that this single dissent in the early texts probably reflects actual Buddhist attitudes during the four centuries between Gautama's life and the beginning of the written tradition. First, quite simply, no figure of the Buddha has been found that can be dated with any certainty before the first century A.D. Second, the earliest known scenes of the Buddha's life, beginning in the second century B.C., show many of the people around him but indicate his presence only by his royal umbrella sheltering empty space, his footprint, his riderless horse, his vacant throne, a pillar of fire, the tree of his enlightenment, or the burial mound of his relics. The Buddha was probably first represented by these symbols because it was considered inappropriate, perhaps inconceivable, to portray the one who epitomized liberation from appearances as he had appeared. The presence revealed by this absence can be very moving.

For about two millennia, however, the sheer number of Buddha images throughout all of Asia indicate how significant they have become in clearing the Buddhist path. Many texts confirm this. We have referred to the story of the Buddha acknowledging the salute of his image that had been made for King Udayana. Tibetan tradition even remembers the Buddha about to enter final nirvana saying, "Set up representations of my body, that my teaching may endure and heretics be converted." An example from the *Lotus Sutra*: "Even boys in play who draw a picture of the Buddha with pieces of grass or wood, or a brush, or with the back of their fingernails, become able to accumulate merit."[70]

Buddhists have never known anything like the extremes of Christian iconoclasm. Not that Asia hasn't had provocation with its share of stories of images speaking, moving, curing, and protecting. Many "secret Buddhas" have been kept from view to prevent the powers inherent in them from being squandered. Nor have Buddhists failed to distinguish between idols and symbols. "[We] do not honor the clay as such, but . . . honor the deathless principles referred to in these images."[71] And, like Christians, Buddhists have usually ignored the distinction. But there has not been much polemic.

Zen, in "transmitting mind through mind," has leaned the furthest toward iconoclasm. No Buddhist tradition has so consistently kept its wealth of literature and painting in perspective. If often of great value, words and images are finally irrelevant scenery along the Zen path.

Even the Buddha himself is finally irrelevant. When a monk asked the master Ummon, "What is Buddha?" Ummon replied, "A shit-stick!" The founder of the Rinzai school of Zen

58
66

reputedly said, "If you meet the Buddha, kill him." Paintings showing the Sixth Patriarch tearing up Buddhist scripture help Zen Buddhists past the penultimate to enlightenment.

Since Buddha is made by your own nature, do not look for him outside your body. If you are deluded in your own nature, Buddha is then a sentient being; if you are awakened in your own nature, sentient beings are then Buddhas.[72]

54 In the popular story of a Chan master, the cheerful monk uses a temple's wooden Buddha image as fuel for his fire. The abbot rebukes him. The monk replies that since the image contains no sacred relic there is nothing special about it, and, besides, he is cold.

―――――――――――――――――――

Why fix in stone or paint the Victorious One who has "gone, gone, gone beyond, altogether gone beyond"? The mainstreams of Buddhism have three interrelated justifications. Buddha images remind Buddhists of Buddha and his teachings. Images also help bring meditators to single-minded focus and finally into identification with the reality to which the image points and in which it disappears. And the more popular and equally ancient Indian practice of veneration (*puja*) encourages respect and offerings to images as a way of gaining meritorious energy favorable to spiritual progress. Images help Buddhists through the conventional world of perception toward the wisdom that transcends all duality and substance. In Mahayana thought, when we overcome dualism and know that "form is emptiness, emptiness is form,"[73] we recognize the absolute as everything—even as a Buddha image.

5·
Resurgent Symbols

Prior to any known human representations of Buddha or Christ, other symbols indi-
cated their presence, and such symbols have persisted, with or without human figures,
suggesting something too complex, intense, and fluid to be expressed any other way.

Most symbols live only within specific cultural contexts. Mention lotus, and
many Christians think of computer softwear. For many Buddhists a crucifix is an
exhibit of torture and its veneration masochistic. Even within traditions responses
vary. Much of the complex symbolism developed by Indian Brahmins and European
scholastics was hardly appreciated by the craftsmen who made the images or by those
of other castes and classes who used them. In French bank windows Buddha has sug- 55
gested the wisdom of owning a Visa Card, while on London fences the rockers Jesus 56
and Mary Chain advertise their latest album.

Symbolic power fluctuates. Growing imperceptibly, it may condense the sacred
into art objects, ritual acts, or mythical stories; then slackening, it may evoke nostal-
gia or mere recognition; finally dying, it may become ornamental, only to revive, its
latent power invested with new meaning. The swastika, a variant of the primordial
cross within a circle and used widely in ancient times from Peru to India, probably
symbolized good fortune in the form of the whirling sun. It occasionally appears on
the Buddha's feet, chest, or lotus throne and on early Christian remains in Rome and 118
China. Until relatively recently it had lapsed into decoration.

A symbol's ability to function on several different levels of understanding,
the wealth of Buddhist and Christian symbolism, and the continuous existence
of many of these symbols since long before the two religions began has enabled
Buddha and Christ to appeal to all dimensions of human experience and to meet the
needs of the widest possible variety of people. Consider some of the most prominent
symbols.

Light, Circle, and Tree

Light

> *Sometimes when the sun gets up in the morning,*
> *he see that the weather is bad, so he goes to where it is good.74*

The earliest known halos stand behind second-century heads of the Buddha; around the middle of the fourth century they begin framing the head of Christ. Circles of light symbolizing glory and power, they may have come from the Iranian solar god, Mithra. Myths throughout the world equate the sun with divine power, fire festivals light the night from the Indian Dewali to the Jewish Hanukkah, and meditators from Mediterranean mystery cults to Eskimo shamans join psychedelic drug users in attesting to climactic moments of overwhelming radiance.

Light and darkness almost universally symbolize life and death, good and evil, the known and the unknown. The last words attributed to William Turner: "The sun is God." His *Angel Standing in the Sun* (1846; London, Tate Gallery) congeals the same energy that Vincent Van Gogh captured in sunflowers. In the earliest known representation of the sun god, he ascends between two mountains on an Akkadian cylinder seal dated about 2800 B.C.

Excavations made below St. Peter's Basilica in the 1950s in the hope of finding St. Peter's tomb revealed a cemetery, part pagan and part Christian, and on a curved vault the earliest known Christian mosaic. It portrays Christ as the invincible sun driving his horse-drawn chariot through the sky to light the world. Paintings at Mathura, India, and Bamiyan, Afghanistan, associate Buddha with Sura, the Indian solar diety. Associations of Buddha and Christ with light are inevitable and inexhaustible.

Many texts refer to the extraordinary radiance emanating from the Buddha. Vairocana, the Sun Buddha, illuminates the center of many mandalas. Amitabha, Buddha of the Pure Land, is "Infinite Light." Dipankara, the Buddha from unthinkable millions of years ago who inspired the Buddha for our eon to achieve nirvana, is the "Lightmaker."

The Sakya clan, and thus Sakyamuni, claimed descent from the sun. "When the preceptor was born on earth, a delightful light spread everywhere." He described the moment of his enlightenment: "Ignorance was dispelled, knowledge arose, darkness was dispelled, light arose." Images with flames flickering from his shoulders may recall this moment or any one of several miraculous instances when he effused fire. "The Divine Light of Buddha fills the entire universe . . . To understand our Divine Light is to meet and experience the real Buddha."75

The birthday of Christ was only finally fixed in the Roman calendar in the fourth century when December 25 was chosen to correspond with the winter solstice, the birth of Mithra, and other ancient celebrations of the sun's ascent. The whole liturgical cycle of Christmas centers on the coming of the divine light into the world and concludes when lustral processions of Candlemas commemorate Simeon's proclamation of Christ as "a light of revelation to the gentiles and a glory to the people of Israel."76

Easter Sunday, also tuned to the cycle of the sun, follows the first full moon after the spring equinox. As the priest lights the Paschal candle for the "mother of all vigils" he says, "May the light of Christ, rising in glory, dispel the darkness of our hearts and minds."

Throughout the Orthodox liturgy glory cohabits with light. Christ is *Phosdotos* (Giver of Light). An Epiphany Vesper hymn begins: "Today there shines the Sun that never sets and the world is sparking with the Light of the Lord."[77]

When Christ first spoke to the apostle Paul, he appeared as blinding light. Paul soon reminded the Church at Corinth:

> *For it is the God who said, "Let light shine out of darkness," who has shone in our*
> *hearts to give the light of the knowledge of the glory of God in the face of Christ.*

Gnostic descriptions of the resurrection portray the risen Lord only as light, or, as in one of Paul's accounts of his experience, as a voice from within a light. The Fourth Gospel begins by identifying Christ with "the true light that enlightens every man," and elaborates the imagery throughout. "Believe in the light, that you may become sons of light."[78] The Nicene Creed epithetizes Christ: "Light of Light." When Christianity first came to China the Chinese called it the "Luminous Religion."

Christ in majesty frequently holds the Book of Life open to his words "I am the light of the world," and Buddha is never more exalted than when, sitting before thousands of millions of beings throughout vast Buddha-fields in the opening vision of the *Lotus Sutra*, he sends a ray of light from his *urna* to illuminate the universe. As personified light Buddha and Christ sometimes emit such radiance as to surround their entire bodies in variously shaped aureoles, but the seminal shape of this glory is circular.

80

81, 83

Circle

> *God is the intelligible sphere whose center is everywhere*
> *and whose circumference is nowhere.*[79]

Without beginning or end, the circle is the most self-evident symbol of unity, universality, security, wholeness, emptiness, simultaneity, and recurrence. An expanded dot, it generates energy. It is both constant movement and complete fulfillment. It is sun, moon, earth, eye, zero, the first organized shape a child draws, and the mandala's final integration.

Mandala (literally, "circle") means, a Buddhist tantra says, "to surround any prominent facet of reality with beauty."[80] About the time the rose was becoming a symbol of human passion and divine love in Europe, the rose window blossomed out of decorative rosettes—originally probably sacred symbols of the sun—and Romanesque wheel windows into a Christian mandala of incredible complexity. The radiation of light both diffuses and concentrates attention in a centrifugal storm of colors and forms.

112

113

Stand in Chartres Cathedral at the crossing of the transept and nave to see the three great stone flowers of the Virgin. The rose is the Virgin's emblem, Chartres her most glorious shrine. Even the guides, the best of them, having explained the significance of some extraordinary sculpture and glass, become silent as these sunbursts move forward to dominate everything—inexplicable exploding circles of light.

People everywhere have used a limited number of symbols to portray the geometry of the sacred. Stupas and Byzantine churches coordinate square and circle as earth and heaven.

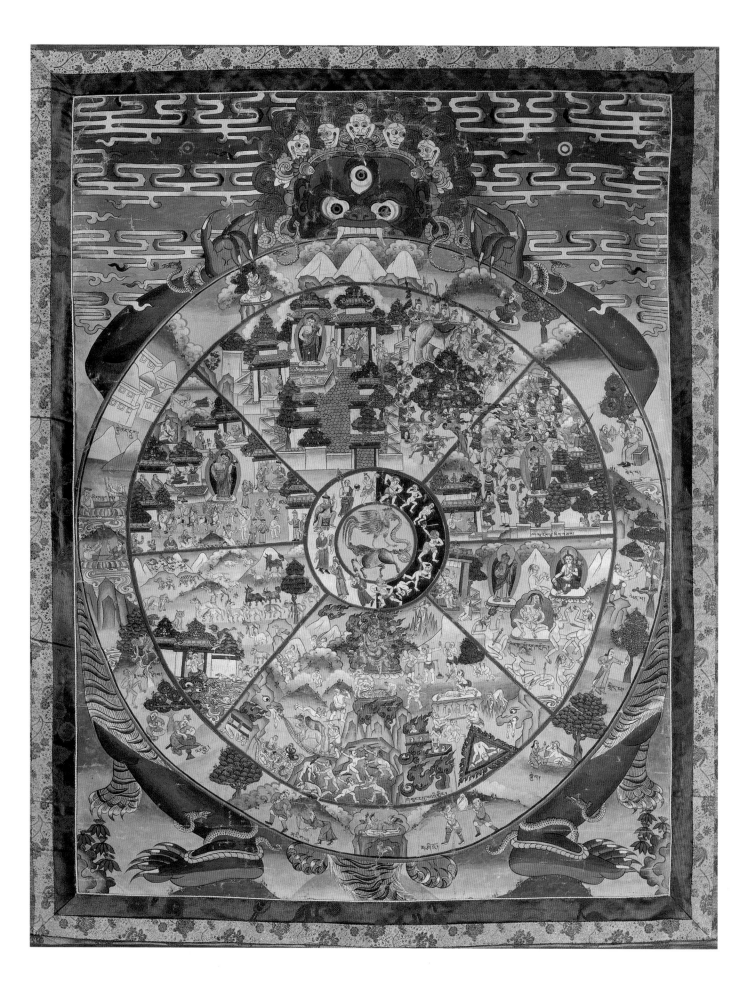

Fig. 60
Thousand Buddhas.
7th century, Longmen,
China. Author's photo

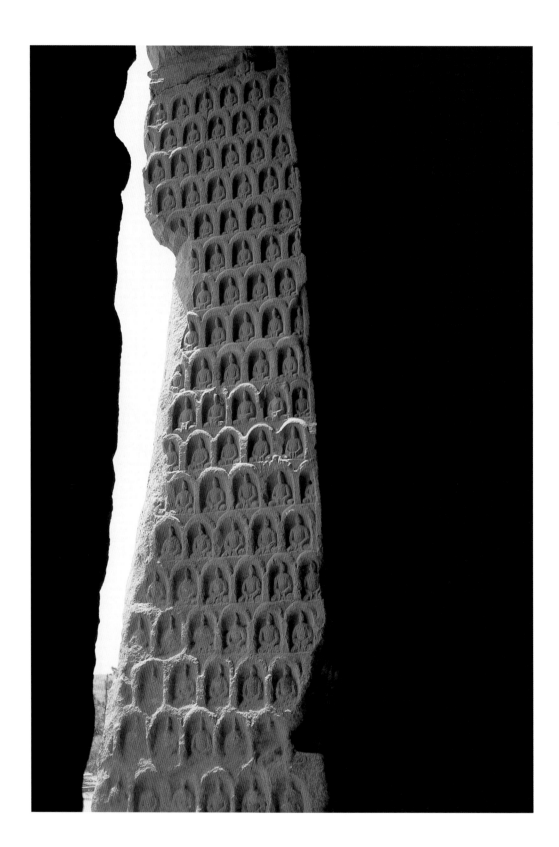

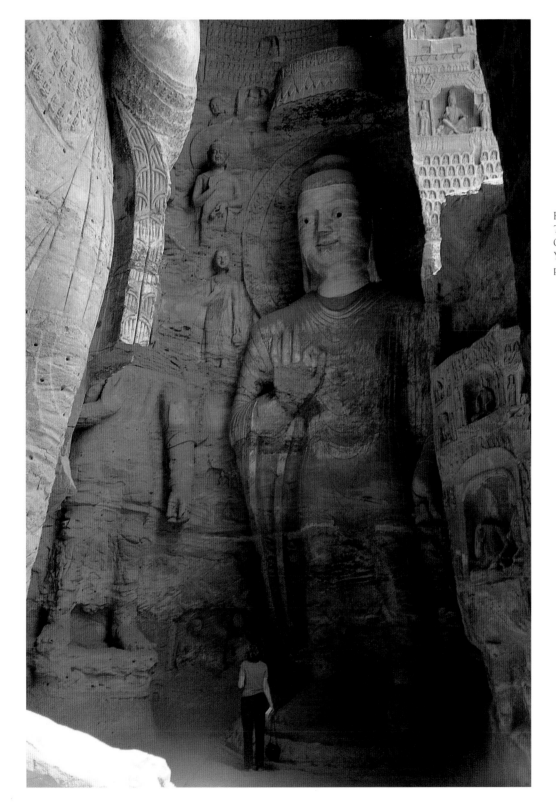

FIG. 61
*Thousand Buddhas and
Colossal Buddha.* 6th century,
Yungang, China. Author's
photo

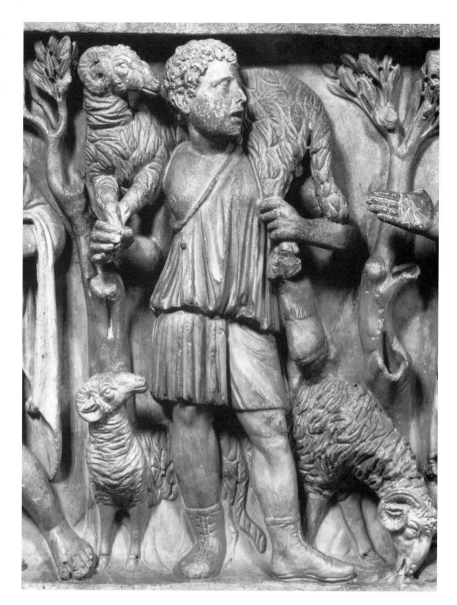

Fig. 62
Good Shepherd. 3rd century, Rome. Museo Pio Cristiano, Vatican. Photo: Hirmer Verlag

Fig. 63
Fish and Loaves. 3rd century, Catacomb of St. Callistus, Rome. Photo: Scala/Art Resource, N.Y.

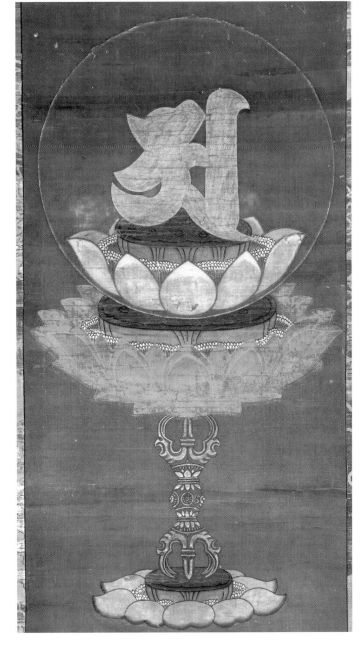

Fig. 64
Sanskrit Syllable "A." 18th century, Japan. William Sturgis Bigelow Collection, courtesy Museum of Fine Arts, Boston. Copyright 1999 Museum of Fine Arts, Boston.

Fig. 65
Chi Rho, detail of Sarcophagus of Domitilla. 4th century, Rome. Museo Pio Cristiano, Vatican. Photo: Scala/Art Resource, N.Y.

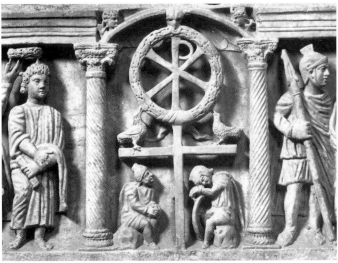

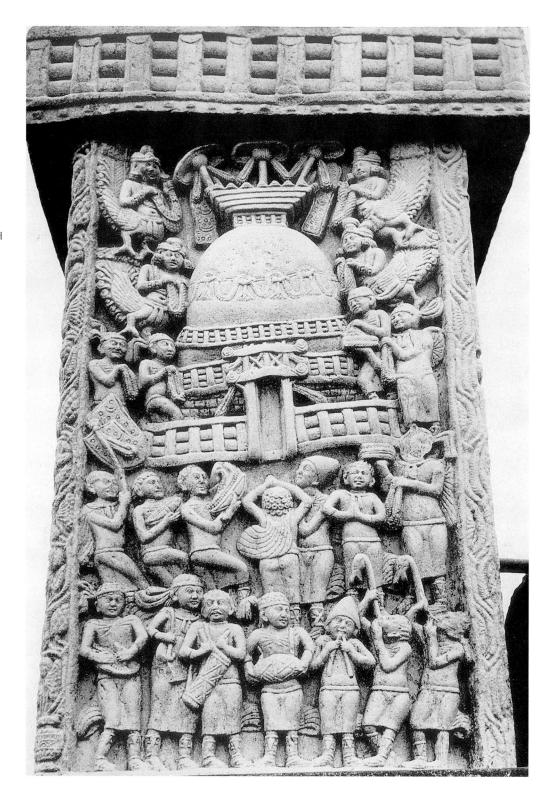

F<small>IG</small>. 66
Adoration of the Stupa. 1st-2nd
century B.C. Sanchi, Madhya
Pradesh, India. Photo:
Heinrich Zimmer, *Art of
Indian Asia*, Vol. II, 1955

F<small>IG</small>. 67 (<small>OPPOSITE</small>)
Adoration of the Lamb, detail
of the *Ghent Altarpiece.*
Hubert and Jan van Eyck,
1432. St. Bavon Cathedral,
Ghent, Belgium. Photo:
Scala/Art Resource, N.Y.

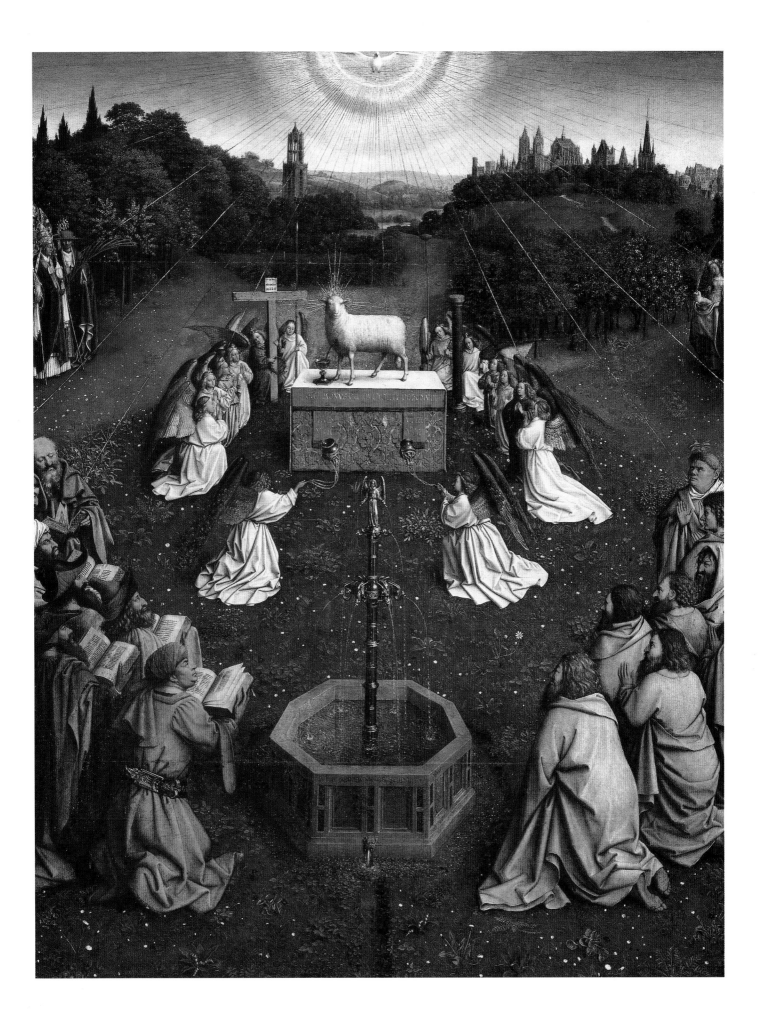

51

We have seen the Byzantine model of three concentric circles delineate Christ's head. An encircled Christ frequently illuminates the center of a cross, the signs of the zodiac, and emblems of paradise. A circle connects the arms of the Celtic cross. Three interlocking circles symbolize the Holy Trinity.

Buddhists usually see the circle as a wheel. Long pre-Buddhist Indian traditions of sun wheels represent both the perpetual motion of rebirth and Cakravartin, the world ruler who rolls his wheel before his armies, giving him dominion over the world, as the sun dominates all space. A solar wheel still flies at the center of the flag of the Republic of India. Wheels appear on the earliest known Buddhist monuments and they remain a preeminent Buddhist emblem.

77

21

Buddha set the "Wheel of Dharma" turning in Deer Park at Sarnath. Two deer with a wheel symbolize this place of his first teaching. We have referred to the Buddha's teaching gesture (the *dharmacakra*): his fingers form the circles of the turning wheel. The wheel symbolizes both the teaching and the teacher. Wheels mark the palms of the Buddha's hands and the soles of his feet—always, even if we do not see them: they are among his thirty-two auspicious marks.

77

57

Buddhist wheels take many forms. Multi-spoked, they are Cakravartin's thousand-rayed sun wheel with which the Buddha asserts his temporal and spiritual authority. Later wheels usually have fewer spokes. Eight spokes suggest the eight-fold path of the Dharma. The relatively complex Tibetan "Wheel of Life" has around its center a pig, a cock, and a snake (greed, hatred, and delusion) each grasping the one in front to continuously turn three concentric circles. Within the first, people either improve as they move upward in the light or deteriorate as they tumble down in the dark. The next circle divides into the six realms of rebirth—peaceful gods, wrathful gods, restless ghosts, hot and cold hells, animals, and humans—each with its image of a Buddha or *bodhisattva* assuring eventual liberation from every realm. Finally, around the rim figures depict the twelve links in the chain of causation, beginning with ignorance, moving through life to decay and death, and so back to ignorance. The demon of life and death grasps the ever-turning wheel as he devours it. In the Mahayana view of the sameness of the phenomenal world and nirvana, the "Wheel of Life" and the "Wheel of Dharma" complement each other as ways to the center, where all multiples contract in the axial hub of Emptiness.

Wheels seldom turn with symbolic significance in the Bible. Biblical time moves from a beginning to an end rather than in cyclical recurrence. In two great visions, however, the Almighty sits on a blazing chariot throne, like such sun-gods as Apollo and Mithra: Daniel (7:9-11) beholds God's throne with wheels of burning fire, and Ezekiel (1:15-28) sees him above glittering wheels with rims full of eyes. Although this solar imagery plays no part in the New Testament, when the early Christians encircled the first two intersected letters of Χριστός (Christ) as ✸ or the initials of Ιησοῦς Χριστός (Jesus Christ) as ✸, they let all the power of the invincible sun suffuse the six-spoked monograms of their savior.

65

In later Christian painting, a wheel usually signifies the martyrdom of St. Catherine of Alexandria. Or it is the "Wheel of Fortune" moving humanity inexorably through the vicissitudes of life. Occasionally, however, the wheel's central axis signifies the Creator and its spokes the multiplicity of the created world contained within the unity of the rim's circumference. When Dante's imagination finally fails in his vision of paradise, his will, "like

a wheel whose circling nothing jars," merges with "the Love that moves the sun and the other stars."[81]

Tree

> *Then I was standing on the highest mountain of them all, and round about beneath me was the whole hoop of the world . . . And I saw the sacred hoop of my people was one of the many hoops that made one circle, wide as daylight and as starlight, and in the center grew one mighty flowering tree to shelter all the children of one mother and one father. And I saw that it was holy.*[82]

The tree of life grows throughout the world as the principal symbol of cosmic centering and regeneration. Continually reborn through its seed at the world axis, its roots thrust down through the earth to the underworld, its trunk rises through the world, where it grasps everything in its immeasurable arms, and its crown glances heaven. Jack's beanstalk is a folk analogue.

Early Indian scriptures portray Brahman as an inverted tree with roots on high and branches below cradling the world. God instructed Moses to make the original golden menorah according to the six-branched image of the sacred tree familiar in the ancient Near East. The Bodhi tree and Christ's cross are cosmic trees.

The denuded tree on which Christ hung was made from the wood of Eden's Tree of Knowledge. Life was thus fulfilled on the tree through which death had come, and the Tree of Knowledge assimilated to the Tree of Life. The tree planted at Golgotha, the site of Adam's tomb, on Friday, the day when Adam was created, stands between the Tree of Life in Paradise at the beginning of time and the Tree of Life in the Heavenly City of Jerusalem at the end of time. Medieval representations of the cross frequently portray its cosmic dimension: its roots from a skull, its top in the heavens, its branches providing ascent.

As "Refuge Trees" portray the lineages through which Tibetan Buddhist teachings are transmitted, the "Tree of Jesse" traces Christ's ancestry from King David's father, often through vine foliage allusive to him who said, "I am the vine, you are the branches." Christ finally is the Tree, as in a Syriac text:

> *The altar signifies to us Emmanuel himself, who is the tree of life.*
> *The bread and wine which are upon it [signify] the body of God the Word*
> *. . . and they are the fruits of the tree of life.*[83]

Although biblical references suggest the prevalence of tree cults surrounding and infiltrating ancient Israel, tree worship was an even more common feature of pre-Buddhist India. A young woman who approached the Bodhi Tree mistook the Buddha sitting under it for a tree spirit. Born beneath a sal tree whose branch bent down to come within his mother's reach, the Buddha died between sal trees whose flowers fell out of season to cover his body. His auspicious marks prescribe his proportions: the symmetry of a banyan tree.

Each of Sakyamuni Buddha's predecessors became enlightened under a distinctive species of Bodhi Tree. At the moment he was born, Sakyamuni's fig tree sprang up at

7

23

58

Bodhgaya, just south of the ancient town of Gaya in present-day Bihar. Pilgrims have always taken souvenirs from this preeminent Buddhist pilgrimage site, and the most prized has been the most common: a dark, shiny, heart-shaped, drip-tailed leaf from the tree itself.

The sacred tree at Anuradhapura, Sri Lanka, is regarded as an outgrowth of a sapling taken from Bodhgaya and brought to the island in the third century B.C. Bodhi Trees in monasteries throughout Southeast Asia have grown from its seeds. The Bodhi Tree in Amida Buddha's Pure Land is "always in flower . . . adorned with hundreds of golden chains . . . strings of rose pearls and strings of black pearls."[84] Those who see it are free from disease, those who meditate on it will be enlightened.

The tree of the cross and of enlightenment are the same tree. It centers the world, growing everywhere and always, wherever and whenever one is transformed, awakened, made whole.

Colossal and Multiple Buddhas & the Buddha as Lotus and Vajra

Colossal and Multiple

I am large, I contain multitudes.[85]

Reflecting on his commission for Coventry Cathedral, Graham Sutherland wrote, "I wanted to do a large figure like a Buddha or one of the Egyptian figures in the Valley of the Kings."[86] His almost seventy-five foot tapestry reredos of Christ in Glory (1962) now dominates the building the way the almost 100-foot Christ the Redeemer (1931) on the peak of Corcovado succors the whole of Rio.

But the Buddha is even more susceptible to gigantic scale. In Afghanistan two enormous Buddhas—one 120 feet, the other 180—still stand in the sandstone cliffs from which they were cut in the sixth or seventh century, visible for miles across the Bamiyan valley. And travelers arriving at Japan's Narita airport can see in the distance one of the world's largest statues: a bronze Amida Buddha (1994), almost four times the height of Rio's Christ.

61, 27, 90

Between ancient Bamiyan and modern Narita an astonishing number of colossal Buddhas stand, sit, or recline.

When we confront colossal images our familiar perception patterns collapse. The sudden change of scale throws us into a different order of reality. A five-foot thumb is a transcendental thumb. Little wonder Gautama Buddha was thought to have been extraordinarily tall and Buddhists imagine Maitreya, the Buddha of the age to come, as well as the human beings of that age, as much larger than humans of our experience.

Mahayana Buddhists borrowed the Hindu tradition of giving deities multiple body parts to symbolize their various functions extending throughout the universe. Several heads may suggest more wisdom and compassion than one head could possibly contain. Avalokitesvara,

the *bodhisattva* of perfect compassion, frequently has eleven heads and from four to a thousand arms. His many hands provided with as many eyes, he can see and do whatever is necessary to lead everyone to salvation.

A few two-headed Buddha figures have been found in central Asia. Their significance remains unknown. But many images portray the miracle at Sravasti when the Buddha multiplied himself in several directions to demonstrate his power. And when the "Thousand Buddhas" sit in rows—often hundreds of small figures, either identical or alternating in gesture or robe—they reflect the Mahayana vision of an infinite number of worlds, each with its Buddha. He is everywhere, all the time. Mahayana Buddhists have from five to nine Medicine Buddhas to care for any physical and mental illness and thirty-five Confession Buddhas for our more numerous spiritual ailments, just as Catholic and Orthodox Christians invoke a heavenly host of angels and saints.

60

Caves concentrate the spiritual momentum of size and multitude. Every cave abbreviates the world: the vault is the sky, the patch of ground the earth. A cave is both the womb of the world promising life and passage to the underworld and death. Wall paintings indicate the sanctity of caves in Paleolithic times.

At Ajanta, India, twenty-nine rock-cut sanctuaries abound in fifth and sixth-century Buddha images: reliefs cut into the rock, large cult figures at the furthest end of some caves, welcoming figures on the facades of others, and the oldest surviving Indian painting. Cave sculpture and painting trace the Buddha's passage from India across the ancient trade routes of Central Asia to China. At Longmen alone, more than forty caves shelter more than 100,000 images, ranging in size from less than an inch to more than fifty-five feet. Of the hundreds of Buddhist cave sites throughout China, those at Longmen and Yungang are especially renowned for their sculpture. At Longmen, where the harder stone is more amenable to carving detail, some of the figures are masterpieces. But when standing in one of the earlier caves at Yungang with only the heavy blocky volumes of a gigantic Buddha filling the small cup of earth with his all-encompassing presence, the world and all of its art ebbs out of mind.

86
61

Lotus

> *All birth, all coming into existence, is in fact 'a being established in the Waters . . .'*
> *He who stands or sits upon the Lotus 'lives.'*[87]

The lotus flower is an ancient symbol rising from Egypt to China. Opening at dawn with the sun, it forms a circle, a wheel, its petals expanding in every direction. Closing in the evening, it suggests the endless cycle of rebirth. It is the birth of something in the infinite sea of possibility.

In Hindu tradition the cosmic waters grew a thousand-petalled golden lotus at the beginning of creation: it opened to give birth to Brahma. Not only the generative origin of the universe, in the ever-present equation of macrocosm with microcosm the lotus is the "depository of consciousness": visualize the subtle centers of our bodies and they take lotus-form.

Buddha frequently sits or stands on this frail flower. Buddhists consider the lotus growing from muddy darkness through the water, opening beyond the surface, unsullied by the elements, an especially appropriate metaphor for Buddha's arising in the world unaffected by desire and illusion.

95

7

On the night the Buddha entered his mother's womb a stalk rose from the water below the earth, penetrated the earth, and bore a lotus in Brahma's heaven. A lotus sprang up from the print of each of the Buddha's first seven steps. His eyes and tongue resemble a lotus petal, his teeth the stem of a lotus. At the creation of the world the primal Adi-Buddha revealed himself in a flame issuing from a lotus flower, and in a pond in Amitabha Buddha's Western Paradise a lotus bud rises to the surface whenever a Buddhist is born, to bloom or fade according to the life he leads. A lotus blossom offered to the Buddha signifies the surrender of the Buddhist to the Buddha.

Whether eight-petalled, pointing to the four cardinal and intermediate directions, and suggesting the eight-fold path to enlightenment, or multi-petalled, suggesting the thousand-rayed sun wheel; whether red, white, or blue—the red associated with compassion, the white with purity, the blue (always in bud, its center never seen) with wisdom—whatever its form, the lotus grounds our being in the unchartered seas of cosmic geography and in every individual undimensioned point of consciousness where all time and space are focused.

70

Personifications of the lotus, the goddess Padma, stand on the gates and railings of the earliest known Buddhist monuments. The lotus lends its name to more than fifteen Buddhas, deities, and *bodhisattvas*, as well as to the fundamental yogic posture (*padmasana*) and a basic ritual gesture (*padmanka-mudra*), one of the world ages (*paduma kalpa*) and one of the cold hells (*Mahapadma*), the venerated founder of Tibetan Buddhism (*Padmasamb-hava*), and the most influential of all Mahayana texts (*Saddharmapundarika*, popularly called the *Lotus Sutra*). The embodiments of compassion—Amitabha, Avalokitesvara, Guanyin, and Tara,—associate themselves with the lotus. Tara was born from a lotus floating in a tear on the face of Avalokitesvara. The personification of wisdom, Prajnaparamita, usually sits with a lotus on a lotus in the lotus position. With patterns of petals in concentric circles, lotuses adorn Buddhist monuments everywhere.

84, 36, 37

All Buddha images may be understood as transformations of the lotus.

Vajra

> O Lord! Tell us of that quiddity comprised of the Vajra essence,
> The All Tathagata Secret, that Unity of secret origin.[88]

From Sumer, Babylonia, and Assyria the voice of the sky gods became the scepter of Zeus and Indra. The thunderbolt (*vajra*), although not in the company of the major early Buddhist symbols of wheel, tree, and lotus, finally gave its name to the whole tantric branch of Buddhism: Vajrayana. Vajrasattva or Vajradhara, the personification of the *vajra*, is the supreme tantric transcendent Buddha. Vajrapani, thunderbolt in hand, serves as Sakyamuni's special guardian. Later, as a fully developed terrifying *bodhisattva*, he and his fierce family combat demons and guard the Dharma.

39

70

Originally weapons, the earliest *vajras* resemble a club with blunt edges, or they have a single sharply pointed prong on either end of the grip. The typical *vajra* stem corresponds to the vertical axis of the universe. From it two lotus blossoms grow, each culminating in from one to nine prongs that converge in the unity of a point. The widely used three-pronged

118

64

variation may represent the three mysteries (act, word, and thought) or the three jewels (Buddha, Dharma, Sangha); five prongs, the most common, may signify the five cosmic Buddhas or the five elements. Crossed *vajras* suggest the Dharma wheel.

Tantric ritual frequently requires a *vajra* held in the right hand, symbolizing masculine energy as compassionate action, and a bell held in the left hand, symbolizing feminine energy as the wisdom of Emptiness. Vajra-handled bells represent the union of this compassion and wisdom. The "rolling of the Dharma thunder" spreads the teaching of liberation to all living beings.

The thunderbolt reduced to its hardest constituency is synonymous with the hardest of gems: *vajra* also means "diamond," and this is the primary symbolism of Vajrayana (the Diamond Vehicle). Clear and pure, itself colorless, the diamond produces all colors. Itself impenetrable, it cuts anything. Physically represented as Buddha's scepter, the emblem of the immutable power of his wisdom shatters all illusion. Buddhas achieve enlightenment while sitting beneath the Bodhi Tree on the Diamond Seat at the immovable center of the world. As the parabolic *Lotus Sutra* has flourished in East Asia, the brief paradoxical *Diamond Sutra* has become especially popular in the West.

118

Fragile feminine lotus and adamantine masculine sceptre—no greater contrast can be imagined in symbolizing the reconciler of all opposites. "Hail jewel in the lotus! Amen."[89]

Christ as Bread and Wine, Fish, Lamb, and Shepherd

Bread and Wine

> There is another food which bestows salvation and life,
> another food which both commits and restores man to God Most-high,
> another food which relieves the sick, recalls the wandering, raises the fallen . . . [90]

Known in the early Church as the "Lord's Supper" or the "Eucharist" (thanksgiving), then as the "Mass," the "Divine Liturgy," or "Holy Communion," the sacrament has as many interpretations as names. In the consecrated elements of bread and wine, Christians see Christ himself: the bread transubstantiated into his body, the wine into his blood. Or with less radical perceptions of reality, they see Christ present with the bread and wine, or in their own minds, or in the whole Church. For all, the heart of the sacrament is the living presence of Christ. It is he who at every consecration of the elements speaks through the person officiating, as the bread and wine and all participants in faith become his one, eternal, mystical body.

The taking of bread and wine soon became the central act of Christian worship. Liturgical practices undoubtedly influenced the biblical accounts of Jesus' last supper. In the earliest reference, Paul's first letter to the Corinthians, Jesus anticipates his imminent death by breaking bread, saying: "This is my body which is broken for you. Do this in remembrance of me . . . This cup is the new covenant in my blood." Paul reminds the Church "as often as you eat this bread and drink this cup, you proclaim the Lord's death until he comes."[91]

Nothing unites people, and people and their god, more than eating and drinking. The origins of sacred meals are rooted in animism, wherein families and religious fellowships consumed the power of deity in a common meal. Bread was the basic food in biblical lands, wine a common beverage in an area where water was scarce, and both were readily available wherever the faith spread. Both had long histories of symbolic and ritual significance as offerings of the earth and human cultivation: bread the means of physical subsistence, wine the stimulant of the spirit. The one who said "I am the bread of life; he who comes to me shall not hunger," and "I am the vine, you are the branches"[92] finally made of bread his body broken and of wine his blood poured out. An informed eye sees the grain in paintings of the Nativity or the grapes held by the Christ Child as intimations of the death that seals the covenant of new life.

Pictorial representations of the Last Supper portray Christ and the disciples lying or sitting around a table according to prevailing table manners. Most people now instinctively see the event in a Renaissance dining room, the way Leonardo da Vinci painted it. Christ has just told his disciples that one of them will betray him. Isolated and serene amid their agitated reaction, only his gesture toward the bread and wine before him anticipates the sacrament.

In the more liturgical compositions of the "Apostles' Communion," more common in the Orthodox Church, Christ stands before the apostles and hands the bread or the chalice to one of them. Or he is represented twice in the same composition standing behind an altar offering one of the elements to each of two groups of apostles.

Whether at table or altar, Christians not only see in the bread and wine the offering of Christ, they offer themselves through God's grace in what the Scottish reformers simply called "the Action."

Fish

> *But we small fish, thus named after our great Icthus Jesus Christ,*
> *are born in water and only by remaining in water can we live."*[93]

Fish are an almost universal symbol. They were associated with the life-force in the primordial waters and the fertility of the great goddesses. They were sacred all around the Mediterranean and revered totems among primitive societies in Oceania, Africa, and the Americas. In his incarnation as a fish Vishnu led the first human through the world flood to safety. As one of the eight auspicious signs of Chinese and Tibetan Buddhism, two golden fish swim free of all attachments. Fish probably came into Christianity through the multiple Jewish symbolism of the faithful as little fish swimming in the Torah, the Messiah as the great fish, and a Messianic meal with fish as the foretaste of immortality.

Drawings of fish are among the earliest symbols in the Roman catacombs. At about the same time as these drawings, when the meaning of both the liturgy and pictorial representations was deliberately hidden from the uninitiated, Christians saw the Greek word *IXΘΥΣ* (fish) as an acronym for *Ιησοῦς Χριστός Θεοῦ Υιός Σωτήρ* (Jesus Christ, Son of God, Savior). They put the drawing or the word on their cups, lamps, gems, and rings, on their funeral monuments, on the doors of their homes, and on the walls of their baptisteries and basilicas.

The fish symbolized both Christ and his followers. He who had descended into the abyss of the waters of the world to redeem floundering humanity would make his disciples "fishers of men."

Fish were associated with the two main sacraments. As Christ had stood in the water of the Jordan at his baptism when the Spirit of God descended on him, baptized Christians, immersed in a fish-pond *(piscena)*, swam cleansed of their sin in the living water of their new life in Christ. And when Christ had miraculously multiplied the bread and fish to feed the multitude near the Sea of Galilee he had prefigured the Eucharist. At his resurrection breakfast by the same Sea, he gave the same food to his disciples.

Early cemetery murals and sarcophagi sculpture characteristically represent the Eucharist simply with loaves of bread and one or two fish, or Christ stands between two disciples who hold bread and fish for him to bless, or several disciples sit or recline at a table bearing bread and fish. The catacombs also preserve paintings of the deceased at the meal anticipated by the Eucharist—the heavenly banquet of fish and wine.

After the fifth century the fish declined as a baptismal symbol, and as representations of the Last Supper began displacing the more veiled symbols of the Eucharist, fish only occasionally continued in the place of the designated ritual elements of bread and wine. In the earliest known mosaic of the event (early sixth century; Ravenna, S. Apollinare Nuovo), our attention divides between Christ lying at the side of the table and the food he is to become, the large Christ-fish at the center of the mosaic.

A fish carrying a ship on its back symbolizes Christ and his Church. When assimilated into astrological beliefs, Christ becomes the first fish of the last age, the Pisces aeon. On today's automobiles a bumper-sticker fish tells us a Christian is driving.

Lamb

And was the holy Lamb of God on England's pleasant pastures seen?[94]

The fish, lion, ox, stag, ram, ass, rooster, pelican, heron, eagle, goldfinch, dolphin, griffin, unicorn, and phoenix have symbolized Christ. But the sacrificial lamb is the most obvious animal form of the crucified innocent. "Behold the Lamb of God", John the Baptist says when he sees Christ coming toward him.[95]

Lambs manifest the power of spring. Nomads sacrificed the first lamb of their flocks to their gods to assure the continuance of this annual renewal. The Jews particularized the sacrifice when they remembered their forefathers marking their doorposts with the blood of a lamb so the Lord would pass over them when killing Egypt's firstborn. The Paschal Lamb eaten to commemorate deliverance from Egyptian slavery became the Christian Eucharistic Lamb eaten for freedom from bondage to sin. "Like a lamb that is led to the slaughter," Christ dies for our transgressions. Bread used in the Orthodox Liturgy is called the Lamb. In preparing the celebration a priest pierces it, saying: "one of the soldiers pierced his side with a spear."[96]

This Lamb is God's offering, not ours. Slain by us, he is exalted by God. In the final book of scripture John of Patmos hears angels:

> thousands of thousands, saying with a loud voice, "Worthy is the Lamb who was slain,
> to receive power and wealth and wisdom and might and honor and glory and blessing!"[97]

28

Emblematic of sacrificial death, the Lamb's blood flows into a chalice; in triumphant resurrection, he holds a white banner emblazoned with a red cross. The apocalyptic Lamb with seven horns and seven eyes (power and knowledge) brings victory in the war against the powers of evil, and judgment on the day of his wrath. Finally, with the marriage of the Lamb and his Bride (the Church), the Lamb shows his original gentleness, leading the faithful to springs of living water.

On the mountain of Paradise or on a sacred throne, imbedded in a cross or in sacramental bread—allegory seemed ready to consume history. The Council of Constantinople in 692 decreed that "Christ our God . . . should henceforward be set up in human form on images also, in the place of the ancient lamb."[98] Thereafter the lamb almost disappeared from Byzantine art.

67

The Pope, however, did not accept the Council's authority and the symbol of the triumphant innocent continued as a figure of Christ in the West, nowhere more gloriously than in Hubert and Jan van Eyck's *Ghent Altarpiece*. Beneath the Dove of the Holy Spirit in a radiant sun the eucharistic Lamb stands on an altar pouring his blood into a chalice while looking directly at us over the Fountain of Life. Around this axis four angels hold the instruments of his passion, eight kneel in adoration, two swing thuribles. The whole authority of the Church—patriarchs, prophets, apostles, ecclesiastics, holy maidens, judges, knights, hermits, and pilgrims—moves toward the Lamb: a vision of the paradise of eternal adoration in the garden of God.

Chocolate flag-bearing lambs in Easter shop windows suggest the precariousness of a pastoral symbol in a technological world. But every mass affirms its persistence: "O Lamb of God, who takes away the sins of the world, have mercy upon us."

Shepherd

Know me, my keeper my shepherd, take me to Thee.[99]

The early Christians saw around them the Greek ram-bearing messenger god Hermes and faithful shepherds in popular Hellenistic scenes of country life. The image of shepherd pulses through the Bible from Abel, the first shepherd, to Moses tending his father-in-law's sheep in Midian; from young David defending his father's flocks near Bethlehem, to shepherds in the same fields hearing angelic news of a great joy and going to see the child who would become Shepherd. Hebrew prophets and poets reminded kings that they were shepherds of their subjects and sang of the shepherd-God who feeds, gathers, and guides his flock. As Christ is both fish and fisherman, he is both Lamb of God and Good Shepherd.

Jesus taught of his life with sinners as searching for the lost sheep, of bringing those not within the fold of Judaism into the one flock with one shepherd, of laying down his life for his sheep, of the scattering of the sheep when the shepherd is smitten, and of coming at the final judgment to separate the sheep from the goats. He charged Peter: "Feed my sheep." And the apostle was soon writing to dispersed Christian communities: "You were straying like sheep, but have now returned to the Shepherd and Guardian of your souls . . . And when the chief Shepherd is manifested you will obtain the unfading crown of glory."[100]

The shepherd is among the earliest images of Christ, and during the Church's first four centuries it remained his most popular representation. The boy bearing a sheep on his shoulders appears about 120 times in the catacombs; he is a frequent subject on sarcophagi and the subject of several statuettes; he carries an oversize sheep in the earliest known baptistery painting (ca. 240, Dura-Europos; New Haven, Yale University Art Gallery). Usually in a short tunic with one shoulder bare, occasionally standing or sitting with his sheep in the garden of paradise, he symbolizes deliverance into the peace of the redeemed.

Then, when the church became visibly triumphant, this youthful, essentially defensive figure lost significance and almost vanished. When revived in the fifteenth century, literary references indicate earlier pastoral associations absorbed in images of benevolent authority and submissive obedience. Bishops still walk with shepherd's crooks.

Is Picasso's monumental bronze *Man with Sheep* (1944; Paris, Musee Picasso) the Good Shepherd? Picasso denied any symbolic intentions, and reliefs of men bearing sheep antedate Christ by at least a thousand years. We see what we bring.

Buddha's Stupa and the Cross of Christ

Stupa

> *After its rising, the stupa . . . stood in the sky sparkling . . . decorated with five thousand successive terraces of flowers, adorned with many thousands of arches, embellished by thousands of banners and triumphal streamers, hung with thousands of jewel-garlands . . . and emitting the scent of Xanthochymus and sandal, which scent filled the whole world . . . Let my stupa here, this stupa of my proper bodily form, arise wherever in any Buddha-field in the ten directions of space, in all worlds . . . the Lotus of the True Law is being preached by some Lord Buddha or another.*[101]

Burial mounds as relic chambers were sacred throughout the ancient world. According to tradition, the Buddha ordered his relics enshrined in such a mound (known to Buddhists as *stupa*), his ashes were divided among eight of them, and two centuries later Asoka opened these to distribute the relics to the 84,000 stupas he had erected throughout his empire.

The stupa became a spiritual powerhouse. Like the cross, its very abstraction makes it one of the most exact impersonal symbols of the sacred, but with complex, varied, and now often uncertain references.

Early stupas were usually surrounded by a fence separating the sacred place from the profane world. Entering one of four gates (at the four cardinal directions), the devout circumambulate a hemispherical mound of brick or stone (center, container, and source: cosmic egg and womb, turning wheel and unfolding lotus), keeping it always on the right (following the course of the sun, and the favored, clean, masculine side). From a rectangular structure at the top of the dome (alternately a fire altar, gods' seat, relic container, or railing around the sacred tree) a central shaft rises from the foundation to emerge as a spire (axial pillar: the world tree and tip of the cosmic mountain connecting the earth with all other

66

realms of existence) supporting one or more usually flattened umbrellas (insignia of royal protection and, perhaps, suggesting the upper heavens). Foundation and crowning ritual deposits of relics, seeds, jewels, coins, or scripture bring the stupa to life.

The stupa's form has been endlessly elaborated. Emphasizing vertical movement, the dome recedes as it rises from a square, stepped, pyramid-shaped base, preeminently in the temple mountains of Java and Cambodia. In East Asia the dome disappears as the central pillar expands into a many-tiered rectilinear tower usually called a "pagoda." In Nepal all-seeing eyes survey the four directions from the square that joins the dome and spire. The symbolism of the center remains constant: every stupa envelops the axis of the world.

Throughout the Buddhist world a great variety of miniature stupas serve as reliquaries, incense holders, or votive offerings. Emphasizing either the dome or the spire, they often incorporate such symbols as the lotus, the sun-moon, the pearl drop of unifed opposites, or the vase of enlightenment's plenitude and emptiness. Especially popular in Japan as tomb-stones, stupas superimpose the five physical elements—cube (earth), sphere (water), pyra-mid (fire), hemisphere (air), and jewel (ether or space), each element associated with one of the five cosmic Buddhas.

Whatever the form, when Buddhists see stupas mindfully they not only venerate Buddha's physical manifestation, they identify with the living, universal Dharma, much as Christians when venerating the cross see both the crucified and risen Lord.

Cross

> *Life is but the shadow thrown by the cross of Christ,*
> *outside that shadow is death.*[102]

In the pre-Christian world the cross appears everywhere. It is among the oldest and most rudimentary marks of the species, and no one knows its earliest significance. Most generally, it brought order out of chaos, whether as a simple mark of identity or as a cosmic symbol, its vertical and horizontal lines spanning the universe. At the center of the cross everything has its origin. To the center everything returns. In the formless center point all opposites are reconciled. Poets recognized the cross in such constants as mast and yard, warp and woof, birds flying, and the plow. Christians brought all the density of this symbol into an historical event when they turned a common Roman instrument of death into their symbol of victory, signing themselves with the cross "at every step, at every movement, at every coming in and going out."[103]

Few Old Testament references to wood were safe from the Church Fathers' ability to see in them harbingers of the cross. Noah's ark, Jacob's ladder, Moses' rod, even the wood for Isaac's burnt offering prefigured the cross. Prominence as a Christian public emblem, however, came only after Constantine's vision nearly three hundred years after the crucifix-ion. Several versions of another legend tell how the Emperor's elderly mother, while on pil-grimage to Jerusalem, discovered the true cross of Calvary under the present Church of the Holy Sepulcher. Just as the tradition of Ashoka putting Buddha's relics into 84,000 stupas legitimized claims of finding the Buddha's true relics wherever Buddhism became established, the true cross divided and subdivided to sanctify shrines throughout Christendom.

The glorified cross, studded with jewels or geometrically elaborated, became the antithesis of the tree of death. Sign of benediction and consecration and of every sacrament, the most frequent gesture of public and private devotion, the sign of the cross puts demons to flight and souls to rest, and it helps ball players score points. Ground plan of baptisteries, mausoleums, and cathedrals; market-crosses for proclaiming or commemorating, sanctuary-crosses for fugitives' refuge, huge crosses on hills designating Christian towns and small markers as boundary stones of sacred land; pectoral emblems of ecclesiastical authority, vestment embroidery, amulets around necks or in ears, and tatoos wherever; heraldic and national insignia, military and civil medals, and stations of prayer—the cross of Christ reaches up on spires and down on graves, introduces wills, deeds, charters, and signatures, moves through the world on stamps and coins, processes down aisles and streets, dissolves on bread, and names towns, colleges, liturgical feasts, and those eight Medieval expeditions to recover the Holy Land from Islam. The crusading Gregory of Lorraine's double traversed cross became an American Christmas seal fighting tuberculosis, just as the crusader's red cross on a white field now brings relief to disaster victims throughout the world. Fiery crosses called Scottish clansmen to battle and were raised in warning by American Klansmen. Dante is buried with Machiavelli in Santa Croce, and their souls, if with the just in Dante's Paradise, kneel in eternal prayer within a cross of fire.

As the stupa diagrams the Buddha sitting in meditation, from folded leg base through torso to head, centered in enlightenment, the cross images Christ raised up, arms extended in redemptive love. "In the cross of Christ I glory, towering o'er the wrecks of time; all the light of sacred story gathers round its head sublime."[104]

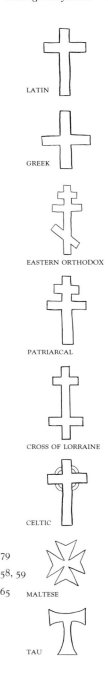

LATIN

GREEK

EASTERN ORTHODOX

PATRIARCAL

CROSS OF LORRAINE

CELTIC

79

58, 59

65 MALTESE

TAU

Anything can be a symbol, and nothing is intrinsically symbolic. An anchor is a Christian symbol of hope in the storms of life; a fly once symbolized sin, a strawberry righteousness, an egg resurrection. A bowl held in one hand identifies Sakyamuni Buddha; held in both hands on his lap, it signifies Amitabha Buddha. Fly whisks, like parasols, indicate royalty and the Buddha as Universal Monarch. A book carried by a Bodhisattva is usually the *Prajnaparamita*, testament of transcendental wisdom; when carried by Christ it is the gospel, the Book of Life. An empty throne with a tree symbolizes Buddha's enlightenment; with a cross, it awaits the second coming of Christ. Peacocks symbolize passion in India and immortality in Christianity.

Non-human symbols of Buddha and Christ accentuate the paradox of incarnation through their higher level of abstraction. Referring to a specific person, their obvious difference suggests Buddha or Christ is not just another person among people, as the symbolic object is not just another thing among things. A human figure, however, remains the most potent symbol. It represents the highest known form of intelligence, the most complex emotional life, the greatest creative and destructive potential: it represents us. Our bodies remain the medium through which we necessarily experience and express the compassion in transcendence that distinguishes both Buddha and Christ.

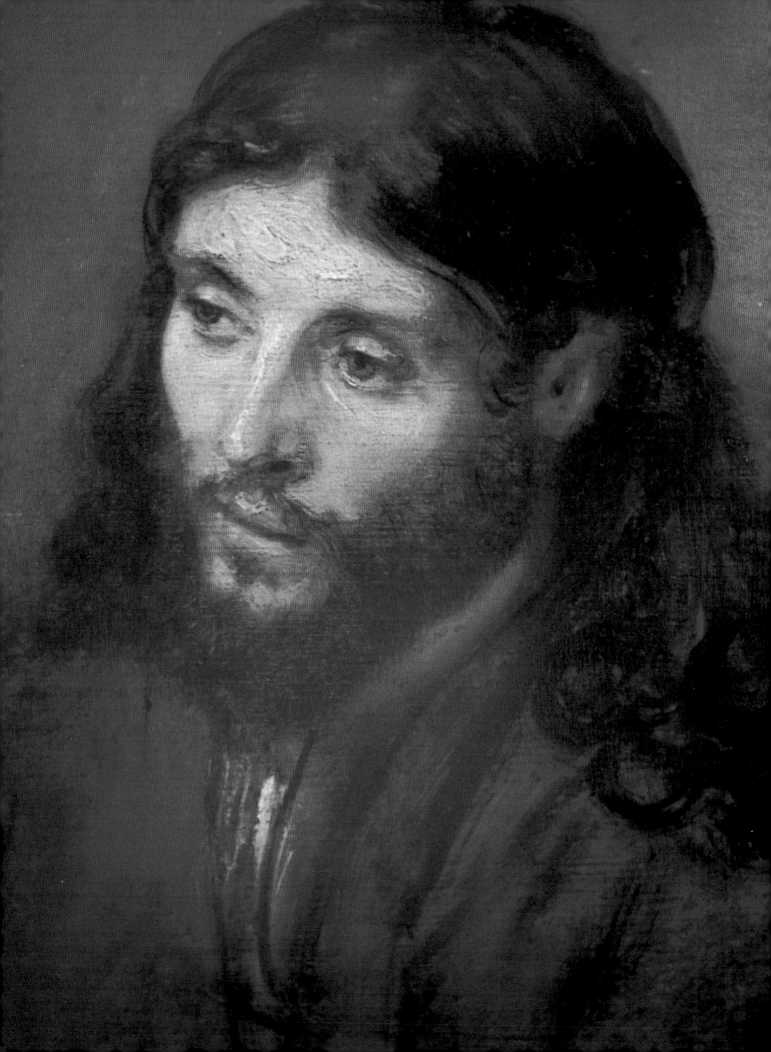

Part 11
Transformations

All Buddhas, cleansed of individuality, look alike.

—Joseph Campbell

We waste our time if we try to go around or above
or under the definite; we must literally go through it.

—William Lynch

When in aesthetic experience the thing-in-itself
is directly seen, the continuity of Nirvana is upheld,
while when…no such vision obtains,
continuity in Samsara is guaranteed.

—Theg-pa'i mchog rin-po-che'i mdzod

There was no fog in London before Whistler painted it.

—Oscar Wilde[1]

6.

Early Images

Sometime in the first or second century Buddhists and Christians overcame their reluctance to depict their Lords as human figures.

The earliest known generally accepted Buddha images are the very small figures on several of Emperor Kanishka's gold and copper coins of the first or second century, the only slightly larger figures on two relic caskets (a bronze one from Shahjiki Dheri, Pakistan, from the same period, and a gold one from Bimran, Afghanistan, probably made sometime between the late first and early third century) and several second-century sandstone sculptures from Mathura, India.

Obscurity also surrounds the dates of the earliest known images of Christ. Priority goes to the late second or early third-century Roman catacomb frescoes, and then, as the Church attracted people of a higher social class who could afford more impressive burials, the sculpture on some third-century sarcophagi. The only known exceptions to funerary images until the end of the third century are the frescoes painted about 240 A.D. in the baptistery of a small church-house in the garrison town of Dura-Europos at the edge of the Roman Empire.

The popular need for adoration apparently stimulated the proliferation of these early images of both Buddha and Christ. Both images appeared about the time the first biographies of Buddha and most of the apocryphal gospels were being written. Both religions faced intense competition as they accelerated their movement into many lands with different gods whose stories were told in sacred texts and whose images were everywhere.

As Buddhism and Christianity became religions of empires, Buddha and Christ often appropriated the imagery used to present the emperor. By the second half of the fourth century Christ gives the scroll of the Law to Peter in a gesture of the emperor delegating power to officials. The apostle's hands are covered in the custom of Byzantine court etiquette, where objects were received from the emperor by covered hands as a sign of respect. The similarities between several reliefs of Buddha's "Great Renunciation" and Christ's "Entry into Jerusalem" probably derive from a common model. The central mounted figures raise their right hands in authority; a servant holds a royal umbrella behind Buddha, and an apostle lifts his arm behind Christ in a protective gesture; gods carry the hoofs of Buddha's horse to muffle the sound of his leaving the palace, and children spread cloths before Christ's animal as it enters Jerusalem. Roman imperial coins extol the glory of the emperor entering or leaving a town in this fashion.[2]

Having supreme authority over the world as well as ruling through the rulers, Buddha and Christ both usurped and reinforced the emperor's power. Buddha gave authority to

74

70

20
62

25, 26

74, 75

Kanishka's coins, and by the end of the seventh century Christ was on Justinian II's. Buddha was Cakravartin and Christ Pantocrator: soon majestically enthroned, their dominion the sun's run.

70, 62

Nothing, however, could be less imperial than the earliest images of Buddha the monk or of Christ the shepherd. Buddha, especially in meditation, disengages himself from the world. The state's response to Christ is crucifixion. Both men astound with miracles and teachings that come from their own inner energy, pointing to an authority other than royal privilege.

Variety naturally characterizes what would become a continuous process: portraying one who embraces all the facets of ultimate reality in the hearts and minds of all who adore him.

The Greek Buddha and Christ

68, 69

Many early images of Buddha and Christ look like each other because, resembling neither Indians nor Jews, they look like Greek gods. The Greeks, believing the gods inspired their artists to portray the gods as Greeks, glorified themselves: noble characters and brilliant minds in beautiful bodies. They sought perfect harmonious proportions, while at the same time bringing marble and bronze to the threshold of life through closely observed anatomical detail.

As this classical idealized realism of the fifth century B.C. moved through the Hellenistic world of the next five centuries, the ideal frequently turned to either florid elegance or natural distinctions. Roman portraits reveal bony, fat, wrinkled faces with individual graces. Then, by the end of the second century A.D., with Near Eastern influences penetrating both the religion and art of the Empire, especially in the provinces, figures became more abstract and expressionistic. Gestures are more rigid, colors more brilliant, surfaces rougher. Disproportionately large heads feature large black eyes obsessive with hidden inner life staring out into the mystery of another world.

Early Christian catacomb frescoes often have this expressionist quality, and this would later flourish throughout the Byzantine Empire as especially viable for the metaphorical, symbolic, and often confrontational quality of Christian art. But it was out of classical Greco-Roman imperial art that Apollo—youthful god of reason, health, justice, and light— became Buddha at Gandhara and Christ around the Mediterranean.

Gandhara (present southeast Afghanistan and northwest Pakistan), in the middle of trade routes between East and West, had long mingled Greek, Roman, and Persian influences in an essentially Indian culture. Missionaries of Emperor Asoka had built a stupa there in the third century B.C., and by the late first or early second century, under the patronage of the Emperor Kanishka, Buddhism flourished. Images soon followed. At least the first generation of craftsmen probably came to this western extremity of Buddhism from the eastern provinces of the Roman Empire. When called upon to represent the Buddha they incorporated traditional Indian symbols into the same first-century Greco-Roman imperial style that would be revived in images of Christ when Christianity became triumphant in the fourth century.

At their best, these beautiful, youthful Aryan heads of Buddha and Christ are crowned with wavy hair and graced with perfectly arched brows above a straight nose leading to a

sinuous bow of a mouth. They can be charming, even elegant. Buddha occasionally has a mustache he will usually lose. Christ does not have the beard he will usually gain. Although Apollo celebrated the whole body—usually nude, in perfect proportion—Gandharan Buddhas and Roman Christs emphasize the head and minimize the body, which is usually short, stocky, and always clothed. (Only in the Indian Gupta period did the Buddha's robes transpire into transparent tissue, and it wasn't until the Italian Renaissance that Christ's body assumed a fully physical character.) Ideal figures, rather than portraits of mortal teachers, these Gandharan Buddhas and Roman Christs are, however, thoroughly human, devoid of transcendence. 25, 26 / 77 / 33

These early images contain much of what would become the traditional iconography of Buddha and Christ. In them we see most of the auspicious marks of the Buddha we will ever see. He appears in his three principal postures and, with the exception of the *vitarka mudra* (reasoned argument), his six major gestures.

More than a hundred different scenes found at Gandhara trace the Buddha's story from previous incarnations to the distribution of his relics. Some episodes were repeated from earlier Indian aniconic models, but many were created here for the first time and became a part of the canon. A few, such as his emaciation from extreme asceticism, were subsequently generally ignored. (Centuries later Chinese and Japanese artists represented this experience with a disconsolate Buddha resting his head on his hands, clasping his stark raised leg, or, in Zen paintings, as a haggard Buddha descending a mountain.) 17

94

The "Four Great Events," Buddha's gifts to all humanity—his birth, enlightenment, first sermon, and final nirvana—sometimes appeared together. Eventually, four more localized events were added to make the "Eight Great Events": he performs miracles at Sravasti (water streams from his feet as flames leap from his shoulders or he multiplies his body in all directions); after teaching the gods and his mother in one of the heavens, he descends at Samkasya (accompanied by the gods Indra and Brahma on a triple stairway, his of jewels, theirs of gold and silver); a monkey offers him a bowl of honey at Vaisali (the monkey became so excited at seeing his offering accepted that he leaped and danced, fell and died, and was immediately reborn the son of a Brahman); and at Rajagrha he tames with love the mad elephant sent to kill him. In the Buddha's last discourse he encourages pilgrimages to the sites of the four primary events. The idea of pilgrimage was probably a factor in the choice of all eight. By the ninth century these narratives were often radically summarized in symmetrical compositions: in the center and larger than the others, the greatest event, enlightenment; across the top, his final nirvana; and along each side, three in various sequences. 21

19

92

Compared with Gandharan Buddhists, the early Christians depicted fewer episodes from their Lord's life. But they repeated endlessly certain scenes symbolic of incarnation and redemption: the nativity (especially the adoration of the magi as a symbol of pagan submission to Christ), teaching the Law, the miraculous healings, turning water into wine and multiplying the loaves, the raising of Lazarus, entering Jerusalem, and the ascension. Intermixed with them, episodes from the Hebrew Bible prefigure salvation in Christ: Adam and Eve, Noah and the ark, Abraham and Isaac, Jonah and the great fish, Daniel in the lion's den, the three heroes in the fiery furnace, the Israelites crossing the Red Sea, and Moses drawing water from the rock. Incidentally, just as Moses strikes the rock with his wonder-working wand, Christ frequently holds a similar wand for his miracles—another example of pictorial tradition developing independently of scripture. 72, 20 / 26

Fig. 68
Buddha. 2nd-3rd century,
Pakistan. British Museum,
London. Photo copyright The
British Museum

Fig. 69
Christ. c. 350-360, Eastern
Mediterranean(?). Museo
Nazionale delle Terme,
Rome. Photo: Alinari/Art
Resource, N.Y.

Fig. 70 (OPPOSITE, LEFT)
Buddha. 2nd-3rd century,
Ahicchatra, Uttar Pradesh,
India. Museum of India, New
Delhi.

Fig. 71 (OPPOSITE, RIGHT)
Buddha. 5th-6th century,
Dong-duong, Vietnam.
Vietnam National Museum,
Saigon. Photo from David
Snellgrove, ed., *The Image of
the Buddha,* copyright
UNESCO, 1978, reproduced
by permision of UNESCO

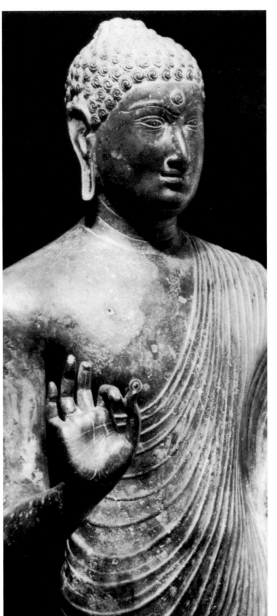

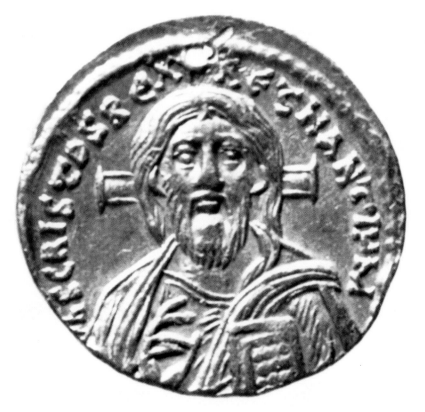

FIG. 72 (OPPOSITE, TOP)
Christ Teaching the Apostles
(detail). c. 400, Santa
Pudenziana, Rome. Photo:
Scala/Art Resource, N.Y.

FIG. 73 (OPPOSITE, BOTTOM)
Christ. 4th century, Catacomb
of Saints Peter and Marcel-
linus, Rome. Author's photo.

FIG. 74
Buddha. Gold coin. 1st-2nd
century, Afghanistan.
British Museum, London.
Photo copyright The British
Museum

FIG. 75
Christ. Gold coin. 7th
century, Constantinople.
Photo copyright 1996,
Dumbarton Oaks, Trustees
of Harvard University,
Washington, D.C.

The Church rarely adopted pagan figures. Orpheus may have come in through a Jewish pictorial and literary tradition that had already assimilated him. In charming wild beasts with his lyre Orpheus suggested David and then Christ stilling dangerous passions—David with his lyre, Christ with his word. Or Christians may have seen Christ directly in the Thracian poet's descent into the underworld and his triumph over a violent death, and heard in his lyre music of the heavenly spheres, linking hope for peace and harmony on earth with a future golden age.

25, 26

These scenes from the lives of Buddha and Christ are simple and lucid. Boldly conceived figures are isolated against plain or summarily outlined backgrounds with only enough detail to identify the events. Occasionally the same garland-bearing cupids that wind around pagan Roman sarcophagi decorate these Buddhist and Christian scenes, probably still bearing for their patrons their old power as symbols of love, giving meaning to life and hope for immortality.

The Greek Buddha and Christ never completely died. The Gandharan Buddha had his greatest influence in Central and East Asia where, with Persian, Indian, and Chinese infusions, he accompanied missionaries, merchants, diplomats, and returning pilgrims along the silk routes of Turkestan going into China, and then Korea and Japan, where, just as in India, the alien was absorbed and transformed into the distinctive traditions of these

45

ancient cultures. The famous Udayana image, from which China's Buddha image derived most of its authority, retained several Gandharan characteristics even as it was modified in moving along these northern roads.

69

Once Christianity passed from obscurity and persecution through the victory arch of imperial favor, a fully formed classical Christ emerged. In the Eastern Church this Greek Christ remained a fluctuating influence in an essentially alien Byzantine form. With the fall of Rome he almost disappeared in the West, only to be revived when Charlemagne's Holy Roman Empire and the subsequent Ottonian age sponsored him again, with his new Byzantine and barbarian inheritance showing. After this Empire disintegrated, the youthful

87

beardless Christ appeared only sporadically until his Renaissance revival. But the classical influence of humanity observed and idealized was seldom completely submerged.

Although craftsmen diffused the Greek ideal across most of Europe and Asia, Buddha exerted by far his greatest influence in his native Indian form, Christ in his Semitic form.

The Indian Buddha and the Semitic Christ

The controversy over primacy in creating Buddha images that once divided European and Indian scholars has waned in a consensus that the image emerged at about the same time in the first or second century, apparently independently, in two parts of the Kushan Empire, in two very different forms: Greek, in its Roman refraction, and Indian.

Mathura, now on the rail line from Delhi to Agra and traditional birthplace of Krishna, was as Indian as Gandhara was cosmopolitan. Although traditional texts note two visits of the Buddha to Mathura, the ancient city only became a Buddhist center when Kanishka made it a seat of his empire. Several archaeological campaigns have revealed over forty

Buddhist sites in the Mathuran neighborhood and thousands of images from the second century to the sixth, when the Huns plundered the place.

The typical early Mathura Buddha has a shaved head except for the hair centered on the top—an *ushnisha* coiled like the hair of an ascetic yogi instead of Gandhara's Greek-inspired long wavy hair tied in a chignon. His animated round face contrasts with the calm expression in the classical oval shape of Gandhara. Eyes wide open, his attention less inner-directed, he looks at us as a lively teacher. His broad shoulders and ample body recall the heavy statues of the guardian spirits (*yakshas*) of central India. Without the usual overcoat of the cold northwest, his robe falls over his left shoulder in rhymical uniformly shaped folds, transparent through the radiance of his body. His deep navel and both nipples are prominent. His sensuous fullness is indigenously Indian.

In yogic discipline concentrated breathing yields an inner lightness and warmth to dissolve the carnal body into the "subtle body." Whatever activity or concern Indian artists portray, they give form to this idea of breath circulating through the body's vital centers and animating all its parts. "Breath is the essence of the limbs." "Organs of speech, the eyes, the ears, or the mind . . . the vital breath alone is all these."[3]

The "Lion of the Sakyas" usually sits on a lion throne, symbolic of royalty, rather than on the lotus throne more characteristic of Gandhara. In distinction to the more specialized gestures of Gandhara, he usually raises his right hand to shoulder height in an energetic *abhaya mudra* (dispelling fear). His halo's scalloped edging may suggest a cobra's hood. Gandharan figures of gray schist may seem somewhat cold in their refinement beside one of these earthy respirations of soft mottled pink sandstone.

Only slightly later than at Gandhara and Mathura the Buddha took a third form in present-day Andhra Pradesh, where the great stupa of Amaravati gave its name to a school of sculpture. The Amaravati Buddha exercised an influence in Sri Lanka and Southeast Asia comparable to Gandharan sculpture in the North.

Thoroughly Indian, like Mathura, this Buddha in greenish white limestone is more supple and sophisticated. The dichotomy between hieratic cult images and the more relaxed natural postures of other figures is not as apparent at Amaravati as in the North. The Amaravati Buddha has a low *ushnisha* and a more oval head covered with the evenly spaced identical curls that become a hallmark of subsequent images. His right shoulder often uncovered, he holds a voluminous fold from the heavily pleated robe thrown over his left arm. Scenes of his life are more complicated than the often stiff symmetrical reliefs of Gandhara and the few narratives preserved from Mathura. Lithe figures crowd every inch of surface in dramatic exuberance.

Later sculpture from Gandhara and Mathura shows a mutual influence, and both influenced Amaravati. But of these early schools, only the Mathuran would achieve the mature spiritual quality that was to emerge, after a period of political instability, in the consummate Buddha image of the Gupta Empire.

The Church Fathers set the direction of much subsequent Christian thought by responding to their Greco-Roman inheritance in two essentially opposite ways. Some, such as Clement of Alexandria, appreciated most of this tradition and considered Christianity its consummation. The delicate features and gentle expression of the youthful Christ, especially as the

70

71

19

69

Good Shepherd or Orpheus, reflect this sense of continuity. Others, like another North African, Tertullian, saw Christianity as the antithesis of a corrupt and illusory world: "What has Athens to do with Jerusalem?" he asked.

73

72

A more austere, majestic Christ was the answer. More in the line of kings, prophets, and philosophers, he has a black beard and long dark hair. Less frequently, short curly hair and a very short beard frame a triangular face. More rugged, his eyes more deeply set, he is a mature man, authoritative, often severe. He can bear the suffering of the sins of the world.

Although the earliest third-century catacomb and sarcophagus images portray the youthful beardless Christ, and the earliest example of the so-called Syrian or Semitic Christ comes from the middle of the century, the relatively short time between the two makes it difficult to grant priority to either. Occasionally they coexist on the same object, apparently unrelated to the context of the narrative or the function of the image. Either may symbolize eternity: youthfulness, outside of time and forever young, or longevity suggested by vigorous maturity. Indeed, the powerful bearded Zeus/Jupiter and Poseidon/Neptune remind us that the Semitic Christ might also be a Christian relative of these old Greco-Roman gods of sky and sea.

7.

"Into All the World"

At about the same time, almost eight hundred years after Gautama and four hundred years after Jesus, images of Buddha and Christ reached maturity. For the first time Buddhist and Christian values clearly determined not only iconography but also form. All the great Gupta and Byzantine images embody the numinous in compassion, although not always in equal measure.

The Gupta Buddha and the Byzantine Christ

During the reign of India's Gupta kings, from about 320 to 467, Northern India was united under native rule for the first time since the Maurian Empire collapsed in the second century B.C. Most areas enjoyed prosperity, and a golden age of art, science, and scholarship survived the collapse of the Gupta dynasty by almost two centuries. Hinduism and Buddhism flourished together, even as the Hindu revival that began during this period gradually began to absorb Buddhism.

Within a decade of the founding of the Gupta Empire, Constantine had moved the capital of the Roman Empire to an ancient but insignificant Greek town called Byzantium in the center of that large area between Europe and Asia that is not quite a part of either. He named the new Rome after himself and dedicated it to the Holy Virgin. Rebuilt in magnificence, Constantinople became the mother-city of an empire that would, at its height, embrace the whole civilized Western world. It perpetuated Greek and Roman civilization for a thousand years after Rome fell. Christianity, in the service of the emperors, was the light and glue of Byzantium.

When the two civilizations were at their florescence—the Gupta in the fourth and fifth centuries, the Byzantine in the sixth and again in the ninth through the twelfth— Indian craftsmen drew primarily on the Mathuran tradition, which had absorbed Gandharan elements, and the Byzantines fused Hellenistic elegance and naturalism with the more monumental abstract style of the Near East to create this first truly Buddhist and Christian art.

The much longer Byzantine period produced at least three major trends. Fueled by the impetus of the newly triumphant faith, an early Hellenistic Christ with increasing Semitic, abstract, hieratic qualities established the Byzantine norm. A more majestic Christ followed the eighth century iconoclastic controversy. Then, from the twelfth century until the fall of

34

78, 80

116

78

77

Constantinople in the fifteenth, with the Empire greatly reduced, a more approachable figure showed a new depth of compassion in a more narrative, less monumental context, with paint used more frequently than costly mosaics.

Gupta and Byzantine lines suggest more than describe. Symmetrical reduction of distinctions into elemental unity eliminates most anatomical and muscular detail. Frontallity suggests completeness; a profile the beginning of absence. Unlike Greek sculpture, which implies motion, the Gupta Buddha and Byzantine Christ are almost still. Almost. Each makes a gesture, perfectly poised, more the expression of a liberating idea than body movement. The standing Buddha often shifts his weight slightly to one leg, his body tilts gently at the waist and again in the opposite direction at the shoulders. He almost moves toward us. The mosaic cubes of the Byzantine Christ—their varied planes catching the shifting sun or the glow of lamps and candles—brighten and fade in response to our changing position.

Like all the gods in the best of Indian art, the Gupta Buddha is "at once serene and energetic, spiritual and voluptuous."[4] Brows arch like the double curve of an Indian bow above lotus-bud downcast eyes and sensuous full lips. Close cropped curls with a prominent *ushnisha*, extended ears, and three conch-like neck lines contour his oval head. There is no *urna*. He has wide shoulders, an expanded chest, a slim waist, long well-turned legs, and, usually, webbed hands. His robe covers his body, as at Gandhara, but reduced to schematic conventions, the natural folds become a diaphanous membrane of either parallel looping lines or a sheath suggested by a few incisions. Both reveal the uninterrupted smoothness of subtly swelling surfaces, an immaculate nude sustained by breath rather than muscle and bone, strangely weightless. A large elegantly carved halo accents his simplicity.

Images of the Buddha were made throughout the Gupta Empire, the finest ones in monastic complexes in the Ganges valley at Sarnath and Mathura. Sarnath, where Buddha preached his first sermon, retains the single most frequently reproduced image of the event. More than illustrating this episode in the Buddha's career, it is an image of the eternal turning of the wheel. It has strained more prose than any other Buddha image.

The composition is most delightful, breathing poise, profundity, and sweetness that are stressed by horizontals, triangles, and circles . . . The hovering angels deftly integrated into the nimbus produce an atmosphere of ethereality.—Radhakamal Mukerjee

The unearthly character of the Enlightened One . . . shines forth with the radiance of a genuine inward experience, transforming the solid matter into a luminous subtle essence suffused by the inner light of wisdom and perfection.—Heinrich Zimmer

It was so human and yet without any earthly taint. It was like a full-blown lotus in its delicacy . . . There is surpassing tenderness…such as we dream of on the face of a long-lost loving mother . . . The eyelids flickered, and the music of the world which knows neither sorrow nor sadness was about me.—K.M. Munshi[5]

At least one critic considers it a "weak piece, not a product of Gupta genius at [its] best . . . It ushers in the dusk" as, he continues, Giotto did with medieval art.[6] More softly modeled than some of its more architectonic Gupta predecessors, this Sarnath Buddha pro-

jects human qualities into the numinous character of the best of Gupta images, much as Giotto breathed life into the grave intensity of Gothic art. Stand before this image, however, after the crowds have left, and at least something of what Zimmer called its "luminous subtle essence" breaks through any comparative considerations with intimations of the Buddha's wisdom and compassion.

Byzantium gave Christianity its single most influential image of Christ: the "Holy Face." The distinctive head like a mask with neither neck nor shoulders was probably derived from evil-averting Gorgon heads set frequently over city gates. Orthodox tradition receives the Holy Face from the Edessa cloth. Large eyes, a long thin nose, and a small mouth suggest spiritual animation without material needs. Abundant dark hair, parted in the middle and often with a double forelock, falls shoulder length to frame his head. A mustache droops into a beard that either forks or ends in a single point. A cruciform nimbus contains the symmetrical halves of his face, hair, and beard. The image epitomizes the vigorous abstract harmony of the Byzantine Christ as the source of truth and wholeness, the perfect judge of every thought and action.

76

High in the dome or apse of the church, where grounds of gold deliver him from any temporal or spacial setting, Christ Pantocrator (Ruler of all) depicts at once the divine and human nature of Christ in the unity of Father and Son. His eyes penetrate everyone who looks at him. His right hand raised in benediction, his left hand usually holds the Gospel Book. But his features often express the creator judging the failure of his favored in all creation to fulfill the covenant made at Sinai. Frequently it is the smaller, more accessible Pantocrator images on the walls and painted panels that grace the awesome wrath with the redemptive love of the new covenant sealed at Calvary. In the *deesis* (prayer), the enthroned Pantocrator sits in judgment while on either side stand the Virgin Mary, who first rejoiced in him, and John the Baptist, who first recognized him publicly. Hands outstretched, they intercede for all humanity.

80

79

From mosaics to manuscripts, everywhere in Byzantium a golden glow conjures up the glory of God. Not a part of the spectrum, gold is light, and, like the sun, its light is self-sufficient. Artifacts from Stone Age graves indicate the use of this beautiful, durable, malleable, scarce metal is as old as human culture. Only before their fall were Adam and Eve immune to the temptations of "the land of Havilah, where there is gold," and by 1966 American Express had introduced prestige plastic with a Gold Card. Always associated with wealth and power, the New Testament condemns the metal as an object of covetousness and the material of idols. But the magi gave gold to the infant Jesus. Like a glorious innocent child playing in the forbidden garden of delights, gold is the Church's symbol of transcendent splendor.

14

And we remember the Buddha's golden skin. It is one of his thirty-two marks. Everyone reborn in Amitabha Buddha's Western Paradise will share this color. Throughout Asia merit accrues to those who cover images with gold leaf: one ounce of it beaten into a sheet covers nearly a hundred square feet. From Japanese paper screens to the dome of Jerusalem's Temple of the Rock, gold transforms its subjects into light.

81

Byzantine interpretations of several Biblical themes, though frequently absorbed in the West, remain characteristic of Eastern Orthodoxy. Christ is born in a cave rather than a

8

stable, often lies on a raised structure more like an altar than a manger, and, like the Buddha, he is a small adult. Mary, distinguished by her large size and central position, lies on her bed after the birth. Angels stand on the mountain top, shepherds approach from one side, magi from the other. Star rays pierce the cavern. At the bottom on one side Joseph rests his head in his hands, pensive or puzzled; on the other side midwives bathe the child.

14 At his baptism Christ stands in the Jordan. Frequently, near his feet, a small male figure personifies the river. With his right hand Christ blesses the water that becomes the symbol of birth into new life. John stands on a rocky bank where a tree and axe allude to his sermon of repentance. He draws Christ by the hand out of the water or he confirms the descent of the Holy Spirit with his raised right hand over Christ's head. Attending angels, hands covered in reverence, stand on the other side. From heaven the hand of God points toward his son, and the Holy Spirit descends in the form of a dove.

Narratives of his ministry portray Christ as the transfigured Lord. Light is uniformly distributed; no shadows fall in the kingdom of heaven. His elongated figure emphasizes those parts of the body most capable of expressing spiritual intensity: head, eyes, and hands. The folds in his clothing, more geometrical than natural, suggest transcendence. Even when crucified, the victorious savior retains his majesty, and his death usually remains within the framework of the liturgical cycle, seldom assuming the preeminent place it 34 attained in the West. His resurrection is portrayed not by a step or leap from the tomb but by his storming into limbo to rescue the souls of the righteous.

Scripture, liturgy, doctrine, and image bonded in mutual support. Consider one example. The story of Abraham offering hospitality to the Lord who visited his home in the form of three men (*Genesis* 18:1-8) prefigures the feast of Pentecost, celebrating the outpouring of the Holy Spirit on the apostles and the completion of the revelation of the Holy Trinity. Since the Orthodox Church considers the transcendence of God the Father beyond representation, this story became this Church's only authentic vehicle for pictures of the triune God.

42 Portrayed as early as the late fourth or early fifth century, the outstanding example of this revelation of the Holy Trinity is Andrei Rublev's fifteenth-century icon. The Russian painter retained only a trace of Abraham's house, a mountain, and a tree to set the scene. Nothing intrudes on three elongated, monumental figures—their single nature expressed through golden halos, angelic wings, lithe sceptres, and their almost identical androgenous features and postures. We see them only in their relationship. Inclining toward each other, they gesture in movements so contained as to suggest inner life rather than physical action. Mutually envisioning the act of redemption, they point to a chalice on a table. We look into the chalice as we see its side and we look down on the table at the same time we see its front. The chalice comes toward us. Disoriented, without a fixed perspective, we move into a space beyond perception.

We tentatively identify Christ by his robe's slightly stronger hues, his central, slightly elevated position directly beneath the tree and over the chalice, and by his two extended fingers, perhaps suggesting his two natures. But the painting's circular composition and fluid lines, and the glowing, joyful, soft summer colors melting into each other reveal only the certainty of a single harmonious tranquility in the divine life of love. As we stand before this representation of the central mystery of the Christian faith in Moscow's Tretyakov

Gallery, the murmur of the crowd fades into a choir at Vespers on the night before Pentecost: "Come faithful, let us worship the trinitarian God, the Son with the Father together with the Holy Spirit."[7]

The cosmic Person in numinous abstraction and salvific gesture continues to show two faces. The Gupta Buddha, in withdrawing from the world the Byzantine Christ rules, bears the spiritual forms of India as clearly as the Byzantine Christ embodies his Semitic inheritance.

Both images frequently ran out into sentimentality, rigidity, or decoration. But they also frequently renewed themselves in the various cultures they encountered, even as they were modified by them. The Gupta Buddha became normative throughout Asia. Its essential qualities pervade the early Buddhas of Nepal and Tibet, and they run through Central Asia to the great Buddhas of the Sui and Tang dynasties of China, and from there into Japan. In South Asia, often following an initial wave of Amaravati sculpture, provincial variants of the Gupta style extend from Sri Lanka to Java. The Byzantine Christ spread over the entire Mediterranean, later influencing the barbarian tribes of Europe and becoming an ingredient of Romanesque. After the fall of Constantinople, this Christ settled into the Balkans, the Near East, and Russia, where he has never ceased to reign through the Orthodox Church.

Buddha in China and Japan and Christ in Europe

Definitive events in the histories of Chinese and European civilizations occurred at about the same time. Buddhism was introduced into China and Christianity into Europe during strong, stable, imperial governments of the first century, and each expanded as these governments declined.

The legend of the Buddha's entry into China begins with the Han emperor Ming Ti's dream of a golden man arriving from the West. When the emperor awoke he sent a welcoming embassy who met two Indian monks leading a white horse bearing on its back an image of the Buddha and some texts. The present White Horse Temple in Luoyang stands on the site of the monastery built in the then-imperial capital and named for the animal who bore the honored image. Until modern times, Buddhism was the only foreign influence to become a major, integral part of China.

With the Han dynasty's collapse in the third century, China divided into two areas: the South, governed by a succession of weak dynasties in Nanjing, and the North, ruled by non-Chinese tribes. In the somewhat more stable South we know Chinese Buddhism almost exclusively through the elite, who were cultivating traditions from the lost Han Empire. Only a few images of their Buddha remain. The earliest known Chinese Buddhas—small, late fourth-century votive statues, cave paintings at Dunhuang on China's north-west border, and even the somewhat later giant rock cut images at Yungang—all show various

combinations of Hellenistic, Persian, and Indian ancestry from their overland trips out of India through Central Asia.

The vigorous Wei dynasty that finally prevailed in the North lasted for almost a hundred and fifty years until in 534 it divided into Eastern Wei and Western Wei, which, within twenty years, became Northern Chi and Northern Chou, which, in a few years became the Sui dynasty, which in 589 overwhelmed the last of the dynasties at Nanjing and unified the country again.

These centuries of division, warfare, political instability, economic distress, and spiritual confusion in China parallel the contemporary chaos on the post-Roman western end of the continent. Into this turbulence Buddhism and Christianity brought comfort, spread themselves, and finally settled. Buddhist monasteries in China, like the Christian monasteries of Europe, became centers of learning, havens of refuge, and, eventually, highly endowed pockets of affluence, some doing a brisk trade producing and selling images.

The Wei Buddha and the Romanesque Christ

By the end of the fifth century something new emerged from China's Wei Dynasty. As the northern Kushan conquerors of India, who were not Hindus, had embraced Buddhism and become enthusiastic patrons of the first Buddha images, so the northern nomadic Turkish-Mongolian chieftains, who were not Confucianists or Taoists, became Buddhists and the first patrons of a distinctly Chinese Buddha image. From one of their earliest edicts: "Buddha being a barbarian god is the very one we should worship." During a period of about sixty years, the number of Buddhist monasteries increased from less than seven thousand to more than thirty thousand, prompting a prime minister to complain: "Now Buddhist monasteries are everywhere, filling cities and towns, located next to butchers and wine shops."[8] Museums throughout the world preserve some of the glorious results.

81, 83 With six centuries and a continent between them, China's Wei Buddha and Europe's Romanesque Christ display a remarkable similarity. Both are a burst of vitality from northerners drawing on the culture of more civilized southerners.

Between the middle of the eleventh century and the middle of the fourteenth, Western Europeans built or renovated eighty cathedrals and thousands of parish churches. The world had not ended at the millennium, as had been widely predicted.

So on the threshold of the aforesaid thousandth year, some two or three years after it . . . every nation of Christendom rivalled with each other, which should worship in the seemliest buildings. So it was as though the very world had shaken herself and cast off her old age, and were clothing herself everywhere in a white garment of churches.9

Christianity and Europe were welded together as they had never been before and as they would never be again. The period opened with recovery from the onslaught of the Vikings and Normans from the North, the Hungarians and Slavs from the East, and the Muslims from the South. Cities and towns began to grow, industry and commerce revived, the climate improved, the first universities appeared, and England and France established national monarchies.

The Church's resurgence was evident in crusades, pilgrimages, monastic reforms, and unprecedented patronage for the arts. For the first time since antiquity, monumental sculpture appeared in Europe. Over church doors the Savior reigned in majesty. The semicircular form of the tympanum, magnified by receding arches, concentrates attention on him. Within a period of fifteen years, people began entering three French churches under three of the most awesome of all Christian theophanies: at Moissac Christ sits enthroned in the glory of the Apocalypse, at Vezelay he empowers the apostles, at Autun he delivers the Last Judgment. Sculpture and painting showed the signs of the zodiac, the labors of the months, the seven liberal arts, and an exuberance of foliage, animals, and monsters proclaiming all things in heaven and earth related in God's plan. As Latin was settling into new Romance languages throughout Europe, a synthesis of Greco-Roman, Byzantine-Near Eastern, and Celtic-Germanic styles emerged in a Romanesque Christ.

Wei Buddhas and Romanesque Christs radiate a strangely astringent spiritual vitality through very similar highly stylized, flat, linear figures. Their slender bodies with sloping shoulders and long limbs disappear under waves of cascading robes from which large hands gesture emphatically. (The Chinese and northern Europeans, like the Byzantines, never shared the Greek and Indian view of the body as intrinsically beautiful). The swirls and angles of the robes of these elongated Wei Buddhas and Romanesque Christs move with independent life, neither with the bone and muscle of Greek inspiration nor with the pneumatic dilation of India. Rectangular mask-like faces and halos amplified by long graceful aureoles further separate these images from the mundane world, suggesting not so much a person as a transcendent presence.

But even in this striking similitude, with the Wei Buddha resembling the Romanesque Christ more than each resembles many representations from other periods in its own tradition, we never mistake the one for the other. Not only do their distinctive gestures and symbols separate them. The Wei Buddha smiles in ineffable wisdom, certain of the eventual liberation of everyone from the world's contingencies; the Romanesque Christ stares in formidable command, assured that every person's response advances that person toward a blessed or infernal eternity.

The Tang Dynasty Buddha

In the later part of the sixth century China began having more direct contact with India. The Buddha image coming into the Middle Kingdom through Southeast Asia as well as from the northern silk routes, often in a Gupta recipe, was considered closer to the source and hence more orthodox. During the six decades of the Northern Chi, Northern Chou, and Sui Dynasties the image mellowed. The traditional Chinese preference for two-dimensional flat, linear, rhythmic form yields to more plastic, columnar figures, more akin to Indian sculptural norms. A low *ushnisha*, more natural facial features, softer robes falling in widely spaced catenaries, and evidence of an incipient interest in anatomy foreshadow even more representational Tang figures, much as the Gothic Christ promises the Renaissance.

During the Tang Dynasty (618–906) the Chinese were the world's most creative, civilized, and powerful people. The Empire extended from Korea across central Asia to the gates of Persia. It was a time of consolidation and assurance. Elegant sculpture found in

83

84

Tang Dynasty tombs indicates that the world's pleasures were well observed and enjoyed. Dunhuang cave paintings of the paradises of Amitabha, Maitreya, and Bhaisajyaguru (the Buddha of healing) reflect opulent imperial Tang courts.

Amitabha had become supremely popular. After death those who had invoked his name would go to his Pure Land, where the sensual pleasures of perpetual spring in sumptuous aerial palaces surrounded by courtyards, lotus ponds, and beautiful dancers and musicians satisfied any desire for final liberation.

During the first two hundred Tang years Buddhism reached the height of its influence in China. Buddhist festivals were the great days of the year, and Buddhist rituals sanctified state observances. Buddhist monks and their congregations opened free hospitals, supported hostels, and planted shade trees. Diverse spiritual needs were met through a variety of Buddhist lineages.

Supported by lavish donations, skilled artists brought the mature Indian Gupta style and the fermentation of centuries of native art into a strong, classical Chinese Buddha image. His halo becomes smaller. Full round cheeks rise to narrow eyes and brows. A sense of body stirs beneath the more natural folds of his robe. The linear patterns that still distinguish him from lesser beings now define subtle muscular modulations. Through this fusion of abstract line and natural modeling in the fully developed Tang image art makes one of its most successful attempts to represent an actual body of absolute bliss.

Most of these Tang images were destroyed in one of the world's periodic cultural catastrophes. During pre-Tang dynasties Buddhism had occasionally suffered persecution as a foreign religion, and in the middle of the ninth century Confucian and Taoist religious interests combined with the government's interest in the wealth of the monasteries to persuade the emperor to order the defrocking of all monks and nuns and the confiscation of all the Sangha's material possessions. The edict was vigorously enforced, at least in the central provinces. Chinese Buddhism never fully recovered. A Japanese pilgrim studying in China agonized in his diary:

> *What limit was there to the bronze, iron, and gold Buddhas of the land?*
> *And yet, in accordance with the Imperial edict, all have been destroyed and*
> *have been turned into trash.*

The actual edict stipulates prudent recycling:

> *Let the bronze images be given into the charge of the superintendent of salt and iron*
> *who shall smelt them for the minting of coins; let the iron images be given into the charge*
> *of the prefectural magistrates to be cast into agricultural implements; let images made*
> *of gold, silver, jade and other kindred precious materials be handed over to the board of*
> *treasury; let the period of one month be granted to the people of wealth and standing*
> *during which to hand over to the authorities images of every description in their posses-*
> *sion; let defaulters receive the same punishment as is usually meted out by the superinten-*
> *dent of salt and iron to those who are found in unlawful possession of bronze; and finally*
> *let images of clay, wood, and stone be left intact . . .* [10]

86

Buddha had moved to Japan. Craftsmen from China or Korea, or their descendants, were the principal sculptors of early Buddha images in this isolated country where some of the finest examples of the mature Tang style still survive.

Buddha in Japan

A story tells of the first Buddha image coming to Japan in 552 accompanied by an appeal for military assistance from a Korean king. No sooner was the new image installed than pestilence ravaged the land. Resident Shinto gods were hissing in anger. The dastardly import was held responsible and thrown into a drainage canal.

Buddhism gradually overcame Shinto resistance and the two religions began merging and mingling in the Japanese mind in a symbiotic relationship that has continued to the present day. Prince Shotoku, Japan's first significant national leader, was a devout and learned Buddhist. As his country turned into the seventh century he promulgated a rudimentary constitution that moved the powers of quarreling clans into the Imperial Court, and he hailed Buddhism as the supreme treasure of the land. Subsequently considered a manifestation of Kannon (Guanyin) and frequently represented in painting and sculpture, until recently Shotoku's portrait moved through the country on 10,000-yen banknotes.

In 710 the Japanese founded their first capital city at Nara, modeling it on Chang'an, the capital of China. The government sponsored Buddhist culture in the Tang Dynasty style. Although Buddhism was largely the religion of only royalty, the nobility, and learned priests, every household was expected to have a shrine with a Buddha image, and every province was ordered to build a monastery and a nunnery, each with a seven-story pagoda housing a statue of the Buddha. At the capital a huge Dainichi Buddha (Mahavairocana in other lands) guarded the nation. Although the state actually supplied most of the money for this largest of all bronze Buddhas and conscripted peasants for most of the labor, the Imperial Edict of 743 includes perhaps the first state request for private contributions:

> *Therefore all who join in the fellowship of this undertaking must be sincerely pious in order to obtain its greatest blessings, and they must daily pay homage to Dainichi Buddha . . . If there are some desirous of helping in the construction of this image, though they have no more to offer than a twig or handful of dirt, they should be permitted to do so . . .* [11]

Frequently recast, Dainichi Buddha is still there, staggering visitors by his sheer size.

In 794 the capital was moved to Heiankyo (modern Kyoto) where, within a hundred years, it became a center of culture surpassed in the world only by Chang'an. Heiankyo remained the effective center of government until the late twelfth century and the seat of the emperor until the nineteenth. Within a decade of the establishment of the new capital, two Japanese monks returned from study in China to introduce two syntheses of doctrine and practice that would profoundly influence the course of subsequent Japanese Buddhism: Tendai embraced elements from most of the other existing schools and found the fullest revelation of truth in the *Lotus Sutra*; Shingon transmitted the hidden truth of Dainichi

Buddha, the ultimate personification of both the perceived world and the illuminated mind. Both sects required countless images to visualize their sophisticated metaphysics and for use in rituals wherein initiates realized their unity with the universal Buddha.

A manifestly Japanese sculpture gradually emerged. Usually it is made of wood rather than metal or stone. At first this Buddha is forbidding, with his round head and full cheeks in a dour expression, large separate curls of hair, distinct contours of chest and abdominal musculature in a heavy body, and deep parallel lines in a "rolling wave" of a robe. Some see this early esoteric image as "baroque" in distinction to the classical Tang-Nara style.

The growing appeal of Amida Buddha (Amitabha in other lands), coupled with developments in the technique of carving several parts of a statue separately and then assembling them, produced a more flexible realistic image. The earlier sternness mellows. The head becomes a harmonious part of the body; expressive hands complement the serene composure of the face. A superb example still sits in the Phoenix Hall of the Western Paradise recreated on earth at Byodo-in near Kyoto. From his great gold lotus throne and dazzling aureole Amida looks out onto the west bank of his lotus pond before which tourists are perpetuated in photographs, if not reborn.

Many paintings survive from the latter half of the Heian period, a time of dominance by the Fujiwara family and their fellow nobles. A sumptuous ripe fruit Buddha in grand, complex, brightly colored compositions displays the elegant splendor of their aristocracy.

Then, beginning in the late twelfth century, ruling power shifted from the nobility to military *shoguns* and from Heiankyo to Kamakura. During this start of Japan's feudal period, seething with social and political strife, three movements reformed Japanese Buddhism in ways somewhat similar to what would occur in Europe's Protestant Reformation. Pure Land's faith in the saving power of Amida Buddha, Zen's commitment to salvation through one's own power of concentration, and Nichiren's invocation of the title of the *Lotus Sutra* as the embodiment of enlightenment—each emphasized faith or discipline rather than meritorious works and reduced the complexities of devotion to simple principles and practices available to everyone.

The painters' traditional "iron wire" lines, devoid of shading or expressive swelling, gave way to the softer lines of a more flexible brush. Sculpture attained remarkable vigor as some pieces began showing an increasingly mortal Buddha with inlaid crystal eyes, nervous energy, muscular detail, and individual personality. Ferocious muscle-bulging colossi were created to guard him. Zen's emphasis on the folly inherent in all existence even led to his caricature. As a counter-current to idealistic paintings of paradise, images of karmic retribution graphically detailed the tortures of the hells.

The virtuosity of Kamakuran art finally ushered in the decline of Buddhist sculpture and painting in Japan (with the notable exception of Zen ink painting), much as the humanistic glories of the Renaissance would erode the power of Christian art in Europe. As an image of Buddha or Christ moves from its intersection of representation and abstraction to resemble a particular person or an ideal human being it becomes more approachable and understandable, losing its authority to reveal what is essentially hidden.

Popular Buddhism continued to spread throughout Japan until the seventeenth century when the Tokugawa rulers—committed to a unified and isolated country—remembered the truculence of several powerful religious houses, turned to Confucianism, and closely regulated

Buddhist activities. Finally, with the mid-nineteenth century restoration of national power in the Meiji Emperor, Shinto was revived as the national heritage and main support of the government. Buddhism was disestablished.

Since the defeat and occupation of Japan at the end of the Second World War, several new sects have surfaced from the rice roots of an urban society where old values and institutions often seemed impotent. Many had little or no relationship to Buddhism and declined with the death of their charismatic founders. But the Nichiren Shoshu, and its derivative Soka Gakkai (Value Creating Society), have achieved spectacular growth with the thirteenth-century teaching of Nichiren. Millions of Japanese in this lineage seek a new age of peace and immediate benefits in their daily lives through social and political commitment, a worldwide mission, and, above all, by chanting the mantra *Namu-myoho-renge-kyo* (Devotion to the *Lotus Sutra*) represented graphically in a mandala of its characters. Explicit images of the Buddha are considered only another distraction and ignored.

Japan remains, however, the world's greatest repository of Buddhist art. Among some eighty thousand temples, those in and around Nara and Kyoto are especially remarkable for images of the Buddha designated simply "National Treasures."

The Late Medieval Christ

As the expressionist forms of China's Wei Buddha evolved into the classical forms of Tang Dynasty images, some six centuries later Europe's expressionist Romanesque Christ evolved into more classical Gothic images. The humanist spirit, especially visible in the sculpture, painting, and stained glass of mid-twelfth-century France, gradually spread over most of Europe. Emphasis shifted from the more abstract figures fostered in the asceticism of rural monasteries to more representational figures that met the needs of the people in the towns and cities around the new universities and towering cathedrals. This change also reflected the theological shift from the primacy of Platonic Christianity that disdained the illusory physical world and saw faith preceding and nurturing reason, to a Christianity that embraced the recently discovered Aristotle and affirmed the significance of the visible world, with self-sufficient provinces of reason and faith.

The new naturalism wedded to liturgical concerns represented Christ's birth and death almost to the exclusion of his miracles that were so prevalent in the catacombs and on early sarcophagi. The Romanesque theme of the Apocalyptic Christ in glory almost disappeared by the end of the twelfth century. Although scenes of the Last Judgment remained prominent, as the cult of Mary became increasingly important, and her intercession frequently portrayed, the judgment featured the hope of salvation more than the terrors of damnation.

New genres and details were created. The most significant innovation: Christ impersonated. He probably first appeared at the end of the Mass talking to Mary Magdalen immediately following his resurrection. From these early tenth-century Latin liturgical episodes enacted by the clergy near the altar, the Church gradually expanded its repertoire of Easter and Nativity themes to full-length plays using various parts of the building.

By the end of the thirteenth century cycles of plays dramatizing scripture from the Creation to the Last Judgment began moving into the marketplace. Exuberant productions performed in the vernacular by secular guilds often engrossed towns for several days. Piety

24

and entertainment mingled freely. Ingenious machinery provided special effects—lifting Christ to the top of the temple for his temptation by Satan, supporting his walk on the sea, multiplying the loaves he touched, withering the fig tree he cursed, and crashing the walls of hell before him. His Passion could require of the actor the stamina of his prototype. In 1437 the town of Metz only averted unexpected realism when the actor fainted and was cut down on the verge of death.

In contrast to these extensive public shows, small private devotional images stimulated contemplative absorption in the mysteries of the faith. From the thirteenth century onward, the "Mercy-seat Trinity" portrayed an enthroned God displaying the Savior on his cross and the Holy Spirit as a dove. Then, as the veneration of Mary threatened to engulf the Church some of her statues opened to reveal the same triune God as the fruit of her womb. Her own birth was sanctified through her "Great Mother" and reflected in images of "St. Anne with the Virgin and Child." Paintings of the annunciation replaced the nativity in popularity. In the devastating plagues and wars of the fourteenth century grief found solace in the "Mother of Sorrows": the seven sorrows of the Virgin's life that foretold the passion of Christ pierce her heart as swords.

Distances of space and time disappear in private devotion. People took pleasure in meticulously clothing small wooden statuettes of the infant Jesus. Or, focusing on small wooden figures of "Christ with St. John," they became one with the beloved disciple leaning on his Master's breast at the Last Supper. Or, above all, they identified with Mary holding her dead Son in the *pieta*, or with the "Man of Sorrows" in one of his many forms: crowned with thorns, standing or sitting alone, an abject, wounded Christ provided lessons of endurance in the face of pain and death. Orthodox icons of a half-length dead Christ—eyes closed, head sunk to his shoulders, arms folded for burial—spread throughout Europe. Some of the most beautiful of all illuminated books, known as "Books of Hours," provided manuals of daily devotion for aristocratic laymen. Their perfect preservation, however, betrays their pre-emptive value as art treasures.

Since the early Church's images had not stressed Christ's humanity or his Passion, creators of both the public plays and the devotional figures embellished their Gospel and liturgical sources with early medieval legends or their own imaginations. The blacksmith's wife, for instance, forges nails for the crucifixion because her husband refused the odious task. Or a servant from the house of the high priest Annas steps to the anvil when the blacksmith pretends an injured hand. Whoever she is, this noncanonical woman with her nails had her moment on stage as well as in medieval sculpture and painting. And the Old Testament continued to provide strained authorizations, such as Christ's beard being plucked by his tormentors in the way Isaiah had endured insult saying, "I have given . . . my cheeks to them that plucked them." The same prophet provided the metaphor for the grim and equally popular image of a bloody Christ being crushed in a winepress.[12] The evangelist Matthew still rides on the back of the prophet Isaiah in a lancet beneath the south rose window of Chartres Cathedral.

Sculpture acquired volume as it moved free of architecture. Christ steps down from his Romanesque aureole of transcendence to bless us at the cathedral door. "Beautiful God," serene and noble, his robes falling in natural folds, the Greco-Roman youth has become a tall, bearded, mature man.

In sculpture, painting, and tapestry, minute detail received attention in a gradual evolution from simplicity to elegance. Mournful scenes of the Passion became as frequent as they were rare in earlier centuries. During the last decades of the fourteenth century and the first of the fifteenth sweet sentiment envelops the Virgin and Child and rampant emotion exposes the pain of crucifixion.

The medieval spirit lingered well into the sixteenth century in northern Europe where painters often expressed our violent, frail, and grotesque nature in a convulsive world. Hieronymus Bosch and Peter Brueghel portrayed Christ surrounded by stupidity and depravity, or lost in a crowd. Matthias Grünewald's most corporeal of all paintings of the crucifixion sanctifies the body in all the horror of that death. Christ's thorn-encrusted head hangs beneath shoulder muscles torn from their sockets. His livid mouth gapes and his fingers claw the air. His abdomen sucked back, knees buckled and ankles askew from body weight, his whole pallid body flayed with wounds, broken bits of wood still stick in the festering flesh. At the foot of the cross the Lamb of God bleeds into a chalice.

Albrecht Dürer, Grünewald's compatriot and contemporary, more than anyone brought the Renaissance across the Alps. From his writing on human proportions:

> Even as the ancients used the fairest figure of a man to represent their false god
> Apollo, we will in chastity employ the same for Christ the Lord, who is the fairest
> of all the earth.[13]

Dürer made his minute studies of people, animals, and flowers for the glory of God; for Leonardo da Vinci, his Italian contemporary, the investigation was an end in itself.

Christ in the Renaissance and into the Modern World

With the Italian Renaissance artists became habitually identified with their work, as they had been in classical Greece. But whereas Plato had denigrated artists as mere tricksters, Renaissance Platonists were convinced that their creative power came from God and that the male nude most clearly reflected God in the world. Working from living models and studying both classical sculpture and dissected bodies, they transformed precisely observed nature into perfect harmonies. Probably in response to Franciscan commitments to the humanity and imitability of Christ, and certainly stimulated by the humanistic studies of the time, Renaissance artists created a fully and ideally human Christ.

Raphael Sanzio's many variations on the "Madonna and Child" bring the child into a warm, exquisite world where every line and color transition is quietly resolved in a perfection of poise and volume. In Piero della Francesca's *Resurrection* the triangular composition symbolizes the subject. Two sides of the triangle rise from the tomb to meet in the eyes of the risen Christ. The light of dawn illuminates his perfectly centered classical body. The trees to the left are bare, to the right they are in leaf: nature is restored. But his eyes hold the memory of pain. He who has emptied himself looks directly at us in an extraordinary painting of Christian love.

Christ's body becomes the supremely confident vehicle of his spirit, now not simply deprived of clothes to express humiliation—as with Adam and Eve, the damned, and some

medieval crucifixions—but in natural proportion, vigorous health, and chaste sensuality. Bodies are seen and celebrated from every angle, nowhere more forcefully and completely than in the painting and sculpture of Michelangelo Buonarroti. His Almighty on the ceiling of the Sistine Chapel, having just created the world, turns and surges out into space with such vigor that his robes swirl open to reveal one of the very few paintings of God's buttocks. On the Chapel's altar wall Christ, with calm certainty in his beardless face, unleashes his whole thick, bemuscled body in a gesture of final judgment that is forceful enough to command not only the hundreds of tumultuous figures in the fresco but the whole Chapel.

The nudity of Michelangelo's marble *Risen Christ* (1514–20; Rome, Santa Maria sopra Minerva), has led one critic to challenge accepted wisdom by seeing the sculpture more in the context of the Renaissance's symbolism than its naturalism.

> *[Michelangelo] must have seen that a loincloth would convict these genitalia of being 'pudenda,' thereby denying the very work of redemption which promised to free human nature from its Adamic contagion of shame . . . This is why Michelangelo in his most Christian moments could look to antiquity for the uniform of the blessed . . . [His] naked Christs—on the cross, dead, or risen, are like the naked Christ Child, not shameful, but literally and profoundly 'shameless.'*[14]

In this new antique Christian synthesis the past paid tribute to Christine truth. But optimistic visions of sheer human potential within a boundless harmonious universe threatened both Apollo and Christ. In the Gothic period renewed concern with observation and individuality had generally conformed to the Church's doctrine and served its liturgical needs. With the Renaissance such concern became increasingly self-sufficient. The Church had become one of the most corrupt institutions in Christendom. With its secular power and moral authority dissipated, the Western Church would soon be rent by the Reformation as divisively as in its earlier schism with Eastern Orthodoxy.

As the Council of Trent developed the Catholic Church's response to the Reformation, the Jesuits, especially, sponsored a theatrical Baroque style in response to the Renaissance. Classical harmony gave way to ecstatic vitality. El Greco's ethereal, elongated Christ stretches all rational restraint. Michelangelo Caravaggio's exaggerated contrasts of light and shade fix attention on Christ's emphatic gesture. Peter Paul Rubens painted a muscular Christ, full of turbulent emotion.

Rembrandt Van Rijn was a Protestant answer to Renaissance idealism. Without the heroic intensity of Michelangelo, the serene classic beauty of Raphael, the ecstatic fervor of El Greco, or the sensuous passion of Rubens, Rembrandt's Christ is worn and wise—the divine incognito who lives among the poor, the afflicted, and the rejected.

Although often working within the Baroque tradition—with light punctuating a picture to pick Christ out as if by a spotlight, or with action stopped at the most dramatic moment as people respond in slack-jawed amazement—Rembrandt also painted, etched, and drew scenes of the most detailed physicality and natural emotion. Without titles who would suspect that some of his domestic scenes represent the Holy Family?

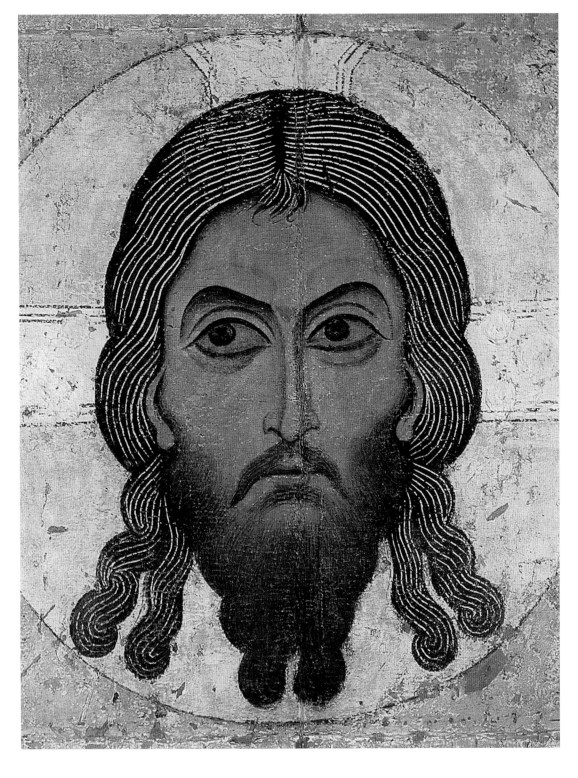

Fig. 76.
The Holy Face. 12th-13th
century, Novgorod, Russia.
Tretyakov Gallery, Moscow

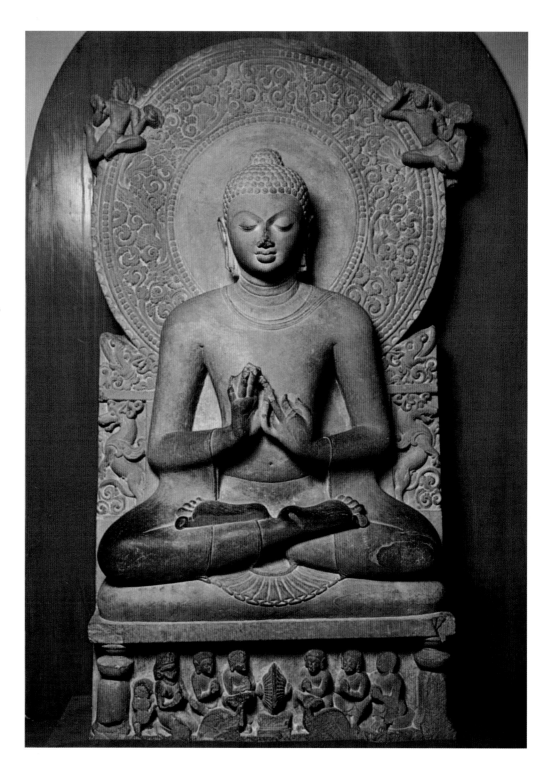

FIG. 77
*Buddha Turning the Wheel
of Dharma.* c. 475-485,
Sarnath, Uttar Pradesh,
India. Archaeological
Museum, Sarnath, India.
Photo from David Snellgrove,
ed., *The Image of the Buddha,*
copyright UNESCO, 1978,
reproduced by permision of
UNESCO

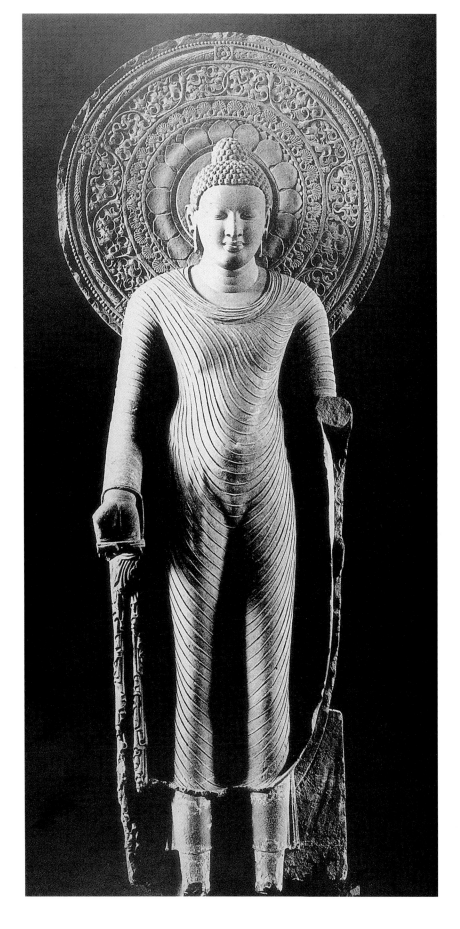

FIG. 78
Buddha. 5th century,
Mathura, India. National
Museum of India, New Delhi

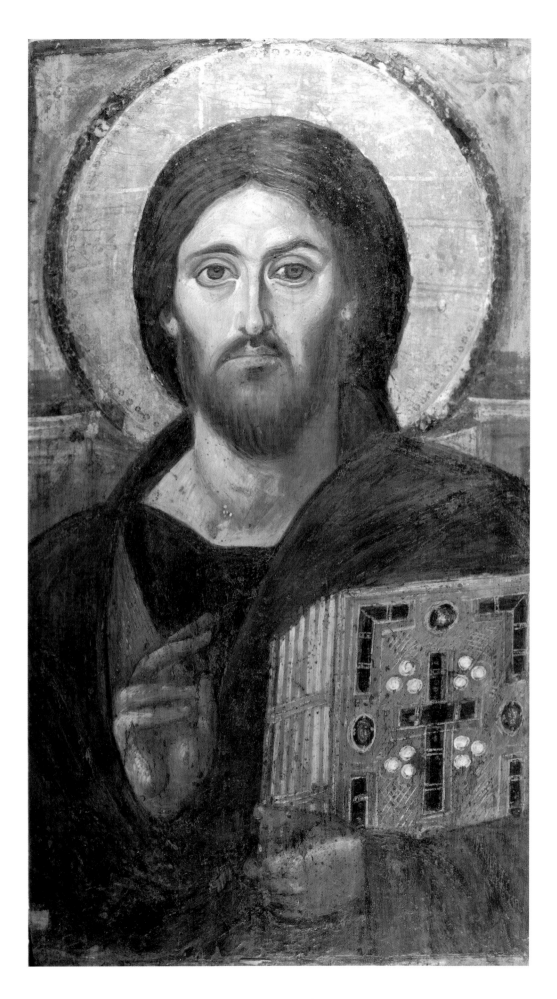

Fig. 79
Christ Pantocrator. 6th
century, Constantinople.
Monastery of St. Catherine,
Mount Sinai, Egypt. Photo
reproduced courtesy of the
Michigan-Princeton-Alexan-
dria Expedition to Mount
Sinai

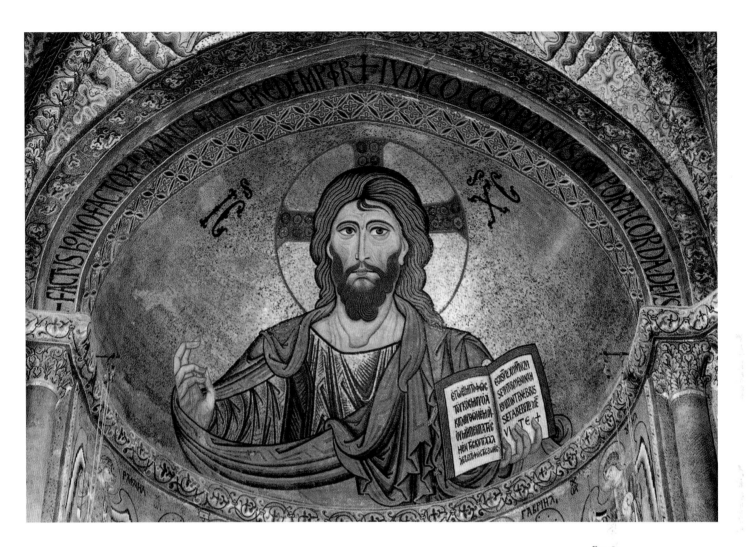

Fig. 80
Christ Pantocrator. 12th
century, Cathedral of Cefalu,
Sicily

Fig. 81
Buddha. 536, Hebei Province,
China. University Museum,
University of Pennsylvania,
Philadelphia. Photo courtesy
of University of Pennsylvania
Museum

Fig. 82
Buddha. 6th century. Long-
men, China. Author's photo

Fig. 83 (opposite)
The Mission of the Apostles
(detail). 1120-32, Church
of La Madeleine, Vézelay,
France. Photo: Foto
Marburg/Art Resource, N.Y.

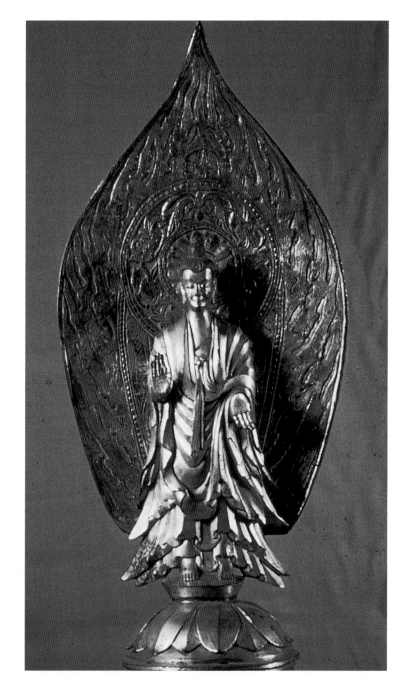

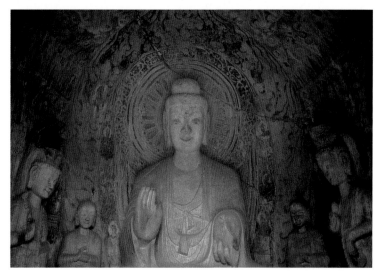

Fig. 84
Buddha Amitabha. 6th
century, China. Arthur M.
Sackler Museum, Harvard
University Art Museums,
Bequest of Grenville L.
Winthrop. Photo provided
by Photographic Services,
copyright President and
Fellows of Harvard College

Fig. 85
Christ. c. 1225, Amiens
Cathedral, Amiens, France.
Photo: Foto Marburg/Art
Resource, N.Y.

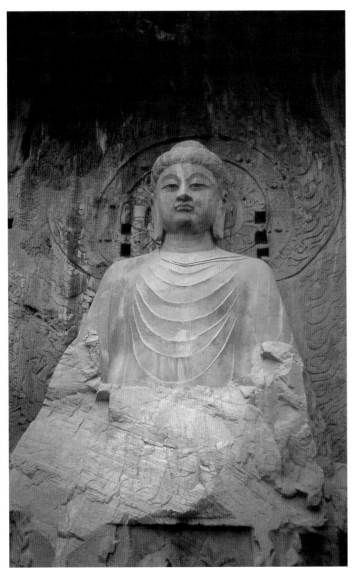

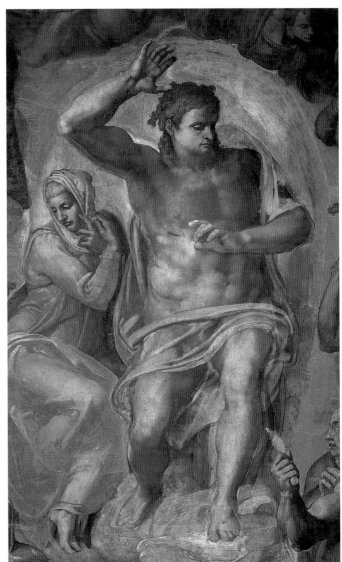

Fig. 86
Vairocana Buddha. 676,
Longmen, China. Author's
photo

Fig. 87
The Last Judgment (detail).
Michelangelo Buonarroti,
1536–41. Sistine Chapel,
Vatican City. Photo: Art
Resource, N.Y.

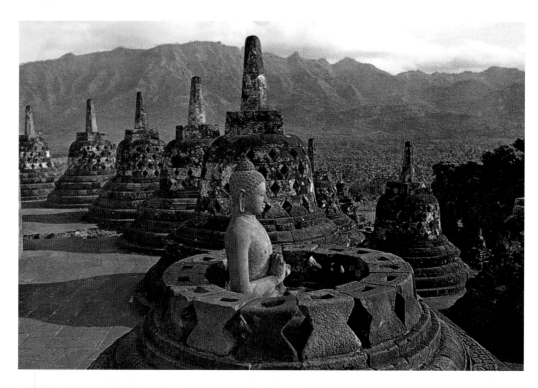

Fig. 88
Buddha. c. 750, Borobudur,
Java, Indonesia

Fig. 89
Buddha. 5th-9th century,
Avukana, Sri Lanka.
Author's photo

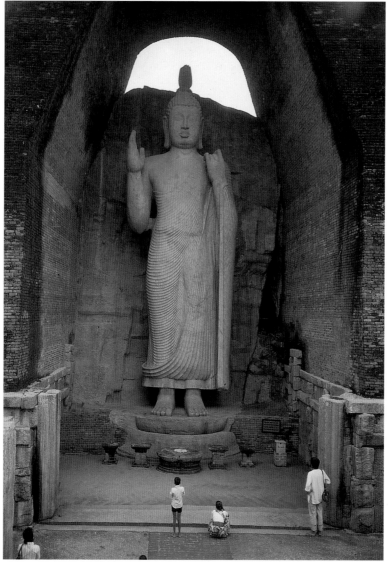

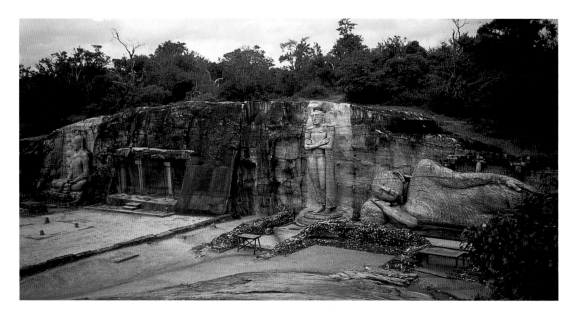

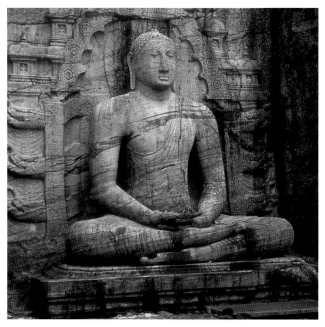

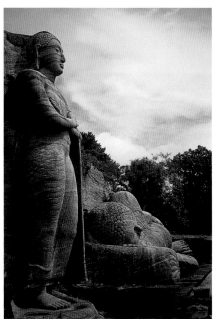

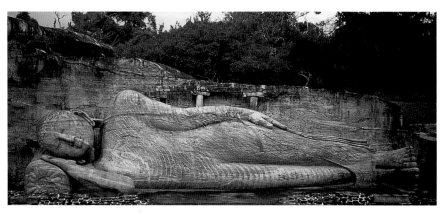

FIG. 90
Buddha (meditating and in
final nirvana) *and* (standing)
his Disciple Ananda(?).
12th century, Gal Vihara,
Polonnaruwa, Sri Lanka.
Author's photos

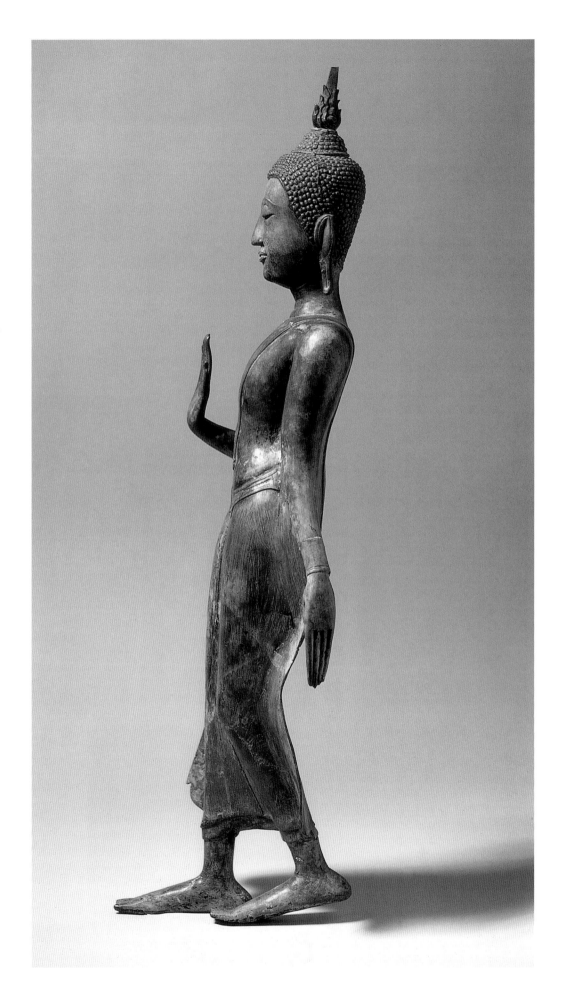

FIG. 91
Buddha. 16th century,
Ayuthaya, Thailand. Photo
courtesy Asian Art Museum
of San Francisco

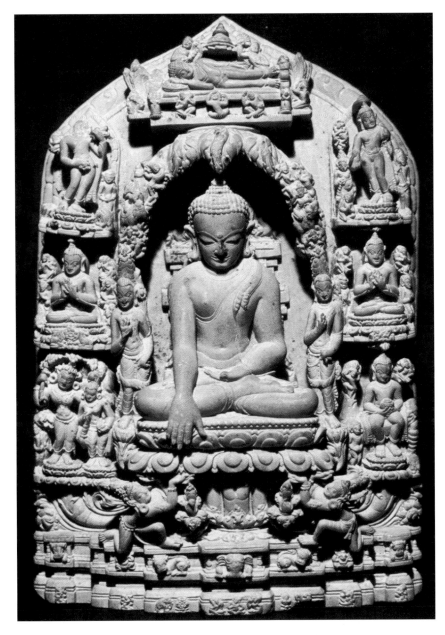

FIG. 92
Buddha, the Eight Great Events. 11th-12th century, Upali Thein, Burma. Pagan Museum, Pagan, Burma. Photo from David Snellgrove, ed., *The Image of the Buddha,* copyright UNESCO, 1978, reproduced by permision of UNESCO

FIG. 93
Buddha. 13th-14th century, Jokhang Temple, Lhasa, Tibet. Author's photo

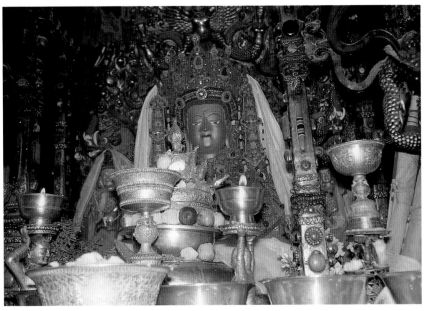

FIG. 94
Sakyamuni Descending the Mountain. Liang Kai, 13th century, China. Tokyo National Museum, Tokyo

FIG. 95 (OPPOSITE)
Buddha. Dharmachari Chintamani, 1978. London Centre of the Friends of the Western Buddhist Order, London. Photo courtesy Windhorse Associates

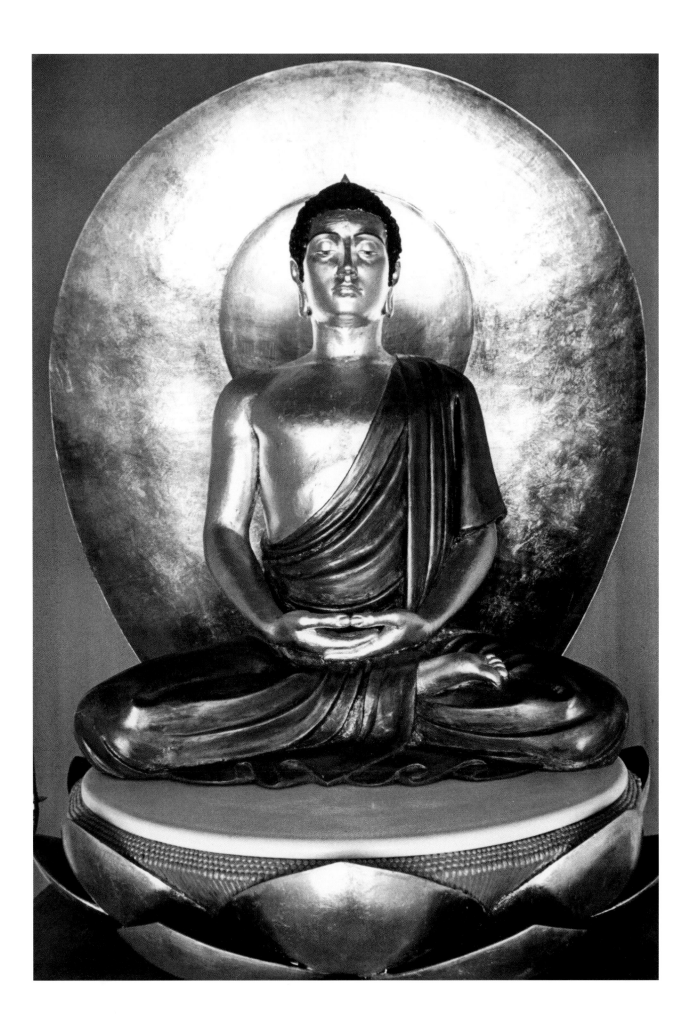

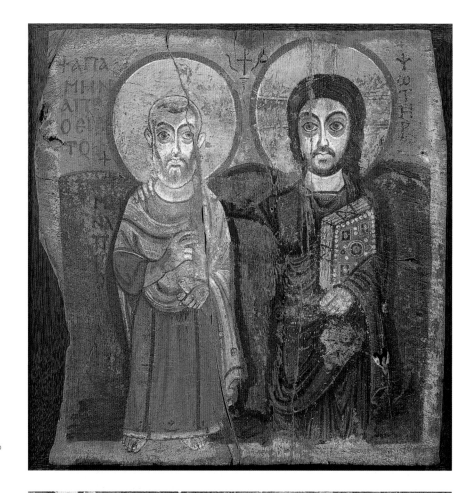

FIG. 96
Christ and the Monk Menas.
6th-7th century, Bawit,
Egypt. Musée du Louvre,
Paris. Photo: Giraudon/Art
Resource, N.Y.

FIG. 97
Christ Blessing and Loaves and Fishes. c. 13th century, Beta
Maryam, Lalibala, Ethiopia.
Photo: Georg Gester,
*Churches in Rock: Early
Christian Art in Ethiopia,* 1970

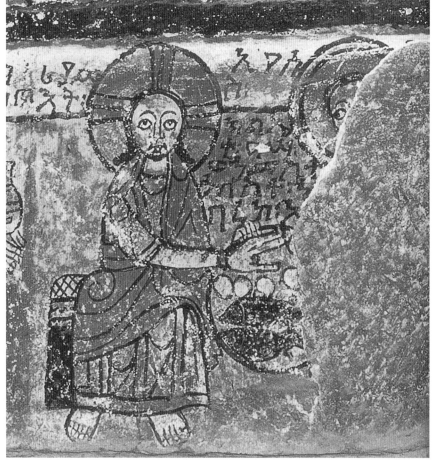

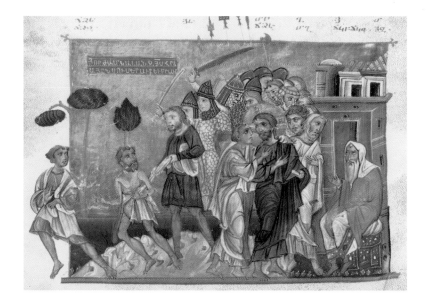

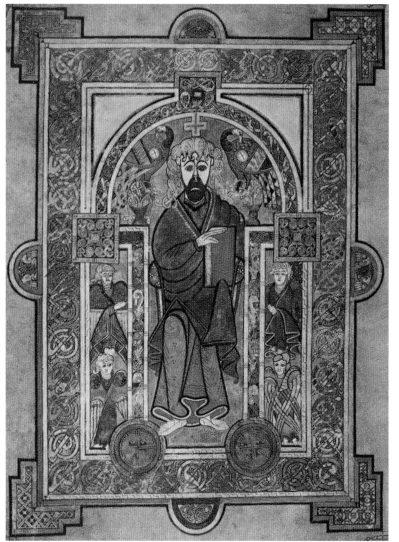

Fig. 98
Betrayal, and Jesus Before the High Priest. T'oros Roslin, 1268, Armenia. Photo courtesy of the Freer Gallery of Art, Smithsonian Institution, Washington, D.C.

Fig. 99
Christ, from the *Book of Kells.* c. 800, Ireland. Trinity College, Dublin.

FIG. 100
Christ of the Apocalypse, from
The Silos Apocalypse. Santo
Domingo of Silos, 1091-1109,
Spain. British Library,
London. By permission of the
British Library

FIG. 101 (OPPOSITE)
Christ, panel 21 from *The
Epic of American Civilization:
Modern Migration of the Spirit.*
Jose Clemente Orozco,
1932-34. Commisioned by
the Trustees of Dartmouth
College, Hanover, New
Hampshire

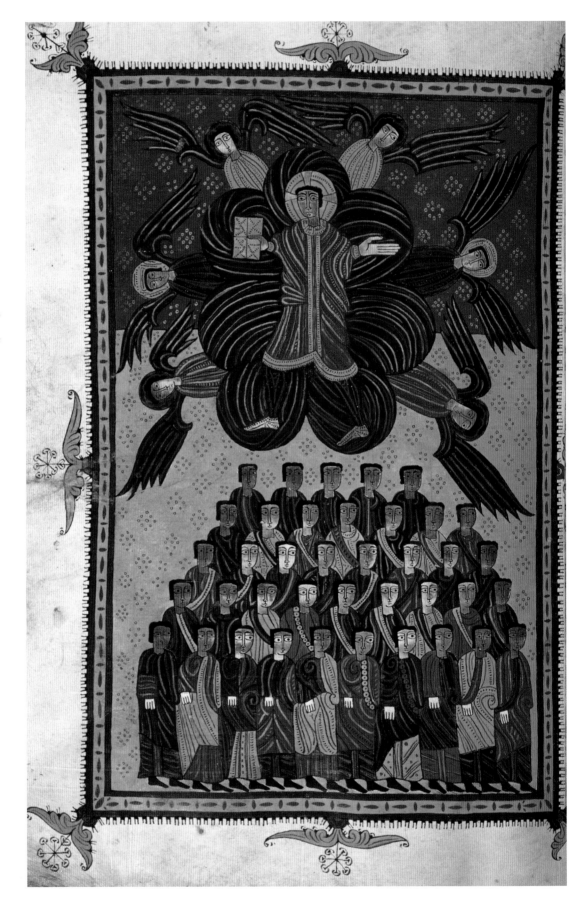

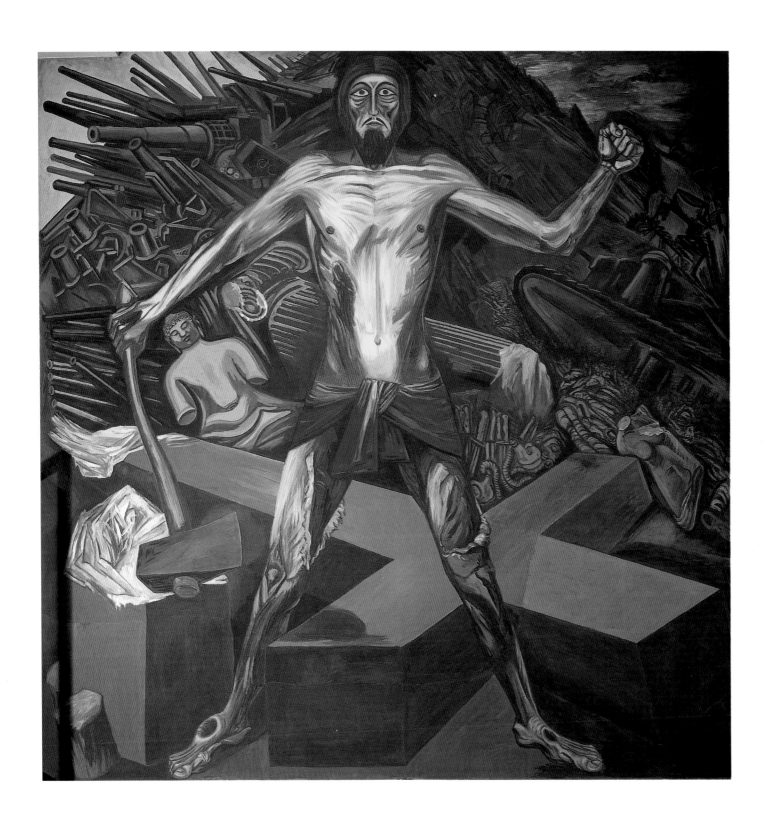

FIG. 102
Crucified Woman. Almuth
Lutkenhaus-Lackey, 1976.
Emmanuel College, University
of Toronto, Toronto. Photo:
Doris Jean Dyke

(OPPOSITE, LEFT TO RIGHT,
TOP TO BOTTOM)
FIG. 103
Buddha Sharini Silva (age 11),
1984. Kandy, Sri Lanka.
Author's photo.

FIG. 104
Jesus. Matthew Henchie (age
10), 1985. Richmond Upon
Thames, England. Author's
photo

FIG. 105
Buddha. Nadie Geetha
Nishanthie (age 7), 1984.
Kandy, Sri Lanka. Author's
photo

FIG. 106
Jesus. E. Powell-Smith (age
11), 1985. Richmond Upon
Thames, England. Author's
photo.

FIG. 107
Buddha. Yasunori Hirano (age
11), 1984. Kyoto, Japan.
Author's photo

FIG. 108
Jesus. Becky Russell (age 13),
1991. Hopkinton, New
Hampshire. Author's photo

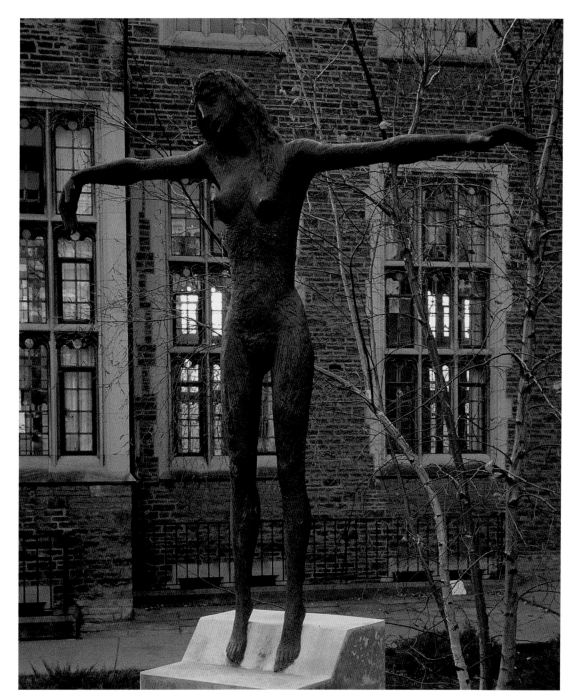

Jesus is

Life.

2

117

Many of his works are relatively small. Since Dutch Calvinists had banished art from their churches, Rembrandt was not constrained by architectural and liturgical needs. The Bible was his inspiration, and no other artist has so consistently and profoundly probed the human elements of its story. He invariably expresses the deepest possible sentiment without sentimentality. His Jewish neighbors probably modeled for his several studies of the head of Christ. The concern in these faces of the man for others allows transcendence only in love.

From the death of Rembrandt in the middle of the seventeenth century until the creative ferment at the turn into the twentieth, the image of Christ in most of Europe and North America reflected an increasingly comfortable piety. In accommodating eighteenth-century rationalism he became an inspired teacher of conventional morality in a neo-classical style. Nineteenth-century romantics saw him reconciling everyone and all of nature in a grand reach for the sublime. With isolated exceptions in folk art and in the private visions of a few paintings by William Blake, James Ensor, Paul Gauguin, and Francisco Goya, his image became as vacuous as Buddha's had become in Asia.

The cult of the Sacred Heart of Jesus was one of the movements of the spirit to escape refinement in the Enlightenment's crucible of reason. This benign Christ points to his wounded flaming heart radiating light, encircled by a crown of thorns, and surmounted by a small cross. When millions think of Jesus they visualize some version of this popular image of Catholic devotion or such melodramatic sentimentalities as Heinrich Hofmann's *Christ in the Garden of Gethsemane* (1890; New York, Riverside Church), William Holman Hunt's *The Light of the World* (1851–53; Oxford, Keble College), or Frederick James Shield's *The Good Shepherd* (late 19th century; Manchester, City Art Gallery) reproduced on the walls of innumerable Sunday schools.

The Expressionist movement at the turn of the century crashed into these strained symbols and idealized appearances with discordant colors and distorted shapes, probing for inward emotional and psychological focus. Georges Rouault reached through his own French Catholic piety back to Coptic and Byzantine portraits and medieval stained glass for an image alternately violent and vulnerable. He painted and etched a Christ of piercing vehemence as well as one of inscrutable sorrow, often disguised in the greasepaint of clowns. Both penetrate all pretension in exposing the sins of the world's kings, judges, prostitutes, and matrons for a cauterizing cross.

Rouault's German contemporary, Emile Nolde, when recovering from a serious illness, turned to Biblical subjects with an overwhelming passion.

> *I obeyed an irresistible impulse to express deep spirituality and ardent religious feeling, but I did so without much deliberation, knowledge or reflection. I stood almost terrified before my drawing, without any model in nature . . . I painted on and on scarcely aware whether it was day or night, whether I was painting or praying. Had I felt bound to keep to the letter of the Bible or that of the dogma, I do not think I could have painted these deeply experienced pictures so powerfully.*[15]

Nolde painted the gospel story, Rouault the archetypal figure. Both artists were solitary men and both painted "deeply experienced pictures" of Christ at a time when Christ was seldom a subject for painters.

The Sri Lankan and Southeast Asian, Tantric, Zen, and Western Buddha

Sri Lanka

Sri Lanka has long been regarded as the fountainhead of Theravada Buddhism because of the island's early conversion in the third century B.C. and its preservation of the earliest known scripture and tradition. Images and texts also confirm an important, at times predominant, Mahayana presence in Sri Lanka from the third century A.D. until the twelfth. From their inception as a Buddhist state until British annexation in 1815, the Sinhalese accepted that only a Buddhist could by right rule the country. Although occasionally severely threatened, the Sangha has survived all the vicissitudes of the island's many struggles with foreign invaders. Buddhism has existed continuously in Sri Lanka longer than in any other land. With few innovative concessions to modernity, it remains a vital force in the private lives of the majority and a formidable political presence.

Anuradhapura, the capital city when Buddhism first came to the island, remained the seat of Sinhalese kings for over a thousand years. Although the earliest Sinhalese Buddha images are in the Indian Amaravati style, those from the Anuradhapura period eventually acquired a characteristically solid masculine appearance and, by at least the seventh century, immensity. This Buddha has no *urna* and a low *ushnisha*. (Auspicious marks were occasionally added or amplified later, as on the famous immense Buddha at Avukana where a modern five-pronged flame rises from his head.) Gestures from this period are restricted to reassurance, meditation, and teaching. When the Buddha's hand rises in reassurance the palm turns toward his face in a peculiarly Sinhalese fashion. When in meditation his legs fold into a wide, flat base. He does not smile. Erect, with broad shoulders and expansive chest, he is self-contained, totally centered, impassive power.

In the eleventh century, during one of the island's periodic recoveries from internal dissension and external invasion, the town of Polonnaruwa became the political and religious center. During the next century at its monastic site now called Gal Vihara, sculptors cut four colossal images from a single scarp of granite: two seated Buddhas, the third, probably the Buddha's disciple Ananda, standing, and the fourth, a forty-six-foot Buddha lying in final nirvana. His head now round with a rather narrow sloping forehead and just the trace of a smile, this Buddha is still sober and majestic, but more supple and approachable. The four figures in the open air continue to attract daily fresh flower offerings. After visiting Gal Vihara, the most famous Trappist monk of the twentieth century wrote in his diary:

> Everything is emptiness and everything is compassion. I don't know when in my life
> I have ever had such a sense of beauty and spiritual validity running together in one
> aesthetic illumination.[16]

In subsequent images the Buddha's robe frequently becomes restless with a thin wavy pattern. Often garishly painted, his body is more orange than gold, his robe more red than yellow, and his cold, bright black eyes remind us that in an early list of his auspicious marks they are blue.

27

89

90

Images made in our time usually return to the sobriety of earlier traditions. Several temple walls in or near Colombo, however, reveal Italian Renaissance perspectives and British Victorian tastes. An image house painted by one of Sri Lanka's most renowned artists, George Keyt, celebrates the traditional episodes of the Buddha's life in sensuous lines and colors with occasional cubist insights. As in most countries, popular greeting cards multiply sentimental images of the Lord for all occasions, and at least two relatively recent colossi in the South demonstrate again that as miniatures can be monumental, size without grandeur can be Disneyesque.

Southeast Asia

The Indianization of Southeast Asia began about the time Christianity and Mahayana Buddhism were first moving into other areas. Image-making followed its usual three-fold process: first, the imports from which craftsmen made copies (more than two centuries elapsed between the introduction of Buddhism and the first extant indigenous images); local workshops then developed an independent tradition that absorbed the original model; finally, a mature, unique ethnic style emerged that was, in turn, exported through assimilation and, occasionally, conquest. The classical period of Indochina, from around 800 to 1350, witnessed the flowering of eminent cultures at Angkor in Cambodia and at Pagan in Burma as well as the beginning of a third at Sukhothai in Thailand. Each culture produced a distinctive Buddha image.

Cambodia

During the first four centuries of Khmer rule at Angkor, when Buddhism was a minority religion, primarily Mahayanist, and often syncretized with Shivaism, Buddha appeared in one of his most singular forms. Heir to several traditions, the primary influence was Dvaravati, a kingdom whose exact boundaries and duration are now lost. From at least the seventh century through the eleventh it populated the center of the Indo-Chinese peninsula with heavy masculine Buddhas. If their clothing shows a late post-Gupta influence, nothing else suggests the delicate voluptuous spirituality of the Gupta style.

Beneath large round curls a broad flat face has a single, almost straight eyebrow over long eyes above high cheekbones, a flat nose with flaring nostrils, and a wide mouth with thick lips in what is known as the "Angkor smile." The flat, horizontal emphasis often results in only engraved double lines for lips and eyes. Sometimes his hair line becomes a broad edging, and his hair tiered into a cone resembles an ornamented cap. Enigmatic expressions of power come through the stone.

The prominence usually accorded the earth-touching gesture yielded to an image related to ancient legends of a cosmic serpent. Following his enlightenment, the Buddha was meditating by a pond when torrential rains suddenly caused the pond to rise. Realizing that the Buddha's concentration was such that he might drown, and remembering a favor he had received from the Buddha in a former life, the serpent-king Mucilinda raises him on his coils, enabling the Buddha to continue meditating under the protective canopy of the serpent's seven-headed hood. Interestingly, a serpent thus becomes the first to recognize the

newly enlightened one and to acknowledge him as Lord. Not a prominent subject in India or the Far East, it attained great popularity in Cambodia, where the great serpent played a major role in the mythical origin of the Khmer kings.

A few images portray him, usually with two attendants, flying on a mythical animal. These earlier Dvaravati flying Buddhas, unlike serpent-supported Buddhas, have no South Asian prototype or textual source. They were apparently made only between the seventh and tenth centuries. One has been found in Cambodia, the rest in Thailand, and no one knows what they signify.

At the end of the twelfth century, with the Khmer Kingdom at the end of its most brilliant period and overextended from the Pacific to the frontiers of Burma, King Jayavarman VII made Buddhism the royal religion. Angkor was soon to decline and Theravada to dominate Cambodia. But during this brief triumph of Mahayana its craftsmen created in the "Bayon style" a very human Buddha, lighter, with fluent surfaces conveying more a sense of consummate tranquility than of impassive power.

Burma

Almost every Burmese village supports a monastery, and a man is considered incomplete unless he spends some time in one. Buddhist festivals fill the year with community activity and opportunities for merit-making. A Burmese tradition remembers the Buddha's visit to Burma, as Sri Lankans remember his visit to their land. Another tradition ascribes the conversion of part of the area to monks sent by Asoka at the time Buddhism was introduced in Sri Lanka in the third century B.C. But the earliest historical evidence of any Buddhist civilization in the area goes back no further than the fifth century A.D.

The ninth century, which had begun with the Khmers establishing themselves at Angkor, ended with the Burmans founding their capital at Pagan. But it was King Aniruddha—a contemporary of William the Conqueror—who converted to Theravada, united Upper and Lower Burma, and founded the dynasty that would bring more than two centuries of peace and prosperity to what would become the most impressive Buddhist city in Southeast Asia.

The ruins of Pagan cover nearly twenty-five square miles. Of the some thirteen-thousand stupas, temples, and monasteries that once studded this plain along a bend in the Irrawaddy River roughly two thousand remain, most of them disintegrating slowly in a huge, silent, sunbaked ghost town. As if affirming the Dharma amidst inevitable impermanence, wall paintings, glazed tiles, and stone reliefs portray episodes from the Buddha's life and his previous incarnations. Statues favor his earth-touching gesture. His disproportionately large head tilts slightly forward, exaggerating a short neck and emphasizing the broad shoulders of his relatively squat body. An expansive forehead balances slit-like eyes, and thin lips curve slightly upward in a bland, almost sweet expression.

After the fall of Pagan, the adornment of the Burmese Buddha increased. He frequently displays a tall projection on his *ushnisha*, and flamboyant ribbons extend from his headdress. His fingers as well as his toes are of equal length. He often sits on a sharply waisted or stepped throne, legs tightly crossed, the soles of both feet visible.

By the early nineteenth century Burmese sculptors portrayed the Buddha more naturally. A wide decorative band runs along his hairline and a prominent decorative robe flap

92

falls from his left shoulder. He may stand, arms lowered, his fingers parting the edges of a sumptuous robe. He is especially well represented in lacquered and gilded wood, more frequently and usually less successfully in marble and alabaster.

Thailand

By the end of the thirteenth century Pagan and Angkor were in decline and King Rama Khamheng, a convert to Theravada, was leading the newly independent kingdom of Thailand to hegemony over the Buddhist lands of Southeast Asia. His capital, Sukhothai, had formerly been a Khmer settlement, and Thai Buddhas reflected the Khmer style until Sukhothai craftsmen developed what was to remain one of the most original of all Buddha images.

Over distended, almond-shaped eyes, long, grandly arched eyebrow lines join to run down a parrot's beak nose to a gentle, sometimes whimsical smile and a pointed chin. Thin, very long ears contain the oval head covered with tight curls from which arises a lotus bud or flame-like spike. From unnaturally broad shoulders his arms, hands, and fingers continue all this fluid elongation. His robe, indicated by only a few lines and a long, narrow band falling over his left shoulder, accents the almost feminine fullness of his chest and thighs. He seldom has a halo.

Although this Buddha's earth-touching gesture remains the most frequent, a position previously rendered only in painting and relief now emerges in the round: the walking Buddha. One hand raised in either reassurance or teaching, his other swings naturally at his side at the end of a jointless liquid line, an elephant's trunk of an arm. His hips curve outward slightly. With the auspicious marks of projecting heels and flat feet, he glides effortlessly.

Bronze is the principal material of this elegant, aristocratic, boldly stylized Sukhothai Buddha. Artists were soon painting temple walls and illuminating manuscripts with charming poetic fantasies of his world. Verging on hauteur, strangely unsensuous, svelte, he may be lotus, but never thunderbolt.

These three distinctive Angkor, Pagan, and Sukhothai images reflect a variety of Indian and indigenous styles; the ethnic features of the Khmers, Burmans, and, to a lesser extent, the Thais; and such religious-political requirements as the Buddha's accommodation to local spirit cults and his visualization as the local king—all quite unrelated to sacred texts. Each, at its best, is Buddha acclimatized, numinous in compassion.

Tantric and Zen Ways

Tantric and Zen Buddhism both appeared late in Buddhist history, about a millennium after the death of Sakyamuni. Although both claim a distinct transmission from the Buddha himself, both drew so heavily on their ancient native cultures that some question their Buddhist credentials. Others find in one or the other the profoundest Buddhist teaching. Both emphasize immediate personal experience. Energy must be properly channeled and reason overcome. It is extremely difficult. Tantric and Zen Buddhists do it differently.

Tantric Buddhism had emerged by the seventh century in Eastern India. As the Diamond Way (Vajrayana), it spread to Nepal and Tibet, then to China in the eighth century, and to Japan, in the sectarian forms of Shingon and Tendai, at the beginning of the ninth. It even infiltrated most of Southeast Asia.

Vajrayana Buddhists understand tantric texts to contain the teachings of the Buddha for advanced meditation. The tantras codify rituals intended to evoke fundamental psychosomatic energy that drives the initiate through all duality to the "unity of secret origin." The way is dangerous and must be learned through the personal guidance of a teacher in a spiritual succession.

The tantric way, more than other Buddhist traditions, values the body as well as the mind in achieving enlightenment. Male and female clearly exemplify and finally dissolve duality when a *bodhisattva* copulates with his female energy in what Tibetans call *yab-yum*. 39
Gaze and bodies interlocked, they express the duality of gender in its most carnal form and almost nullify it in the absolute stillness "when each is both." *Vajra*-handled bells also symbolize this unity of the diamond and womb worlds, male compassionate action and the female wisdom of Emptiness. Chinese and Japanese esoteric sects invariably favor the more abstract symbol.

Dance is the basic art of India. Vishnu danced on the waves of the primeval cosmic ocean, and the world was created. Shiva danced, and the cosmos dissolved into him. Tantric Buddhism expresses the exuberance of the creative and destructive forces of this endless cosmic dance with a pantheon of celestial Buddhas and multi-limbed *bodhisattvas*, their female consorts, and a host of pacific and horrific divinities. As personifications of invisible forces throughout the cosmos and in every psyche, their fantastic colors and forms correspond more to inner visions and dreams than to anything seen in the daily round.

The Buddha's inherent tranquility and gentle humanity are not completely lost in all this voltaic magnificence. He remains at the still hub of the universe in the great bliss of nirvana: motionless, changeless, devoid of duality.

For more than a thousand years tantrism had its greatest triumph in Tibet. The emperor of China and the king of Nepal each gave the first king of Tibet a daughter in marriage. The two princesses reportedly brought with them effigies of the Buddha, thus, as in China and Japan, associating the introduction of Buddhism with the Buddha's image.

By the tenth century, indigenous traditions had combined with Chinese, Nepalese, Indian, and Central Asian influences into the broad square face and often bulky body of a 93
distinctive Tibetan figure. Frequently bejeweled, crowned, and garlanded in scarves, he contrasts sharply with the idea of the ungarnished monk. But Tibetans only elaborated this. Some Gandharan and later Indian and Southeast Asian Buddhas are richly ornamented. They represent the temporal and transcendent ruler, his glorified body of bliss, or the *bodhisattva* prince before enlightenment. Early Theravada commentaries describe the Buddha taking the form of a universal monarch in order to humble and convert an earthly one. Mahavairocana, the primordial Buddha, is always adorned. As Christ in regal robes on the 30, 29
cross anticipates his victory over death, Buddha resplendent in meditation suggests that solitary moment at Bodhgaya wherein he became sovereign everywhere.

Tibetan Buddhas appear in many materials, from gilded bronze to papier-mache or butter, and, most distinctively, when unrolled on rectangular banners (*thankas*). Although originating in India or China, these portable paintings gained wider use in Tibet, where a large part of the population was nomadic. Impersonal, very seldom signed, only a few can be dated. Usually red, blue, and yellow brocade borders represent the building housing the world of the painting. Although of monumental character, *thankas* usually seethe with diminutive figures in the symmetrical compositions and vibrant colors of illuminated manuscripts. Tibetan painters, unlike the Chinese, do not like empty space. Although flat, without perspective or chiaroscuro, most *thankas* would draw the devout deep into Buddha-fields beyond space and time. The central figure of Buddhahood gives the painting its comprehensive spiritual tone. Tibetans call their *thankas* "*mthong grol*," meaning "liberation through sight."

Zen

Legends tell of an Indian prince, Bodhidharma, coming to China in the sixth century to introduce Chan (Zen, in Japan). Bodhidharma is said to have sat in meditation for nine years facing the wall of a cave. Eventually his legs withered away. Frequently pictured as a fierce figure of glaring eyes and bearded jowls, he epitomizes intrepid striving to break all conventional attachments.

As Tantric Buddhism began by reabsorbing Hinduism, Chan was greatly influenced by Taoism. Even more Chinese than Buddhist, it was able to survive the ninth-century persecutions and exert considerable influence for several centuries after Buddhism declined in China. By the thirteenth century Zen was firmly established in Japan.

Gautama gained renewed prominence after being overshadowed by Mahayana's many Buddhas and *bodhisattvas*. We have referred to the popular Zen theme that portrays him haggard, divested of all traditional idealism, returning from the mountain where he had been practicing austerities. In considering the threat of images we have also noted that any traditional Buddha image is superfluous to Zen practice.

Enlightened human beings intuitively grasp the universal unity of existence. When we realize that everything is an extension of ourselves and not external to us, our perception and expression become direct and immediate. Anything, but usually something simple and subtle may awaken us as a Buddha image. Almost empty rooms with the austere lines of straw floor mats and wood skeletal frames supporting the soft light of rice paper walls uniting exterior and interior in spaces that amplify any insight brought to them; walled gardens that open the world by reducing everything to a few things so arranged that nothing more can be said other than that there are stones, sand, and moss; meals of land or sea plants, small portions, only slightly flavored, alive with their own taste; theater suggesting without explaining through masked characters glacially miming or dancing, chanting or silent, on an almost sceneryless stage; the martial arts bringing minds to the point of mindless concentration by directing all energy into the incisive action of a bow, sword, or empty hand; the meticulous ritual of preparing and drinking tea with sober utensils and only incense, a hanging scroll, and a flower to harmonize all the senses of a few guests in a small rustic room; three stems of flowers and any secondary elements arranged in sparce, finely crafted

94

114

accidents; three lines of poetry in seventeen syllables juxtaposing images without comment or transition; questions requiring repetitious returns to themselves in exhausting every logical answer in order to penetrate all duality; black ink painting born of an intention so controlled that nothing is forced from a quickly moving brush in calligraphy of such personal expressiveness the characters may become an art object, or in landscapes with people and their artifacts insignificant in the sweep of nature, or in a single bird or blossom revealing the fleeting fullness of every life, or in comic scenes and grotesque portraits that lance pretension and celebrate paradox—all express the Zen ideal: dry, pithy, and irregular, driving perception beyond all ideas or images into the plenitude of Emptiness.

The Western Buddha

The Buddha has worn so many faces he might now be expected to wear a Western one. The United Kingdom, with more Buddhist organizations per capita than any Western country, may prefigure the Buddha's continuing movement into Europe and America.

When Tissa Ranasinghe was teaching sculpture at London's Royal College of Art, he reached into a corner of his work-strewn office and uncovered a small image he had made. The figure was still emerging from the stone. "The moment of his enlightenment showing compassion and power," Ranasinghe said. "No suggestion of transcendence or any auspicious marks?" "No," he replied. "The Buddha was only a man." His face is as Western as when it was first sculpted at Gandhara. Several blocks away, in the basement of the Buddhist Society, L. Cubitt Bevis sculpted another small Buddha figure. Although seated in the lotus position with hands in a conventional Amitabha gesture and with an *urna* and a head of individual curls, the face clearly fulfills the claim: "an image for the West."

Most of the Buddha images in Britain's shrine rooms are traditional. But not all. Those who meditate at one of more than twenty centers of the Friends of the Western Buddhist Order often sit before Buddha images with Western features. Thomas Lyden's slightly larger than life-size figure in the Glasgow Centre has the traditional long ears but no *urna* or *ushnisha*; he sits on a lotus throne, his gold body full of light amplified in the exploding colors of the canvas behind him. The sculptor Aloka spoke of his work at the West London Centre: "It's not a copy of an Eastern image, it is Western. I was thinking of our own Eric Gill and Henry Moore when I did it." Without any traditional identifying marks, the position and robes suggest a state of meditation more than any particular person. A third sculptor, Chintamani, studied Greek sculpture before portraying what he calls "the most beautiful, serene, and dignified man" in two slightly larger than life-size figures for the London Centre and a small one for the Cambridge Centre. "Why distract Western minds with strange conventions from pre-Buddhist India?" he asked as he considered shortening the long ears of a work in progress.

Will these virile faces, as handsome as any Giorgio Armani model, help Western Buddhists through ancient alien traditions into a realization of the body of bliss?

The North African, Armenian, Celtic, Mozarabic, and Twentieth-Century Christ

Five Churches at the edges of Christendom have left distinctive images of their Christ. Frequently influenced by, but quite distinct from, prevailing Byzantine and Hellenistic styles, many of these images in the arresting abstract forms and bright colors of folk art are congenial with much Western modern art without the latter's subjectivity.

The earliest of these Churches—the Coptic, Ethiopian, and Armenian—have traditions of origin in Apostolic times, and by about the time Constantine was moving the capital of the Roman Empire to Constantinople, Christianity had become the established religion of their lands. In rejecting the fifth-century Council of Chalcedon, they became heretical in the eyes of both Constantinople and Rome. They also shared the fate of being caught in the first waves of Muslim expansion. Responding to isolation and pressure, and lacking the sustained prosperity usually essential for the flowering of an artistic tradition, each Church has preserved to this day an ancient Christianity in its own language and liturgy.

Coptic Egypt

Alexandria—the Egyptian metropolis founded by Alexander the Great, heir to Athenian traditions of learning, center of neo-Platonism, and Mediterranean melting pot—played a decisive role in the intellectual life of the early Church. But it is from the desert to the south that we have received our few images of Christ from the land of the Nile.

Christian monasticism began in the Egyptian desert. At first a few men and even fewer women came seeking total attentiveness to God without the distractions of society. Many followed, "battling the demons of temptation" either as hermits or in communities that would eventually become extensive estates and the source of missionary activity throughout Europe. Removed from much of the theology of the Greek-speaking elite of the Alexandrian Church, the Coptic-speaking monastics of the river valley developed their own spiritual disciplines. They also dispensed with the classical proportions associated with the art of Rome and Alexandria.

More than other early Christian communities, Coptic Christians frequently borrowed themes from Greco-Roman mythology. Dionysus, for example, evoked the vine of the Eucharist; Aphrodite, rebirth in baptism. By the fifth century, with the Church secure in official recognition and the majority of the Egyptian people Christian, artists more frequently portrayed Christ explicitly and a distinctive style characterized their stone, terracotta, wood, ivory, fabric, and painting. Still incorporating many Greco-Roman motifs and generally more concerned with decorative pattern than with representation, figures are usually flat and frontal, short and heavy, and often compelling in their simplicity. If in color, the colors are usually sharp and contrasting. If there are several figures, each usually relates more to the viewer than to one another.

Images of Christ combine Byzantine and Near Eastern features, but this Christ is more informal, less glorious. His large head and halo, symmetrical face with prominent eyes, and rigid, sometimes awkward gestures admit vulnerability and familiarity. The relatively few extant scenes of his life include less well known events from apocryphal gospels. He is frequently portrayed enthroned and surrounded by angels. As the monks were among the first

to take the Virgin Mary to their hearts, he is also frequently seen with his mother. The theme "Virgin Nursing her Child," reminiscent of the Egyptian goddess Isis nursing her son Horus, became especially popular. It may have originated with the monks.

After a brief Persian occupation, Muslims overran Egypt in the middle of the seventh century. The Church never recovered. Islam became the state religion. The Copts, subject to intermittent persecutions, survived as isolated communities sandwiched in the perspective of history between the two great strata of pharaonic and Muslim Egypt. With few exceptions, their art became even more decorative.

Ethiopia

Homer referred to "the distant Ethiopians, the farthest outposts of mankind," and God asked his Israel, "Are you not like the Ethiopians to me?"[17] Ethiopia and Egypt are the only African nations to trace their histories into antiquity. But while successive conquests alienated Egypt from its ancient culture, steep highlands have deterred conquerors and helped preserve Ethiopia's.

Very little remains of the old kingdom and its capital city, Aksum, dominant on both sides of the Red Sea from the third to the sixth centuries and recognized by some of its contemporaries as one of the "four greatest existing empires of the world." In the fourth century its king became a Christian. His bishop had been consecrated in Alexandria, and as Aksumite power waned in the seventh century and Ethiopia began almost a thousand years of complete isolation from the rest of the world, the Ethiopian Church retained this dependence on her neighbor. Until 1950 Ethiopian bishops had all been Copts appointed by the Alexandrian Patriarch.

But the Ethiopians, originally evangelized by Syrian as well as Egyptian missionaries, and drawing on their own pre-Christian heritage, developed a unique Church. Along with ingredients of animism and Islam, they have retained such tinctures of Judaism as Saturday Sabbath, dietary laws, and the legend of a royalty descended from King Solomon and the Queen of Sheba. Ethiopian tradition remembers the illustrious son of this Israelite-African union, Menelik, spiriting the Ark of the Covenant from Jerusalem to Aksum. Replicas of the relic sanctify every Ethiopian church. The Ethiopian emperor was the Lion of Judah.

Primary source and custodian of national culture, the Church has provided a cohesion in Ethiopian life comparable to the role of the Catholic Church in Medieval Europe. When the Marxist government of the 1980s heralded a new national creed of scientific socialism, disestablished the Church, nationalized church land, and imprisoned the patriarch, religious life was hardly effected. The chairman of the Provisional Military Government attended church services.

During periods of relative prosperity from the late twelfth to the mid-fifteenth centuries, the Ethiopians cut hundreds of churches out of their northern mountains. Four in Lalibela are remarkable free-standing monoliths completely excavated from the red rock. The only comparable building in the world is the Kailas temple of Ellora, India.

The murals of these churches and Ethiopian illuminated manuscripts show a special love of the Virgin, but they also abundantly illustrate the central moments in her son's story. Coptic, Syrian, and Byzantine frontality and impassibility combine with Ethiopian features in a distinctive Christ: a close-fitting skullcap head of hair, wide forehead, huge insistent eyes under highly arched brows, long thin nose, small mouth, stubby beard, and

97

long slender fingers with square-cut nails. Painted in a limited number of bright, unmodulated colors, black usually outlines the contours of his body as well as the folds of his robe, which fall stiffly to his large, bare feet. Many of these images were destroyed in a brief sixteenth-century Muslim invasion.

Splendid castles and abbeys attest to another Ethiopian renaissance from the seventeenth century until the middle of the eighteenth at the capital of Gondar. A noble, more elegant Christ appears with the same characteristically long nose and fingers and small mouth, but now almond eyes animate a more narrow face surrounded with wavy hair and a carefully groomed beard.

119

A seventeenth-century Gondaran manuscript painting of Christ healing two blind men was obviously derived from an Antonio Tempesta woodcut (*Four Gospels*, 1591; London, British Library). The Gondaran painter, in eliminating the natural shading, modeling, and perspective of his Roman model, has provided a striking picture that could not have been painted in Europe nor could it have been painted before the sixteenth century influx of Jesuits into Ethiopia. The European scramble for Africa would bring all the Western norms into often uneasy alliances with the bold naivete of the traditional Ethiopian Christ.

Armenia

Occupying the high plateau to the north of Mesopotamia between the Black Sea and the Caspian, Armenia has been a perpetual battlefield and frequent target of its imperial neighbors. Since the seventh to sixth century B.C., when the Armenians emerged as an ethnic group, they have been subjugated by the Persians, Greeks, Syrians, Romans, Byzantines, Arabs, Turks, Mongols, and Russians. This ancient people, who have enjoyed only sporadic periods of independence, have managed several innovations in scholarship, liturgy, and the arts.

When Gregory the Illuminator converted the king of Armenia to Christianity within a few years of the beginning of the fourth century, Armenia forthwith became the first country to make Christianity a state religion. During most of the nation's history, when the nation has existed only in its culture or in exile, the Church has remained a bulwark of national unity. Today the Armenian Apostolic Church guides the religious life of millions of Armenians scattered throughout the world, its spiritual home still the monastery of Echmiadzin, the see established by Gregory in the shadow of Mount Ararat, where the auspicious landing of Noah's ark is said to have assured the survival of us all.

Armenian manuscript illumination probably began soon after the invention of the Armenian alphabet at the beginning of the fifth century, but no manuscripts survive from this period. Considering the vast number destroyed during the country's many devastations, the almost uninterrupted manuscript tradition that does survive from the ninth century to the eighteenth confirms their importance.

Gospel Books were the painter's principle enterprise. Lavishly ornamented canon tables of parallel passages in the four Gospels, as well as portraits of the evangelists and the sponsor, often accompany key scenes in Christ's life. Families passed their Gospel Books from generation to generation. Monasteries attracted pilgrims with celebrated ones known for their curative and protective powers. As the Greek churches paraded their icons before battle, the Armenians paraded their sacred books. Monasteries, libraries, museums, and private collections now preserve about twenty-six thousand of them.

Armenian miniatures show many influences. Generalization in such a volatile history is even more perilous than usual. Sometimes in these paintings Christ, with his Hellenistic clothes and gestures framed in classical columns and architraves, resists any transcendence. Occasionally he has oriental features. Often he is simplified and stylized with expressive intensity. At times sumptuous decoration almost consumes him. Usually he is more natural and more dramatic than the grander Byzantine Christ he most resembles.

Originality and excellence culminate in many works from Cilicea, where, in 1198, following a migration to southwestern Anatolia, the Armenians established a new kingdom that was to last almost two hundred years. Relative prosperity and political stability prompted patronage: commissioning a manuscript was a pious act comparable to building a church.

Contact with the Crusaders and Mongols had introduced the Armenians to art from the Latin West and East Asia. In this new eclectic environment important scriptoria interpreted the Gospels in a fresh manner. Characterized by precise and elegant drawing, both brilliant and subtle colors against gold backgrounds, richness of ornamentation and inventive fantasy, buildings and landscapes are schematically suggested, but figures are delicately modeled with natural expressions. Exuberant narratives of Christ's life unfold in compositions full of action and emotion.

Celtic Ireland

Patrick, patron saint of Ireland, came from Britain in the fifth century to win the island for Christ. For about thirty years the Bishop spread the gospel, ordained clergy, and founded monasteries. Before the end of the seventh century he was a legend. Certainly the monasteries he encouraged, practically the sole repository of literacy, remained the essential structure of the Irish Church and the nation's stability until the Norse invasions of the ninth century.

The names of Coptic monks in Irish missals and similarities between some Coptic and Irish works that probably exceed worldwide parallels in folk art, suggest Coptic contacts with these Irish monasteries. But the Irish image of Christ roots in a much older Celtic tradition whose origins lay buried with the "fathers of Europe" several centuries before Christ. The Celtic chieftains and their image-makers remained largely ignorant of Mediterranean ideals and forms dispersed throughout the Roman Empire. In the sixth century Irish missionaries began infiltrating Scotland and Northern England, and by the eighth a Celtic-Saxon fusion was rolling out an avalanche of sophisticated abstract design.

Almost all of the world's archaic cultures reveal a fascination with repeating, alternating, intersecting, inverted lines in rhythmic curves and symmetrical order. When the Celts were converted, this prehistoric tradition became the repository for their Christian imaginations on metalwork, stone crosses, and especially in their illuminated manuscripts.

Wonderfully but not merely ornamental, these lines sprang from associations with natural universal energies: plants, flames, running water, the sun. When human beings or animals are represented, only minimal identifying features distinguish them from the rhythms and shapes they share with all creation. On stone crosses clerics attack a bird eating a man, bird-headed men with axes pin a human head between their beaks, cats eat frogs and fish, hunters ride, warriors march, dragons wait. In Gospel Books animals and humans telescope into each other, contorted into spirals, imprisoned in the interlaces. On crucifixion emblems Christ usually fills the cross, clothed in a network of ornament with only a spear

98

and a sponge bearer beneath his stubby arms. This fierce imagery caught in the smallest space with maximum movement takes us to the edge of confusion. Christ barely forges through in his own geometric reduction, the power source of primordial pulsating patterns.

By the end of the sixth century the Church of Rome had a vigorous missionary campaign in the south of England. In the middle of the seventh century the Irish Church in predominantly Celtic Northumbrian England met the Roman Benedictines from the south at the Synod of Whitby in a dispute over church practices that was to determine future authority. Rome prevailed. "A few men in the corner of the remotest island" were brought into conformity with the "Church of Christ throughout the world."[18] At the end of the next century Vikings began destroying the great Irish monasteries. Irish monks were ardent missionaries, however, and they had carried their Christ into the far reaches of Europe, where he would become a part of that amalgam known as Romanesque.

Mozarabic Spain

Under Muslim rule southern Spain was the most highly civilized area in Europe. From the end of the eighth century, when the Muslims finally conquered the last of the Christian Visigoth kingdoms, through the eleventh century, when the Reconquest began to make the peninsula a part of Romanesque Europe, Spanish Christians who did not convert to Islam achieved an uneven but usually tolerable assimilation with their conquerors. Called "Mozarabs" (like the Arabs), most adopted Arabic culture and speech. Many took Arabic names. They usually lived in special sections of the cities where they had their own laws and governors, freedom of worship, and the contempt of their neighbors. But many emigrated north to the Christian kingdoms protected by the Catabrian mountains, where several monasteries produced a remarkable apocalyptic tradition.

Since the first convulsions of Arab invasion the monks most popular Biblical book had been the final one. They interpreted the heresies rampant in the Church and Islam's triumph throughout most of the land as harbingers of the end of the world. Visions of the Antichrist's defeat and the Second Coming on the Day of Judgment offered comfort and hope. Around 776 one of these monks, Beatus, integrated several previous commentaries in his *Commentary on the Apocalypse*. It became immensely popular. Twenty-six illustrated copies from the ninth to the thirteenth century survive.

The figures and their relationships in these paintings, like *The Apocalypse*, reflect not the subtleties of the natural world but bold visions of another time and place. Story and doctrine are represented schematically, all illusion of plasticity banished in vibrant colors and fantastic shapes. Massed or swirling through zones of heaven, air, and earth, people and animals collide with dizzying effect. Almost a hundred distinct figures may make a great emblem.

Celtic and Mozarabic artists patterned an almost vanquished darkness with vigorous imagination: the Celts primarily through line, the Mozarabs emphasizing color. Dramatically, these Mozarabic pages are closer to Armenian Cilicean miniatures than to Coptic and Ethiopian scenes, but their childlike forms suggest the Africans more than the Armenians. In their burning intensity, emblematic arrangement, and simplicity on a heroic scale, they are unique revelations of cosmic catastrophe and salvation.

The Christ of these illuminated manuscripts resembles the rigid elongated figures around him. Often distinguished only by his size and halo, beardless, grave, heavily

swathed, his bulging eyes and exaggerated hands command. Elements of Visigothic folk art have combined with Islamic, Carolingian, Byzantine, and Syrian painting in a disturbing image of nothing less than the beginning and the end, the Son of Man coming with clouds to establish a new heaven and a new earth.

The Twentieth-Century Christ

Individual initiatives occasionally relieve the general banality of images in twentieth-century churches. Henry Moore's sculpture, *Madonna and Child* (1943; Northampton, St. Matthew's Church) directly across from Graham Sutherland's painting, *Crucifixion* (1946) charges the transept of an English church with the extremities of Christ's life in the repose of the stone and the anguish of the paint. In a California chapel Stephen De Staebler's *Crucifix* (1968; Berkeley, Holy Spirit Chapel, Newman Hall) hangs off-center, alone, and relatively small on an otherwise unrelieved cement wall. Broken in its fired clay pieces, the almost bare, bald, earthen man rises up, one with his cross. Ivar Lindekrntz's figure in wood, *The Resurrected* (1956; Trollhattan, Hoppets kapell) rises out of the streets of Sweden, young, blond, handsome, and unmarked. If untitled and not on a church wall, he wears white shorts or bathing trunks.

In modern pluralistic societies the relatively few artists who make images of Christ usually work out their personal visions with little corporate consensus. We find their work in museums more frequently than in churches. Their Christ is often in pain, seldom in glory.

Marc Chagall and Francis Bacon painted several crucifixions. The suffering love of Chagall's thoroughly Jewish Christ expresses the common denominator of Judaism and Christianity. Bacon's raw, horrific scenes thrust up the havoc wrought by and upon everyone. Pablo Picasso's *Corrida Crucifixion* (1959; Paris, Musée Picasso) conflates his country's two ancient ritual sacrifices in a series of emotionally charged sketches of Christ-matador. Gender almost overwhelms reactions to the realistic bronze crucifixes by Edwina Sandys and Almuth Lutkenhaus. A strong nude woman hangs from a stark white cross in Sandys' *Christa* (1975; sculptor's collection). Lutkenhaus' *Crucified Woman* stands cruciform without a cross in a garden, reflecting winter snows or summer leaves, constant only in the beauty of her body and the pain of her face.

Salvador Dali's beautiful, popular, sanitized *Christ of St. John of the Cross* (1951; Glasgow, Art Gallery and Museum), *Corpus Hypecubus* (1954; New York, Metropolitan Museum of Art), and *The Sacrament of the Last Supper* (1955; Washington, D.C., National Gallery) share a dreamlike quality with the very different turbulent assaults of Francesco Clemente's *The Fourteen Stations*. Equally uninformed by the gospel, Dali's virtuoso posturings retain references to Church tradition, while only the title of Clemente's nightmares places his series in the long line of self-portraits of the artist as Christ.

Since his story was first represented, Christ has seldom appeared as a first-century Palestinian. He usually wears the clothing and moves among the scenery and artifacts of the artist's time and place. Epiphanies continue to trump history, as in the urban poverty and loneliness of Georges Rouault's *Christ in the Suburbs* (1920; Bridgestone Museum, Tokyo), in the scenes of Christ among the people of Stanley Spencer's English village of Cookham, in contemporary Hatian life surrounding Christ in Wilson Bigaud's paintings, and in the almost imperceptible figure lost among the skyscrapers of Roger Brown's *The Entry of Christ into Chicago* (1976; New York, Whitney Museum of American Art).

Through its particular light and angle, every photograph of an image is a new image. Paul Strand's camera confers as much reality as it records in *Christo with Thorns* (*The Mexican Portfolio*, New York, 1967). A few fronds poking onto whitewashed walls animate a traditional Mexican sculpture of the Man of Sorrows, the points of the living plant analogous to the thorns in the crown of death.

While the Mexican painter Jose Orozco was in the United States, he painted an epic fresco of Latin American civilization in the basement of a library. The drama culminates in an appalling vision of Christ returned. Staring fiercely at us, he stands astride the cross he has destroyed, axe in hand, his back to the ruined emblems of our wars and idolatries. With the same urgency, many Latin American, Asian, and sub-Saharan African artists have broken European conventions to portray a thoroughly indigenous savior. Poverty breeds this liberator from oppression. Let one represent each continent. *The Tortured Christ* of the Brazillian sculptor, Guido Rocha (1975; Nairobi, All Africa Conference of Church's Training Center) screams at us, amplifying the Baroque pathos of Spanish and Portugese Catholicism, now castigating rather than confirming old dominions of class and color. Bangong Kussudiardja's batik Javanese cruciform Christ (second half of the twentieth century; Geneva, Private Collection) soars before circles of blazing color in an apocalyptic vision of the Son of Man. Engelbert Mveng's Cameroon crucifixion fresco (second half of the twentieth century; Douala, Cameroon, Liberman College) is just as distinctively African, using only black, the West African color of suffering, white, the color of death, and red, the color of life. From both the Javanese batik and the African fresco the arms of Christ reach out more in supplication than in blessing.

First Impressions

At about four years of age children throughout the world move from scribbling to the conscious creation of forms. Hardly surprising, their first representational figures usually are people. By the age of ten or eleven these people no longer consist of geometric lines, schematic figures with large heads, hands, and feet. They have become individualized, more closely related to what the child has actually seen. Exaggerated body parts are replaced by "an accumulation of details on those parts that are emotionally significant."[19] Children's drawings give us intimate, immediate insights into the relationships they have established with what they are representing.

When I asked young girls at a Sri Lankan school to draw the Buddha, they drew mostly feminine figures. Most of the young boys in a Japanese school drew virile men. Almost all of these Sri Lankan and Japanese pictures, however, include a traditional symbol, position, or gesture and they invariably suggest a reverence for their subject, as if he were of a different order from themselves.

Almost all the children in two churches in England and two in the United States drew a masculine Jesus. But several saw him as their contemporary: in two drawings he wears torn jeans, in another he carries a guitar. While crosses figure in most of the drawings from two Anglican churches near London, only one cross appears from the rural congregational churches in New Hampshire. In these the sun shines, trees grow, Jesus stands above a globe. One girl drew a cat and wrote "Jesus is Life."

101

103, 105
107

104
106

108

At the Limits of Abstraction and Representation

Christ—the Word made flesh, moving into the world of individuals—is more suscep-
tible to images deriving their power from perception and representation. Buddha—
awakening to Bliss, moving away from the world's contingencies—more frequently
takes us to the limits of conception and abstraction.

Actors and Mandalas

Actors

Motion attracts attention. Parishioners in medieval churches on Palm Sunday saw a wooden donkey bearing a statue of Christ drawn down the nave. On Ascension Thursday they saw a statue of Christ rise slowly from the floor of the choir until it disappeared through a hole in the roof. On Easter Monday, when they saw a stranger join the two travelers going to Emmaus walking in their church, they saw Christ in person. The actor had assumed the features of the Church's images, and his particular interpretation would in turn influence subsequent images. Actors are the final step in representation.

Since medieval Church plays were a natural development of the dramatic tendency inherent in all liturgy, it is not surprising that this most potent religious representation is also the most dangerous in its potential for abuse. Every gesture glosses the gospel. By the sixteenth century these plays "had mingled the Gospel text with a thousand fables, a thousand platitudes, and a thousand coarsenesses."[20] Towns began proscribing them. But religious theater has been irrepressible since at least Paleolithic times, when cave paintings of dance dramas affirm the immemorial alliance of myth and ritual.

Oberammergau's Passion Play and the Yaqui Indian Waehma ceremony suggest the variety of Passion pageants that have invigorated, instructed, and entertained towns throughout Europe and America. Both originated in the seventeenth century, when the citizens of a small Bavarian village vowed a production every ten years in gratitude for surviving a plague and when the Jesuits introduced Christian drama to the Indians of Mexico.

Oberammergau's decennial all-day spectacle now begins with a press performance in May and then runs five days a week through September for about half a million visitors. Reservations made long in advance for combined hotel, meals, and admission assure seats in the spacious theater.

The stage opens to the sky where clouds declare or threaten the Lord of heaven and earth. Scenes progress from his entry into Jerusalem through his death to his resurrection, interspersed with Old Testament prefigurations, all to choral and orchestral accompaniment. Hundreds of statuesque figures appear to have stepped from recently cleaned Renaissance paintings. The actors wear no makeup. Many are from the same families whose ancestors originally pledged their play to God. All must be native Oberammergauers or have lived in the village for at least twenty years.

Two years before "Passion Year" every household may present nominees for the double-cast major parts to a local committee, chaired by the parish priest. The committee makes final choices by secret ballot based on moral reputation as well as acting ability and, especially relevant to the leading role, resemblance to the traditional image.

The Waehma celebrated by the Yaqui of Northern Mexico and Arizona begins with the first Friday of Lent, intensifies every Friday, and reaches its climax during Holy Week. It is the most important event of the year. Two ceremonial societies, promised by vow to the service of Jesus, organize, supervise, and play a major role in the drama that, just as at Oberammergau, touches in some way the lives of all the men, women, and children of the village.

Although the central theme of the Waehma is the Passion, the narrative focuses on the evil forces who pursue Jesus until they capture and crucify him, and the restoration of order and goodness when flowers (the transfigured blood of Christ) ritually kill the evil ones, who throw their masks and swords into a great fire. The Lenten liturgy, deer dances, and fiestas punctuate the thirty to forty episodes that are enacted primarily in pantomime and procession. The Waehma begins and ends in the church. But most of the action takes place in the plaza and around the fourteen stations of the cross surrounding the plaza. Occasionally it runs throughout the town. Sticks clap, rattles shake, and flutes, fiddles, and drums stir the heat and dust. Christ is represented by statues and crosses, never impersonated.

When motion pictures were born at the turn of the century, prizefights and the life of Christ became this potential new art form's most popular subjects. Since then Christ has seldom been off the screen.

Cecil B. DeMille began the first day's shooting of the most expensive of all silent movies, *The King of Kings* (1927), with prayers from a Protestant, Catholic, Jew, Buddhist, and Muslim. In another generation representatives of various faiths watched director George Stevens pour water from the Jordan River into the Colorado River prior to the first day's shooting of the considerably more expensive *The Greatest Story Ever Told* (1965). In still another generation, Martin Scorsese's team heard daily Bible readings before mixing the sound track for *The Last Temptation of Christ* (1988). But the best of the many Biblical epics must be the one made by a Marxist atheist on an economy budget: Pier Paolo Pasolini's *The Gospel According to St. Matthew* (1964).

Pasolini filled the screen with jarring images. Close-ups of unforgettable faces and long shots of distinctively composed crowds particularize the familiar story. A zoom lens or abrupt movements from a hand-held camera pull us into the action. Natural sounds, brief silences, and music ranging from Bach to Leadbelly wrench our emotions through long scenes without dialogue. By filming in black and white and adhering to the most Jewish of the Gospels, drawing only on its language, and, like the Gospel, avoiding transitions between scenes, Pasolini has scaled down detail to focus on the revolutionary character of the story. Non-professional Italian actors in an arid southern Italian landscape give the film

an integrated impression of antiquity. A Spanish college student who happened to be visiting in Rome, Enrique Irazoque, hurls this Christ at us. Demanding total commitment, he draws the pain of the world's sin into himself. Hard love in a cold fierce flame.

But any impersonation reduces our symbolic space, especially within a movie's rich audiovisual recipe for illusion. Whatever elements the actor abstracts from the gospel, he seriously threatens numinous distance. Can this Jesus be the Christ?

Abandoning the Palestinian setting provides greater mythic opportunity. In Jules Dassin's *He Who Must Die* (1957) and Denys Arcand's *Jesus of Montreal* (1989) the actor portraying Christ in a passion play eventually assumes his identity. Through the play within a play we gain sufficient distance to challenge our perceptions of Christ without violating them.

Elements of plot, character, or dialogue in any drama may allude to the gospel story. Or a single scene may suggest a traditional image, as in Ingmar Bergman's *Cries and Whispers* (1973) when Anna holds the dying Agnes in a *pietà*, or in Luis Bunuel's *Viridiana* (1961) when the director's vision of unenlightened compassion focuses on the beggars' parody of Leonardo da Vinci's *Last Supper*, or in Scorsese's *Raging Bull* (1980) with Jake LaMotta's blood-spattered body cruciform on the heavy rope, the arena's light a halo around his bowed head. Or the central character may open the whole film to intimations of the Christ event, as in Milos Forman's *One Flew Over the Cuckoo's Nest* (1975), when McMurphy comes to a mental hospital and in Percy Adlon's *Bagdad Cafe* (1988), when Jasmin comes to a desert cafe. Outsiders, fools wiser than all the others, in their concern for total strangers McMurphy and Jasmin confront authority and bring joy and peace into distraught lives. McMurphy finally dies for the others and rises to new life in the Indian crashing through the hospital window to freedom. Jasmin, faced with immigration regulations, must abandon her magic tricks and leave the cafe that soon sinks into its former stupor, with only her picture on the wall, until she returns and accepts a marriage that will permit her to stay at the cafe forever.

The Buddha has been relatively resistant to theater. Plays depicting the life of Gautama may have been more common in the earliest Buddhist communities. King Bimbisara was said to have ordered a performance. Temples and traveling monks have propagated Buddhist teaching by enacting scenes such as Amitabha Buddha saving a dying girl by placing his heart in her chest. And in Theravada lands young men often reenact the Great Departure prior to entering monasteries. The day before ordination a candidate dresses to recall Prince Siddhartha and rides a horse in procession around his community as attendants hold umbrellas over his head to signify royalty, he enjoys a party in the evening that recalls events at the palace, and the next day he rides his horse from his home to the monastery.

But there are no Buddhist parallels to Christian Mystery Plays, and the motion picture industries of India and Japan have each produced only one major film biography of the Buddha. Western audiences can see a lavish production of Siddhartha's progress to enlightenment in Bernardo Bertolucci's *Little Buddha*.[21] In grafting Siddhartha's story into a story of Tibetan monks selecting an American boy as the possible reincarnation of an eminent lama, and in portraying Siddhartha's life through the eyes of the boy reading a story book, Siddhartha's spiritual journey becomes anecdotal and undemanding. Sumptuous scenes join life of Christ epics as spectacle without mystery.

In Theravada countries any impersonation of the Buddha on stage or in film is still considered sacrilege.

F̲ɪɢ. 109
Shaka. Directed by Kenji
Misumi, 1965. Photo: Japan
Film Library Council

F̲ɪɢ. 110
From the Manger to the Cross.
Directed by Sidney Olcott,
1912. Photo courtesy National
Film Archive Archive/Stills
Library, London

F̲ɪɢ. 111 (ᴏᴘᴘᴏꜱɪᴛᴇ)
*The Gospel According to
St. Matthew*. Directed by Pier
Paolo Pasolini, 1964. Photo:
British Film Institute

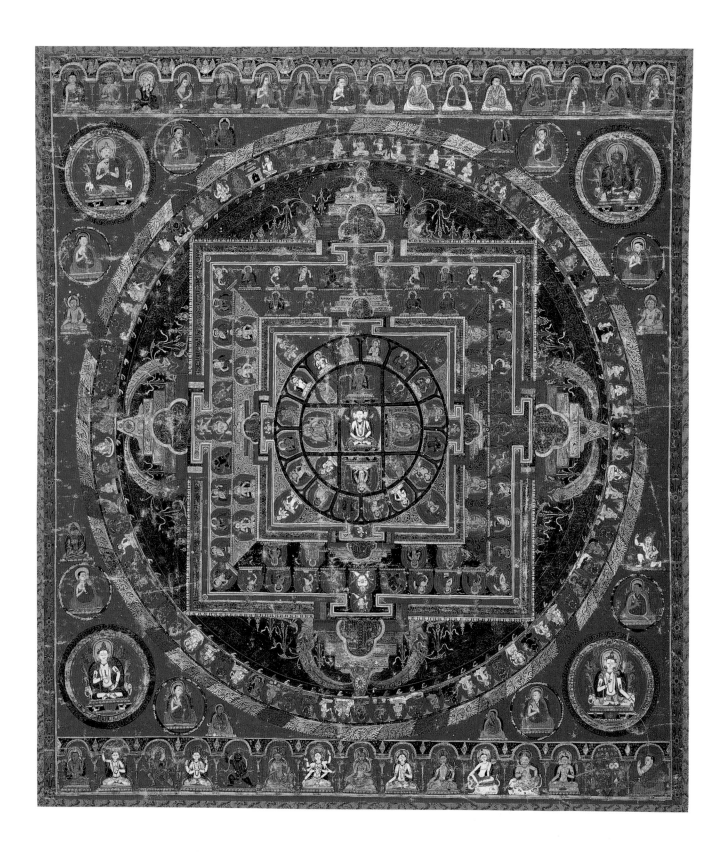

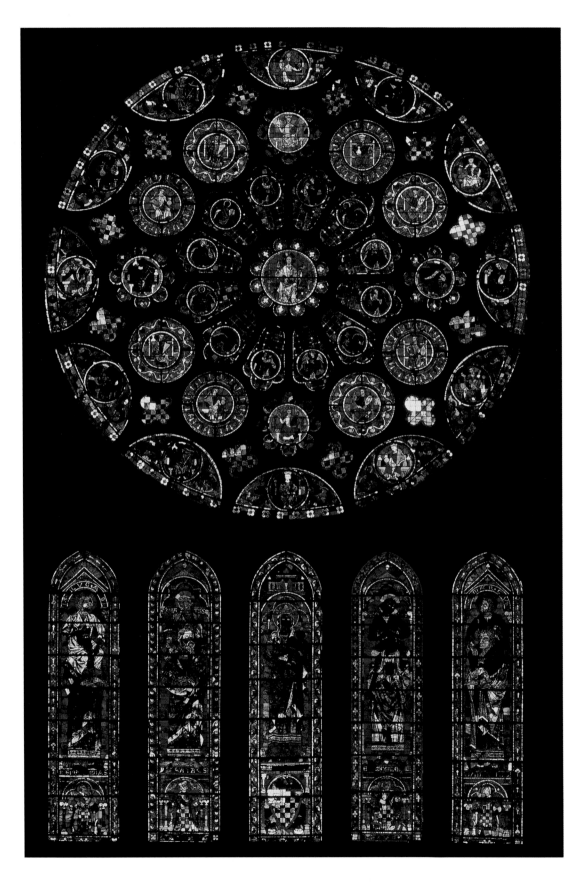

FIG. 112 (OPPOSITE)
Mandala of Vairocana. 17th
century, Tibet. Gift of John
Goelet. Courtesy Museum
of Fine Arts, Boston.
Copyright 1999 Museum of
Fine Arts, Boston.

FIG. 113
South Rose Window, Chartres
Cathedral. c. 1230. Chartres,
France. Photo: Erich
Lessing/Art Resource, N.Y.

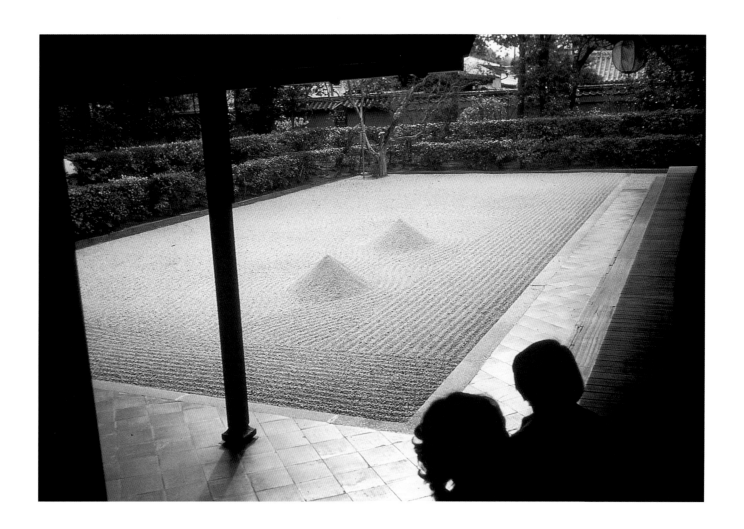

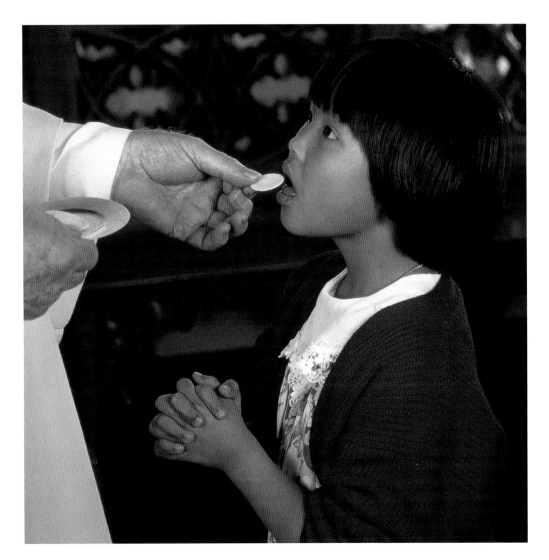

FIG. 114 (OPPOSITE)
Zen Garden. 16th century,
Daitokuji, Kyoto, Japan.
Author's photo

FIG. 115
Receiving the Host. 20th
century. Photo: Tony Stone
Images

Mandalas

The original, eternal sounds from whose vibrations all Buddhas and all things developed may be expressed as "seed letters," (*bijas*), highly concentrated symbols of Emptiness. When Mahayana Buddhists write, see, or say these Sanskrit syllables in the proper spirit, or bring them together as mantras, they may form images or sounds so sacred that their constant vision or recitation will yield health or safety, or will, finally, condense all experience into Emptiness. Vibrations from the mantric stage of meditation may produce multicolored rays of light that condense into mandalas, giving visual shape to metaphysical concepts that can not be verbalized. Mantras and mandalas complement each other. They concentrate energy.

Initiates in meditation visualize themselves within the Buddha-fields of mandalas. Others admire or analyze them. The symbols of these simplified diagrams of vast realms are as esoteric and consistent as the signs of chemistry or physics. Like scientific formulae, they would enable adepts to penetrate appearances and reduce the complexity of the cosmos and themselves to an integrated unity.

Typical of Nepalese and Tibetan mandalas, an outer circle of the flames of the world of change and suffering denies access to the uninitiated while consuming the spiritual impediments of the faithful. Concentric circles, expressing elements of purified consciousness, contain a square with four gates oriented to the four cardinal directions. Finally, centered in this divine mansion at the nucleus of the internal and external world a Buddha figure or symbol (like the Christ in a rose window) energizes all the geometry.

Japanese Shingon temples preserve one of the most fully developed mandala traditions in their complementary "Diamond World" and "Womb World." The former, to the right of the altar-image, represents *vajra*-wisdom, the active knower, in nine squares of equal size in three rows of three each. The spiral movement of this assembly begins with the central square, then moves down, then clockwise. Centered in the central square a circle contains Dainichi (Vairocana), the primordial Buddha. His "wisdom fist" gesture encloses his erect left forefinger in his right fist (living beings held in wisdom or wisdom hidden by appearance, and the union of masculine and feminine). Dainichi's energy manifests itself outward as the four other encircled cosmic Buddhas. The five are enclosed in a circle that in turn generates four tangential circles, each of which repeats the pattern of the central circle, this time with *bodhisattvas* emanating from the four Buddhas. The five large circles containing the twenty-five smaller ones are themselves contained in a single circle of *vajras* supported by the deities of earth, air, fire, and water and surrounded by a square full of Buddhas past, present, and future. In the middle of each side of this enclosure a *bodhisattva* invites us in, past the guardians and *vajras* of the outer border. The eight other squares of the Diamond World are variations on the central square's theme of radial manifesting wisdom, ranging from a single Dainichi in the center of the upper row to symbolic objects replacing human forms in the second and final squares of the spiral. Exactly 1,461 figures, each in a prescribed color and form, populate this most meticulous mystical diagram of Shingon Buddhology.

The correlative "Womb World," to the altar-image's left, represents lotus-compassion, the repository of truth. Less complex than the "Diamond World," its central square encloses a large eight-petaled red lotus. At its center Dainichi now sits in meditation, radiating on each petal the cosmic Buddha of each main direction alternating with a *bodhisattva* for the

intermediate directions. *Vajras* separate the petals, and at each corner of the square they pierce empty vases, affirming the unity of the two mandalas. Constellations of related Buddhas, *bodhisattvas*, gods, goddesses, and guardians fill the surrounding twelve rectangular zones, each with a special significance and function but all representing the compassionate unfolding of different aspects of the primordial Buddha.

Every Shingon temple has both mandalas. Within the inseparable integration of the knower and the known, one is the principle of the other. Apparently static, they actually embody perpetual cycles of energy as their centrifugal force flows from the source of wisdom and compassion through their assemblies to the phenominal world while simultaneously drawing individuals on the periphery through the same assemblies to the mind of enlightenment at the center.

The many types of mandalas in many media—from painted silk to colored sand to stone monuments—establish order. This world of defined boundaries and symmetrical forms provides sacred space for liberation. Mandalas "give birth to the Buddhas."

Bodies as well as minds are extended at Java's huge twelve-hundred year old stone mountain mandala of Borobudur. Incomprehensible from the outside, the monument draws us into itself by one of four steep stairways at the middle of each of the four sides, corresponding to the four primary directions. We enter from the east and begin walking clockwise through narrow, roofless galleries of innumerable images cut into more than 1,300 panels on four steeply tiered, concentric, rectangular terraces. We then climb to three tiered, concentric, circular platforms where suddenly there are no walls or reliefs, but seventy-two identical, unadorned, heavily latticed stupas surrounding a single apparently solid stupa at the summit.

The ways in which the Buddha presents himself have prefigured our ascent. Scenes of Sakyamuni Buddha's previous lives give way to those of his final life until his first preaching of the Dharma at Sarnath, and these, in turn, yield in the upper galleries to the pilgrim Sudhana's long search for the Dharma. The vitality and sensuous beauty of many of the scenes delights us even as their meaning remains obscure. In the niches of the terraces hundreds of life-size figures of four of the cosmic Buddhas sit facing outward in disengaged solitude. Their gestures and direction identify them. Within each stupa on the circular platforms the supreme cosmic Buddha, Vairocana, scarcely visible through the lattice, turns the Wheel of Dharma. In the final central stupa the Buddha retires completely as the whole structure resolves into a single point and dissolves into the sky. The intricate form of Buddhism's largest mandala has finally, like all mandalas, centered us beyond all forms.

In the West, centuries after the most creative period of making rose windows, painters returned to abstracting the order and energy of the world, now onto rectangles of canvas. The paintings of Paul Cézanne, like any mandala, reduce reality to its essential form. But this austere French father of twentieth-century art intended his paintings to reference this form only in the paintings themselves and in the objects painted: each dry, flat brush stroke of color building up the spheres, cones, and cylinders of the actual volumes of the visible world. It was his successors who expected the form of painting to reveal spiritual reality without reference to recognizable objects. Vasili Kandinski's lines, shapes, and "sounding colors" replicate inner emotions that would take us to the creative spirit concealed in matter. Piet Mondrian's subtly varied grids in black and white and primary colors would

88

visualize the universal law of "dynamic equilibrium." Finally, Kazimir Malevich's "supreme reality" of a white square on a square white canvas, Ad Reinhardt's "timeless" trisections of black on black, and Yves Klein's monochromatic blues of "limitless space" accompany Sanskrit seed syllables to the dialectical desert between image and emptiness.

Few have attempted to visualize Christ without a body. Barnett Newman did not intend his *Stations of the Cross* (1958–1966; Washington, D.C., National Gallery of Art) to illustrate the traditional events. His fourteen paintings are devoid of human form. On wheat-colored canvas vertical tones of black and white ask:

> *Why did you forsake me? Why forsake me? To what purpose? Why?*
> *This is the Passion. This outcry of Jesus. Not the terrible walk up the Via Dolorosa,*
> *but the question that has no answer.*[22]

When informed by the title and text, does the contemplation of these stark verticals in their subtle variations of light and darkness take us through the crucifixion of Christ to his ultimate pain, his abandonment by God?

Mark Rothko, a contemporary of Newman and, like Newman, a New Yorker and Jewish, painted fourteen flat, amorphous rectangles to enclose us in an octagon called the Rothko Chapel in Houston, Texas. The paintings are all and only the color of dark blood and wine and blackness. Are they Stations of the Cross? Are the nine in tryptych form with raised central panels emblems of the crucifixion?

Newman's paintings are of human scale; Rothko's are larger. Newman's invite us into spaces charged with energy; Rothko's great voids and veils resist penetration as they envelop us. The paintings in each group interpret and intensify one another. They defy reproduction. As mandalas are traditional and precise, these paintings are personal and volatile. Without answers, they are without borders. Remove the words that accompany Newman's paintings, appreciate the Rothko Chapel's ecumenical intention, and Christ dissolves.

115, 114 Celebration of the eucharist and meditation in a dry garden bring Christians and Zen Buddhists to the ultimate abstraction. In receiving Christ as bread and wine Christians perpetuate an historical event; in meditating on sand and stone Buddhists obliterate time. Christ lives in Christians and Buddhists realize their Buddha-nature through these most impersonal elements only because they have seen in a human figure the incarnation of ultimate reality.

"Christ! What are patterns for?"[23]

In confronting the external forces of nature and society and the internal depths of ourselves—which we neither fully understand nor control—we live by the symbols we assimilate and project. Through the integration of these symbols in mythic patterns, we find meaning and security. Buddhists and Christians visualize perfection in the all-embracing Person through whom they would become whole. They see him, bearing an Indian or Semitic inheritance, in all the variety of their own physical features and intangible values.

The same symbolic process transforms the surface realities of our world into vehicles of religious commitment and into works of art. Just as Buddhists and Christians transform the

historical Gautama and Jesus into the sacred symbols of Buddha and Christ, artists transform their perceptions of the world into art. A religious fundamentalism that understands symbols literally is like an asceticism that considers only the style of art: both ignore the symbolic power that reveals the depths of human experience. Both religious incarnation and aesthetic embodiment validate themselves in the decisions and actions of the lives they empower.

In mediating this transforming power images of Buddha and Christ express that which finally has no name. Names distinguish and finally there is no distinction; we call by name and finally there is silence; names imply knowing and finally there is mystery. But such intimations of transcendence seldom disturb the world of discrete entities in which we live. As persons we personify, evaluate, and organize. Faced with two cosmic lords, one becomes subservient to the other: Buddhists have considered Christ a *bodhisattva* and Christians have seen Buddha as a saint.

We never mistake the Enlightened One for the Anointed One. There were two men. We tell two stories. We see two faces. Buddha and Christ are not always saying the same thing in different languages, nor can they be assimilated in some simple dialectical unity. Buddhists remain enraptured by the Buddha as the definitive expression of wisdom and compassion; Christians find Christ the decisive expression of truth and grace.

We sense in all the great images of Buddha and Christ, however, something of the same self-emptying love at the heart of the sacred. Such disparate forms as the Gupta Buddha and the Byzantine Christ have as their common denominator the power to evoke this liberating, numinous experience. Similarities in the images are more pronounced when they express this common religious experience in a common primordial form, as in the expressionist Wei Buddha and Romanesque Christ or the classical Gupta Buddha and Renaissance Christ.

Human beings move from self-centeredness toward the joy and peace of wholeness in both Buddha and Christ. Commitment to one need not exclude the other. Indeed, both may so inform minds and hearts as to make religious identity a process of interconnected Buddhist and Christian commitments. Distinctions between Buddha and Christ, as between art and religion, become no less real for being provisional. And, of course, an aesthetic experience of these images wherein the world has found some of its most significant art requires neither Buddhist nor Christian commitment.

Ultimate reality resists definition. Every age refashions its Buddhology and Christology according to its insights, anxieties, and aspirations. Graphic truth, like discursive truth, is a continuous creation and remembrance. Art, like religion, not only roots within a particular culture, it is also a judgment on itself and the culture that nurtures it.

Break appearances to see through them. But then we see only appearances. Buddhists looking at an image of Buddha see the form of Bliss; Christians looking at an image of Christ see the mask of God; and whoever we are, when looking at the great Buddha and Christ images we see the beauty of holiness alive in love.

The world has a face.

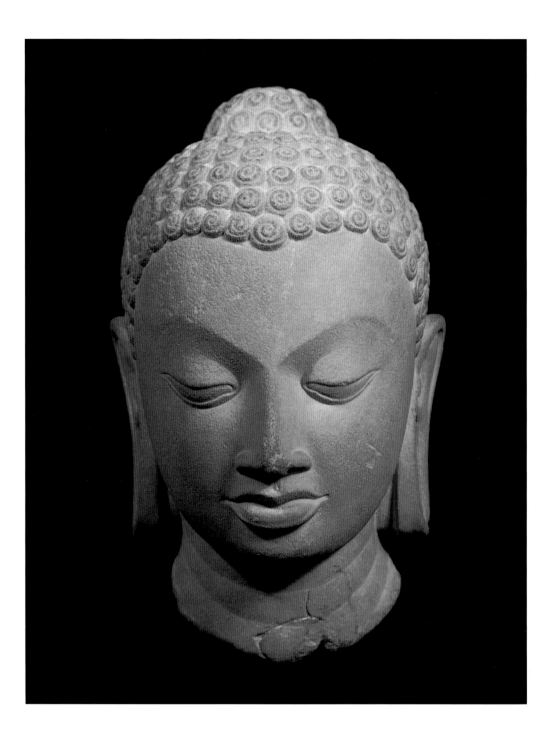

FIG. 116
Buddha. 5th-6th century,
Sarnath, Uttar Pradesh.
National Museum of India,
New Delhi

FIG. 117 (OPPOSITE)
The Holy Face. Georges
Rouault, 1933. Musée
National d'Art Moderne,
Paris. Photo courtesy
Collections Mnam/Cci
Centre Georges Pompidou

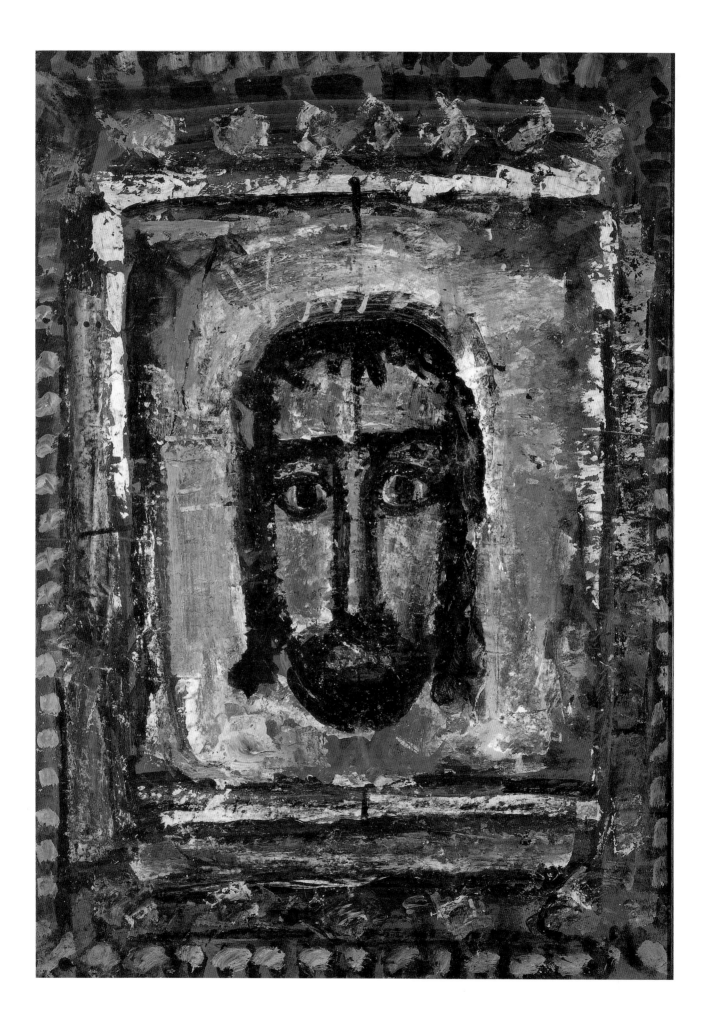

Notes

Prologue: Lords of East and West

1. *Majjhima-nikaya* I.37; Isaac Watts, "Joy to the World! The Lord Is Come," *The New Century Hymnal* (Cleveland, Ohio: 1995), 132; Kobori Sohaku, in an interview with the author at Daitokuji, Kyoto, March 9, 1984.
2. Jacob Epstein, *Epstein: An Autobiography* (New York: 1955), p. 236.
3. *Mahavagga* I.11; *Matthew* 28:19-20.
4. *Matthew* 5:17; *Samyutta-nikaya*, XII.65.

Part 1: The Cage of Form

1. Lu Chi, "Wen Fu," Part I; William Butler Yeats, *Letters of W.B. Yeats* (New York: 1955), p. 922; Thomas Mathews, *The Clash of Gods: A Reinterpretation of Early Christian Art* (Princeton, NJ: 1993), p. 10.
2. The best biographical study of Gautama in English remains Edward Thomas' *The Life of Buddha: as Legend and History* (London: 1949). For an analysis of the resurgence of the quest for the historical Jesus that began in the 1980s, see Bruce Chilton and Craig A. Evans (eds.), *Studying the Historical Jesus: Evaluations of the State of Current Research* (Leiden: 1994). For a briefer and more accessible account, see Marcus J. Borg, *Jesus in Contemporary Scholarship* (Valley Forge, PA: 1994).
3. *Sutta-nipata* 955; *John* 7:46.
4. Nicene Creed; *John* 8:58.
5. K.C.S. Paniker, quoted in Richard Taylor, *Jesus in Indian Painting* (Madras: 1975), p. 73.
6. *Lalitavistara* 85.1; William Butler Yeats, "The Magi," *The Variorum Edition of the Poems of W.B. Yeats* (New York: 1957), p. 318.
7. *Udana* V.5.
8. *Luke* 19:9.
9. Khenpo Tsultrim Gyamtso, *Progressive Stages of Meditation on Emptiness* (Oxford: 1986), p. 23; *Matthew* 16:24; *Galatians* 2:20.
10. *Dhammapada* XV; *John* 15:11.
11. *Samyutta-nikaya* XXII.87; *John* 14:9; *Majjhima-nikaya* I.142; *John* 3:36.
12. Sangharakshita, *A Survey of Buddhism* (Glasgow: 1993) p. 67.
13. Origen, *Commentary on the Song of Songs*, I; Honorius of Autun, *Commentary on Canticles*, quoted in Erwin Panofsky, *Early Netherlandish Painting: Its Origins and Character* (Cambridge, MA: 1953), I, 145.
14. *Revelation* 12.1.
15. Quoted in Leonid Ouspensky, *Theology of the Icon* (New York: 1978), p. 73.
16. *Samyutta-nikaya* I.33; *Galatians* 3:28.
17. *I John* 4:8; *Amitayur-dhyana Sutra* II.18.
18. Eugene O'Neill, *Long Day's Journey into Night* (New Haven, CT: 1956), p. 153.
19. *Revelation* 8:1; *Vimalakirti Nirdesa Sutra* 9.
20. *Dhamapada* XVI.

21. *I John* 4:9,10,19.

22. Augustine, *John's Letter to the Parthians*, VII.8; the Zen teaching is quoted in Heinrich Zimmer, *Artistic Form and Yoga in the Sacred Images of India* (Princeton, NJ: 1984), n. 37, pp. 220f.

23. *Mahavagga* VIII.26; *Matthew* 25:40.

24. Kukai, *Major Works* (New York: 1972), p. 145; P.D. Ouspenski, *A New Model of the Universe* (New York: 1934), p. 369.

25. *Sutta-nipata* 548-550; *Digha-nikaya, Agganna Sutta* 8; *Majjhima-nikaya* I.163; *The Twelve Deeds of Buddha: A Mongolian version of the Lalitavistara*, fol. 9r; Ashvaghosa, *Acts of the Buddha*, V.26.

26. *Isaiah* 53:2; Clement of Rome, *Letter to the Church of Corinth*, 16:3; Origin, *Against Celsius*, VI:75; Tertullian, *On the Flesh of Christ*, IX.

27. M.R. James, ed., *The Apocryphal New Testament* (Oxford: 1960), p. 478; quoted in Adolph Didron, *Christian Iconography* (London: 1886, reprinted 1965), II, 394f; Margery Kempe, *The Book of Margery Kempe*, 85.

28. Irenaeus, *Against Heresies*, I.25; Augustine, *The Trinity*, 8.

29. Hsuan-tsang, quoted in Samuel Beal, *Buddhist Records of the Western World* (London: 1906), I, 235f.

30. Pablo Picasso, quoted in Patrick O'Brian, *Picasso* (New York: 1946), p. 455; Wallace Stevens, "On Poetic Truth," *Opus Posthumous* (New York: 1969), p. 237f.; Paul Klee, *On Modern Art* (London: 1949), p. 49f.

31. Paul Tillich, "Art and Ultimate Reality," *Cross Currents*, X (1960), 5.

32. G.W.F. Hegel, *Early Theological Writings* (Chicago: 1948), p. 196; Albert Einstein, *Out of My Later Years* (London: 1950), p. 92; Laura Jensen, "Window Views," *Shelter* (Port Townsend, WA: 1985); Issa, quoted in Harold Henderson, *An Introduction to Haiku* (Garden City, NY: 1958), p. 139.

33. *Agni Puranam*, quoted in Ulrich Von Schroeder, *Indo-Tibetan Bronzes* (Hong Kong: 1981), p. 54; Desiderius Erasmus, quoted in Michael Camille, *The Gothic Idol* (Cambridge: 1991), p. 229-30.

34. *Sri-maharajaphairava-tantra*, quoted in B.N. Goswamy, *An Early Document of Indian Art* (New Delhi: 1976), p. 24; Cennino Cennini, *Il Libro dell'Arte: The Craftsman's Handbook* (New Haven, CT: 1933), II, 16; Fotis Kontoglous, quoted in Constantine Cavarnos, *Byzantine Sacred Art* (New York: 1957), p. 69.

35. Quoted in David Jackson and Janice Jackson, *Tibetan Thanka Painting* (London: 1984), p. 13; Maxim Gorky, quoted in Heinz Skrubucha, *Introduction to Icons* (Recklinghausen: 1961), p. 54f.

36. Alighieri Dante, *The Convito*, III; Sukracarya, *Sukranitisara*, quoted in Ananda Coomaraswamy, *Mediaeval Sinhalese Art* (New York: 1956), p. 153.

37. For one of the earliest lists see *Digha-nikaya Lakkhana-Sutta* I.2.

38. *Amitayur-dhyana Sutra* II.17.

39. *Citralaksana*, quoted in Goswamy, *op. cit.*, pp. 80-103. Other documents offer similar measurements: see E.W. Marasinghe, ed. and tr., *The Bimbamana of Gautamiyasastra as heard by Sariputra* (Delhi: 1994), Phanindra Bose, *Principles of Indian Silpasastra* (Lahore: 1926), Jitendra Banerjea, *The Development of Hindu Iconography* (Calcutta: 1941), p. 316f., and Ulrich Von Schroeder, *op. cit.*, pp. 32f. For Tibetan iconography see Jackson, *op. cit.*, pp. 45-57, 144-147.

40. *Sariputra*, quoted in Coomaraswamy, *op. cit.*, p. 156.

41. Quoted in Egon Sendler, *The Icon: Image of the Invisible* (Redondo Beach, California: 1988), p. 111.

42. Plotinus, *The Enneads* V.8.

43. Klee, *loc. cit.*

44. *Exodus* 20:4; *Genesis* 1:27.

45. *Scriptores Historiae Augustae*: Severus Alexander, XXIX; Lactantius, *The Divine Institutes*, II.18.

46. *Canons of Elvira*, quoted in Hans Belting, *Likeness and Presence: A History of Images before the Era of Art* (Chicago: 1994), p. 145.

47. Epiphanius, quoted in Cyril Mango, *The Art of the Byzantine Empire 312-1453: Sources and Documents* (Englewood Cliffs, NJ: 1972), p. 42f..

48. Basil, *Homily on the Forty Martyrs*; Paulinus of Nola, *Carmen*, 27.

49. Gregory I, quoted in Charles Garside, *Zwingli and the Arts* (New Haven, CT: 1966), p. 90.

50. Quoted in Stephen Gero, *Byzantine Iconography During the Reign of Constantine V: With Particular Attention to the Oriental Sources* (Louvain, Belgium: 1977), pp. 86ff.

51. Dionysius of Fourna, *The Painter's Manual* (London: 1974), p. 64.

52. Quoted in Roudolf Berliner, "The Freedom of Medieval Art," *Gazette des Beaux-Arts*, XXVIII (1945), 280 n.

53. Basil, *On the Holy Spirit*, 18.45; John of Damascus, *On the Divine Images* (New York: 1980), p. 18f.

54. Quoted in Mango, *op. cit.*, p. 168f.

55. Inscription around a ceiling of the throne room of the palace, quoted in Anthony Bryer and Judith Harrin, eds. *Iconoclasm* (Birmingham, AL: 1977), p. 184.

56. Gregory II, quoted in Hans von Campenhausen, *Tradition and Life in the Church: Essays and Lectures in Church History* (Philadelphia: 1968), p. 189.

57. Thomas Aquinas, *Summa Theologica*, 3a.25.3; Luca Landuci, quoted in G.G. Coulton, *The Fate of Medieval Art in the Renaissance and Reformation* (New York: 1958), p. 356f.

58. Bernard of Clairvaux, quoted in Elizabeth Holt, *A Documentary History of Art* (Garden City, NJ: 1957), I, 19f.

59. Ulrich Zwingli, quoted in Garside, *op. cit.*, p. 160.

60. John Calvin, *Institutes of the Christian Religion*, I.xi.

61. Quoted in John Phillips, *The Reformation of Images: Destruction of Art in England, 1535-1660* (Berkeley, CA: 1973), p. 184.

62. Karl Barth, "The Architectural Problem of Protestant Places of Worship," Anne Bieler (ed.), *Architecture in Worship: The Christian Place of Worship* (Edinburgh and London: 1965), p. 93. (Barth's italics).

63. Martin Luther, *Luther's Works* (Saint Louis, MO: 1958), L, 85, 86; XL, 100.

64. Albrect Dürer, quoted in Wilhelm Waetzoldt, *Durer and His Times* (London: 1950), p. 160.

65. Quoted in Holt, *op. cit.*, II, 64f.

66. Dolce Lodovico, quoted in Anthony Blunt, *Artistic Themes in Italy, 1450-1600* (Oxford: 1970), p. 124; El Greco, quoted in Blunt, *ibid.*, p. 119 n.

67. Pius XII, *Mediator Dei*, Nov. 20, 1947.

68. Ananda Coomaraswamy, "The Nature of Buddhist Art," *Selected Papers* (Princeton, NJ: 1977), I., 153.

69. *Sarvastivadin Vinaya*, quoted in Alexander Soper, "Early Buddhist attitudes toward the Art of Painting," *The Art Bulletin*, XXXII (June, 1950), 148.

70. Quoted in Philip Denwood, "The Tibetan Temple: Art in its Architectural Setting" in William Watson, ed., *Mahayanist Art After AD 900* (London: 1971), p. 47; *Lotus Sutra* II.

71. *Divyavadana*, XXVI, quoted in Ananda Coomaraswamy, *Elements of Buddhist Iconography* (Cambridge, MA: 1935), p. 110.

72. *Mumonkan* 21; *The Record of Rinzai* 20b; *Platform Sutra of the Sixth Patriarch* 35.

73. *Heart Sutra*.

74. From Jean Piaget's interviews with children, quoted in Rudolf Arnheim, *Art and Visual Perception* (Berkeley, CA: 1974), p. 304.

75. *Lalitavistara*, 55.7; *Majjhima-nikaya* 1.22; Dogen, *Shobogenzo*, Komyo.

76. *Luke* 2:32.

77. *The Roman Missal* (London: 1974), pp. 189, 202; quoted in Joseph Raya, *The Face of God* (Denville, NJ: 1976), p. 65.

78. *II Corinthians* 4:6; *John* 1:9; 12:36.

79. Alan of Lille, *Maxims of Theology*, VII.

80. *Theg-pa'i mchog rin-po-che'i mdzod*, fol. 101a, quoted in Herbert Guenther, *Buddhist Philosophy and Theory in Practice* (New York: 1972), p. 198.

81. Alighieri Dante, *The Divine Comedy: Paradisio* 33:143.

82. Black Elk, quoted in John Neihardt, *Black Elk Speaks* (New York: 1932), p. 43.

83. Quoted in Erwin Goodenough, *Jewish Symbols in the Greco-Roman Period* (New York: 1958), VII, 120.

84. *Maha-sukhavati-vyuha Sutra* 32.

85. Walt Whitman, "Song of Myself," *Leaves of Grass*, 51 (New York: 1973), p. 88.

86. John Hayes, *Graham Sutherland* (Oxford: 1980), p. 36.

87. Ananda Coomaraswamy, *Elements*, p. 19.

88. *Guhyasamaja Tantra*, quoted in David Snellgrove, *Indo-Tibetan Buddhism* (Boston: 1987), I, 133.

89. Perhaps the least inadequate of the many English translations of this most popular mantra: *Om mani padme hum*.

90. Julius Firmicus Maternus, *On the Error of the Pagan Religions*, 18.2.

91. *I Corinthians* 11:23-26.

92. *John* 6:35; 15:5.
93. Tertullian, *On Baptism*, I.
94. William Blake, "Milton," *Poetical Works of William Blake* (Oxford: 1948), p. 370.
95. *John* 1:29.
96. *Isaiah* 53:7; *John* 19:34.
97. *Revelation* 5:11-14.
98. Quoted in Mango, *op. cit.*, pp. 139ff.
99. J.S. Bach, *St. Matthew Passion*.
100. *John* 21:17; *I Peter* 2:25, 5:4.
101. *Lotus Sutra* XI.
102. *Praise to the Blessed Virgin Mary*, quoted in Emil Male, *Religious Art in France in the Thirteenth Century* (London: 1913), p. 222.
103. Tertullian, *The Chaplet*, III.
104. John Bowring, "In the Cross of Christ I Glory," *The New Century Hymnal, op. cit.*, 193.

Part II: Transformations

1. Joseph Campbell, *The Masks of God: Creative Mythology* (New York: 1982), p. 33; William Lynch, *Christ and Apollo* (New York: 1960), p. 23; *Theg-pa'i mchog rin-po-che'i mdzod*, fol. 61b, quoted in Guenther, *op. cit.*, p. 164; Oscar Wilde, quoted in E.H. Gombrich, *Art and Illusion* (Princeton, NJ: 1969), p. 324.
2. See Hugo Buchthal, "The Common Classical Sources of Buddhist and Christian Narrative Art," *Journal of the Royal Asiatic Society*, Oct., 1943, p. 137f.
3. *Brihadaranyaka Upanishad* 1.3.19; *Chandogya Upanishad*, V.1.15.
4. Ananda Coomaraswamy, *History of Indian and Indonesian Art* (London: 1927), p. 71.
5. Radhakamal Mukerjee, *The Social Function in Art* (Bombay: 1948), with plate 5; Heinrich Zimmer, *The Art of Indian Asia* (New York: 1955), p. 8f.; K.M. Munshi, *Saga of Indian Sculpture* (Bombay: 1958), p. 13f.
6. Abris Banerji, "Gupta Sculptures of Benares," quoted by John Rosenfield, "On the Dated Carvings of Sarnath," *Artibus Asiae*, XXVI (1963), 10f.
7. *Pentecostarion* (Athens: 1959), p. 201.
8. Quoted in Arthur Wright, "Fo tu-teng: A Biography," *Harvard Journal of Asiatic Studies*, XI, 356; quoted in Xinru Liu, *Ancient India and Ancient China: Trade and Religious Exchanges A.D. 1-600* (Delhi: 1988), p. 168.
9. From the chronicle of Raoul Glaber, written about 1048, quoted in Caecilia Davis-Weyer, *Early Mediaeval Art: 300-1150* (Toronto: 1986), p. 124.
10. Quoted in Edwin Reischauer, *Ennin's Dairy: The Record of a Pilgrimage to China in Search of the Law* (New York: 1955), p. 382; L. Carrington Goodrich, *A Short History of the Chinese People* (New York: 1959), p. 130.
11. Quoted in Jiro Sugiyama, *Classic Buddhist Sculpture: The Tempyo Period* (New York: 1982), p. 14.
12. *Isaiah* 50:6; 63:1-6.
13. Albrecht Dürer, quoted in Holt, *op. cit.*, I, 315.
14. Leo Steinberg, *The Sexuality of Christ in Renaissance Art and in Modern Oblivion* (New York: 1983), pp. 18, 21, 23.
15. Emile Nolde, quoted in Werner Haftmann, *Emile Nolde* (London: 1959), opposite plate 3.
16. Thomas Merton, *The Asian Journal* (New York: 1973), p. 235.
17. Homer, *The Odyssey* I; *Amos* 9:7.
18. Bede, *A History of the English Church and People*, III.25.
19. Viktor Lowenfeld and Lambert Brittain, *Creative and Mental Growth* (New York: 1964), p. 188.
20. Coulton, *op. cit.*, p. 389.
21. *The Light of Asia*, 1925, directed by Franz Osten with Himansu Rai as the Buddha; *Shaka*, 1961, directed by Kenji Misumi with Kojino Hongo as the Buddha; *Little Buddha*, 1993, directed by Bernardo Bertolucci with Keanu Reeves as the Buddha.
22. Barnett Newman, *Selected Writings and Interviews* (New York: 1990), p. 188.
23. Amy Lowell, "Patterns," *The Complete Poetical Works of Amy Lowell* (New York: 1955), p. 75.

Index

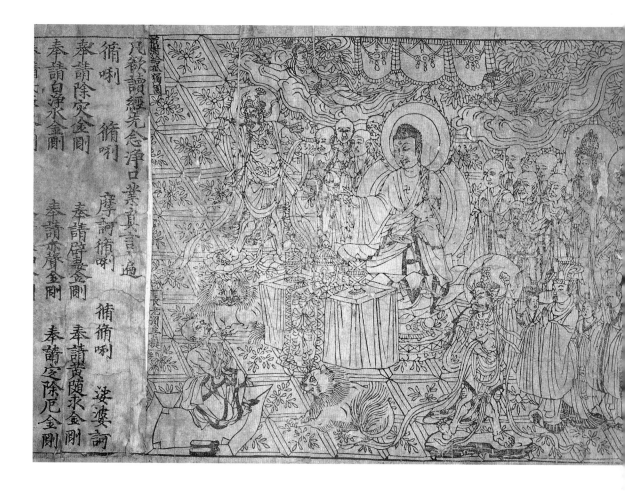

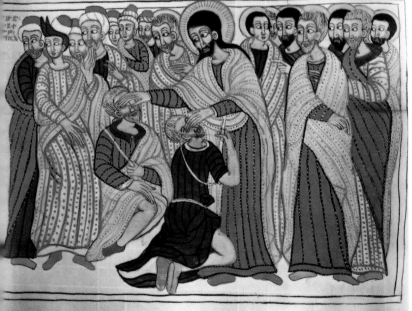

The "weathermark" identifies this book as a production of Weatherhill, Inc., publishers of fine books on Asia and the Pacific. Editorial supervision: Ray Furse. Book and cover design: Mariana Canelo. Production supervision: Bill Rose. Printed and bound by Oceanic Graphic Printing, China. The typeface used is Goudy.